Pelican Book

W9-DCP-168

The Gothic Revival

Sir Kenneth Clark was born in 1903.
He was educated at Winchester and Oxford,
and worked for two years with Bernard
Berenson in Florence. He was appointed
Director of the National Gallery at the age
of thirty and remained there until 1945.
During the war he organized the war
artists' scheme, and with Dame Myra Hess
was responsible for the National Gallery
Concerts. He was twice Slade Professor of
Fine Arts at Oxford. Sir Kenneth was
Chairman of the Arts Council from 1953
to 1960, and was appointed Chairman on
the setting up of the Independent
Television Authority. *The Gothic Revival*,
written at the age of twenty-two, was his
first publication, and many others have
followed; three of them, *Leonardo da Vinci*
(1939), *Landscape into Art* (1949), and
The Nude (1956), have been republished
as Pelicans. Among his other works are
Piero della Francesca (1951) and *Looking at
Pictures* (1960).

Sir Kenneth is married and has three
children.

Kenneth Clark

The Gothic Revival

An Essay in the History of Taste

With sixteen plates

Penguin Books

Penguin Books Ltd, Harmondsworth,
Middlesex, England
Penguin Books Pty Ltd,
Ringwood, Victoria, Australia

First published by Constable 1928
This edition published by John Murray 1962
Published in Pelican Books 1964

Made and printed in Great Britain by
C. Tinling & Co. Ltd,
Liverpool, London, and Prescot

Set in Monotype Bembo

Dedicated to C. F. Bell

Contents

Preface to the First Edition

The idea of writing about a phase of the Gothic Revival was first suggested to me by Mr C. F. Bell, but I should be sorry to make him in any other way responsible for the book as it now stands. His suggestion was an essay on the ethical and religious standards by which men judged architecture from about 1840 to 1860; and perhaps this less ambitious scheme held out better hopes of success, but the whole subject proved so fresh, so unexplored, and so indivisible, that I do not regret my wider ambition. I have limited myself to a point of view, rather than to a period, and I hope that after warning on the title-page, here, and in the introduction, no one will reproach me because this is not an exhaustive textbook on neo-Gothic architecture. To the same end the illustrations are taken from prints, which show Gothic Revival buildings not as they are, but as their authors wished them to be. And, of course, I have not touched on the Revival in any country but England: my subject was vast enough as it was.

The little work which has been done on the Revival has been on Walpole and on the picturesque. In consequence I have not dealt very fully with these early periods, and the reader who cannot spare time for the whole book will probably find the last few chapters more interesting than the first.

I had originally intended to add a bibliography, but I find that all the books I have used are referred to in the notes. There are, however, two essays which are seldom mentioned in the text, but which were of great value to me. One of these is Mr Geoffrey Scott's *Architecture of Humanism*, the other a short, but

very suggestive essay by Mr Goodhart Rendel, published as the R.I.B.A. sessional paper for 1925.

In finding my way through these unmapped regions I have received help from friends more often than I can record. But I must mention Mr Pearsall Smith, who generously lent me his notes on the etymology of Gothic, and who was so kind as to read some parts of the book and criticize my way of writing. To him, as to Mr Bell, I am especially grateful. Chief among the others who have helped me are Mr Roger Mynors of Balliol, the Master of University College, the Master of Balliol and Mr John Sparrow, Mr E. Pugin-Powell, Mr William B. Ivins, jnr, of New York, and my publisher, Mr Michael Sadleir. Although I have never heard Mr Bernard Berenson mention the Gothic Revival, I owe him a debt, difficult to describe and impossible to repay, which most of those who have heard him talk will understand. To my wife I owe the greatest debt of all, for without her I should never have written more than two or three chapters.

Tunbridge Wells, 1928

Preface to Later Editions

In preparing this edition I have been greatly helped by Mr John Piper and Mr John Betjeman whose suggestions and corrections of the text are only part of the great debt of gratitude which I already owe them. My thanks are also due to Mr Howard Colvin who has sent me many valuable corrections.

August 1949
January 1962

A Letter to Michael Sadleir

Dear Michael Sadleir,

When you suggested that *The Gothic Revival* might be worth reprinting, I was greatly flattered, and opened its pages, which I had not read for over twenty years, with pleasant anticipation. But this mood didn't last long. With every page I became more apprehensive. Could it possibly interest new readers? And would it not be wise to leave former readers with the memory of large white margins and an unfamiliar subject? In a new edition the margins would be a normal size, and the subject familiarized by (as our grandfathers used to say) abler and more learned pens than mine. I was alarmed by the thought of all the howlers which a new generation of reviewers would discover in my rather amateurish effort. And as I waded through the first three chapters my heart sank. They were dull. They read like a B.Litt. thesis – which was not surprising, as they had been written at Oxford immediately after taking my final schools. I was still determined to satisfy the examiners, and he who satisfies examiners satisfies no one else. However, I persevered; and by the time I had finished the chapter on Pugin my confidence began to revive. It was something to have rescued that extraordinary character from oblivion. The next three chapters I positively enjoyed. So perhaps after all the book is worth reprinting for the second half alone.

I notice that at that date (although I poke fun at an Ecclesiologist for doing so) I was fond of dividing things into three. I will continue in that spirit and say that the book may be considered in three ways; as history, as entertainment, and as

criticism. I expected to find the history inaccurate, the entertainment out of date, the criticism relatively sound. But it is the criticism which has worn least well. I had been brought up on theories of 'pure art' – the pure form of Roger Fry and the pure architectural values of Geoffrey Scott. *The Architecture of Humanism* had made a profound impression on me, and Scott's powers of lucid exposition had blinded me to the fundamental unreality of his position. I started my book hoping to apply Scott's theories (without, heavens knows, his dialectical skill) to a kind of architecture which everyone agreed was worthless. I thought it a good opportunity of exposing what he had called the ethical fallacy. I read the apologists of the period, Pugin, Ruskin, and even Gilbert Scott, in order to find evidence of this and Scott's other 'fallacies' in their work; and, like better men before me, I was unconsciously persuaded by what I had set out to deride. Finally, in the Epilogue, I attributed the failure of the Revival to ethical and social causes, without realizing that I had implicitly abandoned my pure Scottist position.

This inconsistency of critical values does not seem to have worried readers of the first edition. What irritated them was my far too lenient attitude towards the actual buildings. They had hoped for stronger vituperation, more sustained sneers. They thought me half-hearted: and so I was, though in the opposite sense to that which they intended. Soon after I had begun work on the subject I recognized that the Gothic Revival had produced some great architecture. At first it was the false Gothic of Fonthill and the Houses of Parliament which seemed bearable; then it was the tasteful Gothic of Temple Moore and Bentley; finally, and almost too late, I realized that the greatest architects of the movement were precisely those whom my contemporaries thought most insufferable, Street and Butterfield. A generation influenced by the poetical insight of Mr Betjeman will find it hard to believe in the state of feeling towards nineteenth-century architecture which prevailed in 1927. In Oxford it was universally believed that Ruskin had built

Keble, and that it was the ugliest building in the world. Under-graduates and young dons used to break off on their afternoon walks in order to have a good laugh at the quadrangle. Ruskin, it is interesting to recall, was believed also to have designed Balliol Chapel and Meadow Buildings at Christ Church; and this belief was held not only by the young, but by men whose fathers must have been in Oxford when those buildings were constructed. One eminent historian, now a senior professor, went so far as to call me a liar at a public meeting because I denied Ruskin's part in these buildings. I wish I had got him to put it in writing. This was the atmosphere in which I wrote the short chapter which follows, called Introduction, with its assumption that the whole Revival produced practically nothing which the 'sensitive eye' (a favourite feature of the 1920s) could rest on without pain. By the time I reached the epilogue I had changed my ground. Then it was the by-blows of the Gothic Revival, the banks, grocers, and Wimbledon villas which are cited as deplorable. 'What a pathetic mem-orial', I add, 'to Pugin, Butterfield, and Street!' Implying, I suppose, that I recognized these as great men, and deplored the fact that their styles should be remembered largely through commercialized derivations. 'And why, if you felt like that,' the reader may ask, 'why didn't you try to save them from this degradation by including chapters on Butterfield and Street?' The answer which I gave is contained on page 202 where I repeat that my book was concerned with 'the ideals and motives of the Revival' and not with the actual buildings. But the real answer is that I was not sufficiently sure of my ground. I felt fairly certain that Street was a great architect, but I couldn't say why. I had too little understanding of real Gothic architecture to be a confident judge of its later variants. As for Butterfield, his polychrome decoration and metallic tracery, although they didn't blind me to the conviction of his design, prevented that wholehearted enthusiasm which was needed to swim against the current of informed opinion. So the chapters on Street and Butterfield, although contemplated, were never

written, and it is too late to write them now. They would destroy whatever unity of character the book may claim. For better or worse, *The Gothic Revival* is a period piece, a document, rather pathetically, in the history of taste which it sets out to anatomize.

For this reason I have added nothing to the text, and cut out only a few lines which seemed to be mere repetition. I have left in sentences which are untrue or ridiculous because they are part of the whole, and a few of the more egregious I have annotated. Perhaps some of these notes are rather too septuagenarian in effect. We are often told that the 1920s are as remote from us as the eighteenth century; and *The Gothic Revival* is a book of the twenties. I had the privilege of knowing Lytton Strachey, now the subject of hyena laughter in the highbrow weeklies, and I am proud to say that I was influenced by him. Now that we are all sadder, we believe ourselves to be wiser; we can be certain that we are entertaining. The later chapters of this book were meant to be entertaining, and, considering the sacrifice of truth and decency which this aim usually involves, they strike me as being remarkably fair-minded. So that my notes may suggest more grandfatherly head-shaking than in fact took place. But they do give an indication of the very great change which my attitude towards all the arts has undergone in the last twenty years, and which began with my reading of Ruskin's *Nature of Gothic* in the preparation of this book.

These notes have allowed me to give references to most of what has been printed on the subject since my book appeared. There is less of it than I had expected. Although much, no doubt, was said and thought, practically nothing was written about the Gothic Revival till the 1940s; and then a good deal of it is no more than the documentation of conclusions which were already accepted. No one has equalled the learning, urbanity, and critical insight of Mr Goodhart Rendel, the father of us all, whose kindness to his unworthy children is made more remarkable by the fact that he can see through all their pretences. The best things written have been from the pen

of Mr John Summerson, especially a brilliant article on Butter-field in Volume 98 of the *Architectural Review*, which expresses so exactly my own feelings (except that I would have men-tioned the parallel of Holman Hunt, rather than Millais) that it alone relieves me of the necessity of adding a chapter on that uncomfortable genius. But the most important name of all will not appear in my footnotes because his influence has not been exerted through learned articles, but through poetry and con-versation. It is that of Mr John Betjeman, one of the few original minds of our generation. His first interest in Gothic Revival architecture may have been part of his overflowing love of the neglected; but his sensitive response to architecture, as to everything which expresses human needs and affections, allowed him to see through the distorting fog of fashion, and to recognize the living force of the Gothic Revival in Voysey and in Mr J. N. Comper. The changed point of view which underlies all recent articles on nineteenth-century architecture, and especially those in the *Architectural Review*, is due directly to the stimulus of his talk; which proves once again that history is not to be found solely in files and learned publications, but in human contacts and in the radiation of a single personality. The only trouble is that Mr Betjeman's adventurous spirit may lead the undiscriminating to squeak with joy at any Victorian building sufficiently far outside the canons of conventional good taste. So let me end this letter by urging you, who were far-sighted enough to publish the first book on the Gothic Revival, to find an author who will write the second neither apologetically nor defiantly, neither ironically nor ecstatically, but in a true critical spirit. Also, he will have to know much more about architecture than I do.

Yours sincerely,

KENNETH CLARK

Hampstead, July 1949

Introduction

Since 1872 no book about the Gothic Revival has appeared.[1] During these fifty years books have been written on the architecture and painting and sculpture of every age and every country; it has seemed as if no art could be too strange, no artist too insignificant to escape attention. Yet the most widespread and influential artistic movement which England has ever produced has remained unchronicled. Eastlake, who was himself part of this movement, obviously lacked both detachment and completeness; but no one has tried to supplement his *History*.

One reason for this is that the Gothic Revival was an English movement, perhaps the one purely English movement in the plastic arts;[2] if it had taken place in Germany the history of the Revival would have been in good order by now, and the student would have been writing monographs on Wyatt's relations with Wyatville or on Gilbert Scott's last phase, rather than trying to digest the subject as a whole. But the real reason why the Gothic Revival has been neglected is that it produced so little on which our eyes can rest without pain. Nor is this distaste purely a matter of fashion. In the past the pendulum of fashion swung slowly, so slowly that the metaphor of a pendulum seems a little ridiculous when we must count a hundred

1. *A History of the Gothic Revival*, by Charles L. Eastlake, was published in 1872.

2. Like most statements of the kind known as 'challenging', this is untrue. It underrates the part played in the Revival by German *Sturm und Drang*. In so far as any 'movement' in the Arts can be considered purely English the perpendicular Gothic of the fourteenth century has as good a claim as that of the nineteenth (1949).

years between the beats. But when photography opened a vast field of aesthetic experience to the most stay-at-home person, the world of taste became like a cuckoo-clock, the pendulum rattling away at a great speed, and the critic emerging with a triumphant cry of discovery every hour. Fashion still troubles the surface of our appreciation – adds a sauce to this or that style; but if put to it we can swallow almost anything. The Gothic Revival is one of the very few styles which we cannot swallow; and if we believe in objective values at all, we are justified in thinking that these styles are devoid of merit. So we can understand why art historians have neglected the Gothic Revival. They write about works of art. Either they feel moved by them and hope by their appreciations to convey their enthusiasm to others; or they write because a beautiful object creates a natural desire to know something about the man and times which produced it. Under the influence of beauty many people seem to have an irresistible, but ill-omened, impulse to write; so every object which seems beautiful or saleable has been celebrated in weighty volumes; and the architecture of the Gothic Revival, which is neither of these things, has barely received a paragraph in a learned periodical.

This kind of writing is important, and sometimes delightful, but it is not the only way in which the history of art can be approached. Instead of making a great work of art his central theme and trying to explain it by means of the social and political circumstances of the time, the historian may reverse the process, and examine works of art to learn something of the epochs which made them, something of men's formal, imaginative demands which vary so unaccountably from age to age. At certain times the average man can only look with pleasure at things of a certain shape and character. Why? Where do these shapes come from? How have they been modified? What ideals, what dream worlds do they express? To answer these questions the quality of the object is irrelevant, for though the taste of a time is sometimes concentrated in a great work of art, more often men are satisfied with forms which seem to us

devoid of grace, and a whole epoch may express itself very sincerely, but very unsatisfactorily. Beauty is a historical document; but a historical document is not necessarily beautiful.

The monuments of the Gothic Revival, therefore, are worth studying irrespective of their beauty, provided they once satisfied the imaginative demands of the majority of Englishmen. And of this, alas, there can be no doubt! When the tide of the Gothic Revival ran high, buildings in that style seemed as inevitable as trees and haystacks; only recently we have begun to notice these monsters, these unsightly wrecks stranded upon the mud flat of Victorian taste. And we find them everywhere, in every town, old or new, and in almost every village. Probably there is not a church in England entirely unaffected by the Gothic Revival, and civil architecture was far more plagued than most of us realize; for a sensitive eye, which turns away from ugly shapes instinctively, cannot have noticed a quarter of the neo-Gothic forms which have passed before it.

No chapter in the history of taste should be so easily manageable as the Gothic Revival. It is sufficiently remote for us to view it as a whole, yet not so remote as to be incomprehensible; most of the chief Gothic Revival buildings still stand, no longer crude, but not yet defaced; and more than any other movement in the plastic arts the Revival was a literary movement, every change in form being accompanied by a change in literature which helps the writer in his difficult task of translating shapes into words. For though form is a language, and eventually the trained philologist of form should be able to interpret any monuments in which the impulse to decorate is still visible, the beginner had best start on a language for which many keys exist – on old Provençal, shall we say, rather than on Etruscan, though the latter is more exciting. Otherwise he will find himself producing but another of those *Geists* and *Formproblems* of this or that style in which the Germanic origin of the arts is so frequently emphasized.

Chapter 1

The Survival of Gothic

Writers on English architecture sometimes say that a tiny stream of the Gothic tradition was never lost, but flowed unbroken from Henry VII's chapel to the Houses of Parliament. In one sense this is true: from 1600 to 1800 perhaps no year passed which did not see the building of some pointed arch and gabled roof, or the restoration of some crumbling tracery. There are churches, colleges, private houses, built under the stiffest Augustan tyranny, which can only be classified as Gothic; and they have led some writers to suggest that the phrase 'The Gothic Revival' should be abandoned as misleading.

Classical Latin was read in the dark ages, and read more intelligently than Gothic architecture was used under Queen Anne. Yet the literary models chosen were so fragmentary and unrepresentative, and the interpretations so alien to the spirit of the original, that we speak with confidence of a 'Revival of Learning'. If we study the medievalism of Kent or Hawksmoor we shall find no difficulty in the phrase 'The Revival of Gothic'. The tiny brackish stream need not disturb our traditional phraseology.

Yet the stream never quite disappears, for just as Gothic seems doomed, the antiquarians take it up, and soon the leaders of the literary world begin to appreciate and exploit it for purposes of their own. This scholarly interest in archaeology, followed by a sentimental delight in decay, is the true source of the Revival; and it just overlaps with the use of Gothic as a traditional style. Renaissance forms reached England so late, and were acclimatized so slowly, that Gothic was still being employed when it became the subject of antiquarian inquiry.

When did Gothic cease to be the prevalent national style? Not, certainly, in the sixteenth century. Torrigiano came to England in 1512, and, it seems, was employed on Henry VII's tomb in October of that year. Wolsey began work at Hampton Court in 1515, and the splendid Renaissance carving on King's College Chapel screen dates from 1533. But for all this, Gothic prevailed for a century. Pure Italian[1] work was confined to details of decoration; for instance, the panels of the Countess of Salisbury's chantry at Christchurch, which are set in a fifteenth-century Gothic framework; or the two *putti* who stand over the gallery door at The Vyne, lonely messengers of the Renaissance among a waste of linen-fold panels. Nor was the influence of German and Flemish workmen much more far-reaching. It affected all manner of details, and any parts of the building which required elaborate ornamentation – porches, fireplaces, or tombs. But these were the isolated attempts of foreign workmen, and the efforts of half-instructed native builders. Gothic was still the natural way of building, the shell which might be embellished according to taste, the norm which might be departed from at the dictates of fashion.

The real change was due to Inigo Jones. It is not, of course, suggested that, had he never lived, England would not have assimilated the Classical and Renaissance styles. But in so far as historical movements can be attributed to an individual, there can be no doubt that Inigo's genius gave to our architecture the direction which it maintained for at least 150 years. It is a proof of the tenacity of Gothic in England that Inigo Jones was born in 1573, almost two hundred years later than Filippo Brunelleschi, and that Jones himself did not abandon the use of the pointed arch till after his second visit to Italy (1612).[2] None of his Gothic building has survived; but we can easily accept Walpole's statement that 'Jones was by no means successful when

1. Italian in style; not Italian in workmanship, which is a very different question.
2. East, 5. But the statement rests on the flimsy authority of Walpole's *Anecdotes of Painting*. No building by Jones of that time can now be identified.

he attempted Gothic', for his work shows complete sympathy with Renaissance ideals. When, after ten years' deliberation, it was decided to repair St Paul's Cathedral, Jones made no attempt to conform to the style of the old building.[1] And we may make 1633, the year in which the work was begun, an important date in the decline of Gothic. It was possible to overlook local or fashionable innovations; but when the chief Gothic monument of the land was to be given a classical shell, men's vision must have been dominated by the new forms.

Those who are interested in the history of words may find confirmation of this date in philology. For centuries the Gothic style had no name; it was the only way of building. As soon as it was named it was a separate style, and when the word became widely used we may say that Gothic had become something artificial and peculiar. Perhaps the name came with the new style from Italy,[2] a name full of contempt for barbarism. But, unlike many contemptuous titles, from *Christian* downwards, it was never accepted defiantly and with pride; and the word Gothic remained a source of distress to admirers of that style till the middle of the last century.

In England, as in Italy, the pointed arch was early associated with the Goths. For instance, Sir Henry Wotton in his *Elements of Architecture* (1624), says that this form, 'both for the natural imbecility of the sharp angle it selfe, and likewise for their very

1. The rebuilding was not, of course, completed. Roughly speaking, Jones had put a new renaissance shell on the west end, nave, and transepts before the Civil War put an end to the work.

2. The application of 'Gothic' to architecture was probably Italian. But when and by whom it was first made is not clear. Reinach (*Apollo*, chap. XII) says, 'The term is said to have been first used by Raphael in a report addressed to Leo X, dealing with the works projected in Rome. . . . The epithet *Gothic* was popularized by Vasari.' Raphael does not use the word. He speaks of '*Li edificipoi del tempo delli Gotti*', but always refers to '*architectura Tedescha*'. Nor can I discover the epithet in Vasari. He refers to *i Gotti* once or twice in connexion with architecture, but says, '*Onde ne vennero a risorgere nuovi architetti, che delle loro barbari nazione fecero il modo di quella maniera di edifizi che oggi da noi son chiamati Tedeschi.*'

Britton says that the word Gottica is first found applied to architecture in the writings of Palladio (*Architectural Antiquities*, vol. v, 33).

Vncomelinesse, ought to bee exiled from judicious eyes and left to their first inventors, *The Gothes*, or Lumbards, amongst other Reliques of that barbarous age'. This is the confession of faith of a much-travelled humanist, who in matters of taste was in advance of his countrymen. But the adjective Gothic, the first time we meet it, has the air of a term accepted and understood. In the August of 1641, young John Evelyn noted, 'Haarlem is a very delicate town and hath one of the fairest Churches of the Gotiq design I had seen.'[1] Evelyn uses the word many times in his Diary, and it is found elsewhere. It was, in fact, a common expression, and was soon to become a part of fashionable jargon, a vogue word used for any uncouth anachronism. Soon Millamant was to puzzle poor, old-fashioned Sir Wilfull with her modish rebuff, 'Ah, Rustick, ruder than Gothick.'[2]

By the middle of the seventeenth century, then, Gothic architecture had ceased to be the prevalent style, and in Charles II's reign it was rare and freakish. Yet, as I have said, there are reasons for believing that Gothic never died. Since the means by which it was kept alive have never been examined very clearly, I may be forgiven if I divide them rather pedantically into three classes.

First, those architects who worked habitually in the Renaissance style, but have left us some Gothic buildings built for special reasons. Secondly, local builders and craftsmen who clung to the old tradition. Thirdly, the survival of an interest in Gothic architecture.

In the first class there is one great name – Sir Christopher Wren. His feelings towards Gothic architecture have been presented in various lights, depending on the respect accorded to

1. As Evelyn edited or rewrote his Diary towards the end of his life, it cannot be relied upon as a safe indication of linguistic usage. I have found twenty-five instances of the word *Gothic* in the Diary, and there may well be others which escaped me. It occurs chiefly in the first half of the Diary, and for the first seven times Evelyn seems uncertain how to spell it. He tries *Gotiq*, *Gotick*, and *Gotic*, finally deciding on the last, which he employs, with one lapse into *Gottic*, throughout the rest of the work. This does not look like an interpolation made when revising or editing.

2. Congreve, *The Way of the World*, IV, 2.

him by the fashions of the time. The Gothic Revivalists, disliking, though they dared not despise, his architecture, made a bogy of him, and quoted freely from the *Parentalia*, which is full of contempt for Gothic. A later age, determined to let slip no chance of eulogy, claims that he rose above fashionable prejudice and treats him as an isolated admirer of that style. Neither statement is unbiased, but the former is nearer the truth.

The Goths and Vandals, having demolished the Greek and Roman architecture, introduced in its stead a certain fantastical and licentious manner of building which we have since called modern or Gothic – of the greatest industry and expressive carving, full of fret and lamentable imagery, sparing neither pains nor cost.

This is an attractive, but not a flattering description of medieval building; and, though it comes from Evelyn's *Account of Architects*, I see no reason to doubt that it represents Wren's true sentiments. He expresses the same feelings in documents which are indisputably authentic; his reports on Salisbury Cathedral contains much sound sense and mechanical invention, but very little that can be interpreted as appreciation; and his report on Westminster Abbey is patronizing rather than enthusiastic – Henry VII's chapel is a 'nice embroidered work', but he deplores 'the flutter of arch buttresses'. Shall it be counted to him for virtue that his design for a central spire was in the Gothic manner, and that he considered that 'to deviate from the old form would be to run into a disagreeable Mixture: which no person of good Taste could relish'? This is more than can be said of Inigo Jones before, and Gibbs[1] after him, but it cannot be made to prove a deep sympathy for medieval architecture. Nor can his buildings in that style. Wren's Gothic churches have found admirers, and they have one merit which buildings of the later revival have not: they are extremely simple. Wren

1. At Allhallows, Derby, where Gibbs, who knew his limitations, joined a Palladian nave to the old Gothic steeple. Gibbs is always considered the arch-classicist, but he sometimes expresses admiration for Gothic; thus he writes of King's College Chapel, 'A beautiful building of the Gothick taste, but the finest I ever saw.'

used no more than the bare outlines of Gothic, perhaps fore-seeing that detail depended too much on traditional craftsmanship to be revived with success, perhaps merely despising 'nice embroidered work'. The tower of St Michael's, Cornhill, shows the value of this bareness, for the porch was added by Sir Gilbert Scott. It is a fussy, indigestible design which makes Wren's work[1] look quite distinguished; but it comes far closer to the letter of Gothic than does any design of Wren's, except his great tower at Christ Church. The interior of St Michael's is classical. Wren attempted a Gothic interior at St Albans', Wood Street, and the result is as unsuccessful as any Walpolian chapel of the eighteenth century, the sham groining as sham and the general effect as mean.

As far as we can judge, Wren did not love Gothic, and only used it when circumstances compelled him to do so; but about the year 1702 a change came over the Board of Works. Perhaps Vanbrugh, perhaps Hawksmoor, influenced the seventy-year-old master; perhaps it was Wren himself who developed a new manner; whatever the cause, from that time the works of his school became bolder, fuller of movement, more baroque, as we say. Now of the two architects who developed this native baroque, Vanbrugh and Hawksmoor, neither, so far as we know, had been to Italy. They could take their details from the common classical stock, but for compositions in the round, for the movement and variety at which they aimed, there were no models in England save the monuments of the Middle Ages. It is not surprising, therefore, that almost every student of Vanbrugh's buildings has noticed that they are like castles. Of this he himself was fully conscious, and in 1707 he writes to the Earl of Manchester that he purposes to give Kimbolton a 'Castle Air ... for to have built a Front with pillasters and what the Orders require could never have been born with the Rest'. 'I am sure', he adds, 'this will make a very Noble and Masculine Shew; and is of as Warrantable a kind of building as Any.' At Claremont he not only banished the orders, but

1. In fact the tower of St Michael's is by Hawksmoor.

designed a battlemented tower to stand on the hill behind the house. Even more interesting than these obvious romantic devices is the way he can use nothing but classical detail, and yet give his buildings a stubbornly medieval character, so that Seaton Delaval, seen from certain angles, is like a lion crouching on the defensive. Hawksmoor, who worked mainly on churches, had less opportunity for this kind of romanticism. His interest seems to have been in Gothic detail, and, as was natural in so great a technician, in feats of construction like the lantern at Ely. Vanbrugh never used a pointed arch, whereas Hawksmoor built the North Quadrangle at All Souls College, and designed the towers of Westminster Abbey;[1] and it is even possible that he built the first Gothic temple, in Colonel Tyrrell's garden at Shotover. This use of medieval detail was never as successful as Vanbrugh's use of medieval mass, but it was more obvious to the ordinary observer and probably more influential. Nor is it always a failure. The towers of Westminster Abbey are well proportioned, and despite the Renaissance pediments over the clocks, the detail is accurate enough to bring them into harmony with the rest of the building.[2] Fergusson even praised the towers of All Souls,[3] though his praise was chiefly a means of insulting his Gothic contemporaries, and All Souls has found few serious admirers. The building has that flat, flimsy look which is typical of pre-Puginesque Gothic; the buttresses receive no thrust and the pinnacles are weightless. The great Gothic Revival doctrine of truthful construction still colours our judgements, and at most we can only agree with Walpole, that though the architect knew nothing of Gothic, he 'had blundered into a picturesque scenery, not void of grandeur'.[4]

1. They were not completed till after Hawksmoor's death, by John James.
2. But perhaps this is no test, for externally the Abbey is almost entirely of the eighteenth and nineteenth centuries.
3. *History of Modern Architecture.*
4. *Works,* vol. III, 433. Walpole first attributed All Souls to Gibbs; this quotation is taken from his life of that architect. He corrected the attribution in a footnote.

If we ask how much these great men who dabbled in Gothic influenced the real Revival of the late eighteenth century, I think the answer is: very little. When, in 1718, Wren was dismissed from the Board of Works, there was a reaction against the native baroque of Vanbrugh. The leaders of the new school, Lord Burlington and his friends, had made the Grand Tour, and returned shocked at the Gothic extravagances of Borromini, charmed by the chaste proportion of Palladio. Left to himself, they thought, Vanbrugh bade fair to debauch English architecture as Bernini had debauched Italian. So for about twenty years English architects bent under the Palladian rule, and it was against this narrow Classicism that the real Gothic revivalists reacted. But these men who tired of classical tyranny were not at all influenced by the Gothic of Wren and his school. On the contrary, they despised it, and Walpole considered that Inigo Jones, Wren, and Kent 'blundered into the heaviest and clumsiest compositions whenever they aimed at imitating Gothic'.[1] Not only was Walpole cut off from Wren's pupils by a deep reaction of taste, but their aims had been entirely different from his. They had used Gothic motives to stir up the classical style and create a sort of baroque; Walpole wished to play at medievalism with details copied from ancient monuments. Hawksmoor's Gothic only resembles that of the later revivalists because it is thin and flat; the bond between them is incompetence, not similarity of aim or taste. As it happens, one architect who worked in the interval between Wren and Walpole occasionally attempted a medieval style. This was William Kent, who designed a screen at Gloucester in a Gothic style, and who built a Gothic villa for Henry Pelham. But he cannot be made to link the two groups. He was a leader of the reaction against Vanbrugh, and the real revivalists, Walpole and Gray, would have scorned the idea that he was one of

1. *Collected Works*, vol. III, 95. Walpole made an exception of Wren's tower of the great gateway in Christ Church, where he 'has catched the graces of it (true Gothic) as happily as you could do' (Walpole to Bentley, September 1753).

them. Though Walpole once admired Esher – 'Kent', he said, 'is Kentissime here' – Gray thought it showed that 'Mr Kent had not read the Gothic classics with attention'. Of course he had not. Kent, whose foible was versatility, tried his hand at Gothic when circumstance demanded; but he did not instinctively appreciate its architectural qualities, like Vanbrugh, nor was he an antiquarian like Walpole; and if he influenced the Gothic Revival, it is as the originator of picturesque gardening, not as transmitter of Vanbrugh's taste for the Heroick style.

The Gothic traditions of local builders are a much firmer link in the chain of survival. We have seen that Gothic died hard; this is especially true of ecclesiastical and collegiate architecture. The country contains many traditional Gothic churches built during the seventeenth century. Often the tracery is weak and the crockets doughy, and sometimes classical motives creep in; but many are indistinguishable from those country churches and chapels which men had been building for a hundred and fifty years. To cite examples would be a waste of time, and the curious may find a few mentioned in Sir Reginald Blomfield's *History of Renaissance Architecture in England*. He refers to Welland (1672) and Hanley (1674) as the latest examples of traditional Gothic. Restorations and additions in this style are found of a far later date; and some whole churches may be known to local antiquarians, but I have been unable to find them.

It is usual to lay great stress on the use of Gothic in seventeenth-century Oxford. At that date very few large churches or chapels were being built, and the Universities were almost alone in needing the type of buildings usually in the Gothic style. Respect for surroundings and conservatism may have influenced the choice, but the true reason why Gothic was used is simpler. It was still the natural way of building a church or a college. The surprising features in Wadham (1613) are not the perpendicular windows, but the superimposed orders of the gate. The prominence given to Oxford Gothic may be due partly to its intrinsic merit, but it springs very largely from a

sentimental and religious connexion. The Gothic revivalists were so much a part of the Oxford Movement, and so enchanted by Oxford's Catholic past, that they attributed the late Gothic there to conservatism, and to the University's sympathy with the decorative elements of medieval worship. This is clearly shown by their attitude to St John's College. They liked to treat it as an isolated thing, and as an example of Laud's 'anglo-catholic' zeal. With his love of old forms, they said, he naturally preferred an architecture which was associated with the beauty and richness of catholic ritual. Laud was a high-church worthy, and as such had to be made the first Gothic revivalist. But St John's is neither the last nor the most traditional of the Gothic buildings in Oxford. The Canterbury quadrangle there was built between 1631 and 1636; University College was not begun till 1634; and the roof of Hall stairs at Christ Church, the finest seventeenth-century Gothic in Oxford, dates from 1630. Moreover, St John's new buildings are the least Gothic of their time, the arcaded quadrangle being so Italianate that it is persistently, and groundlessly, attributed to Inigo Jones. Laud certainly encouraged church building; but when we remember that it was Laud who enabled Inigo Jones to rebuild St Paul's in Renaissance style, we can no longer respect his claims to be the first Gothic revivalist. Indeed it would not have been worth exposing the pious fiction had it not found its way into learned books on the subject.

There are a few pieces of Oxford Gothic which are of importance to us. The first of these has been mentioned. The exquisite fan vaulting over the stairs of Christ Church hall was built in 1630 by a mason about whom we have no more particular information than that he was a Mr Smith of London. Whoever he was, he was a master and employed highly skilled workmen. Only men born and bred in the Gothic tradition could have done this work and to judge from it the tradition was far from dead.

The other important piece of late Gothic is the fan vaulting under the gate of the Radcliffe quadrangle at University Col-

lege, which dates from between 1716 and 1720.[1] In these years, too, the north quadrangle at All Souls was being built, and a comparison of these two colleges provides a useful instance of the ways in which Gothic survived. Beneath the arches of All Souls are plain Renaissance vaults; at University stone groining does its work in the traditional way. In one, Gothic ornament alone has survived; in the other we have proof that Gothic methods of construction were still understood. On the whole it was Gothic ornament which proved the more tenacious of life, so that its survival melts imperceptibly into the revival of Batty Langley and Walpole. This is perhaps natural, for even in the eighteenth century a certain amount of church restoration was necessary. Tracery crumbled or chancel roofs fell in; and all over the country there must have been carvers who followed a tradition of ornament many centuries old. We are often unaware how much of what we admire in a Gothic church was wrought under the full dominion of classicism.

Gothic methods of construction also survived in a still more unobtrusive manner. In country districts with plenty of natural materials and a strong local tradition, domestic architecture remained untouched by Italian influences even in the eighteenth century. A Cotswold village will contain houses of every date, from the fifteenth century onwards, scarcely distinguishable from one another. Barns and farm buildings were still roofed and buttressed in the Gothic way; and country workmen followed Pugin's True Principles with a naturalness which he praised but could never attain. While medieval ornament was enjoying its modish revival in the town, medieval construction lived an unassuming country life; and Walpole little suspected that the average barn was more truly Gothic than his bepinnacled Strawberry.

When the Revival was still young, a correspondent to the *Gentleman's Magazine* discovered a colony of masons whose craft had not changed since the Reformation, and there was a

1. Mr Howard Colvin informs me that the mason contractors were William Townsend and Bartholomew Peisley, both of Oxford.

vague feeling that such a discovery was of value. But we have no record that Walpole sought for such men; on the contrary, it is clear from the Strawberry Hill accounts that most of the craftsmen employed there had no connexion with Gothic. We know that many of them were employed by Adam and other classical architects; they were the employees of fashionable firms in London. The one exception is Gayfere, the master mason of Westminster Abbey, who built Walpole's chapel; a man in such a position may have had more than an accidental connexion with Gothic.[1] If so, he is the only definite link between survival and revival, for there is no evidence that Essex, Wyatt, and the other eighteenth-century Goths employed traditional craftsmen, and it is unlikely that they did so. The survival of constructional principles is even less likely to have affected the early revivalists; the very idea was not grasped till Pugin made it his gospel.

Thus, in various ways, trickles of the Gothic stream flowed on; but the main current was divided into at least three rivulets. Two of these we have examined – the rivulet of Gothic ornament, flowing without a break from the seventeenth-century churches and chapels through Wren and Hawksmoor to the revivalists, Batty Langley and Walpole, but becoming more and more divorced from the rivulet of Gothic construction, which flowed on in a sluggish, bucolic, but not a contemptible stream. But beside these unfruitful streams flowed a stronger current from which the revival drew real force. I can find for it no name less vague than the stream of Gothic sentiment. All through the arid Augustan epoch there were some people who, for some reason, took an interest in Gothic architecture. The curious were impressed by its bulk and variety, the pious reflected on an age which could propitiate God so lavishly; most travellers noted the churches or cathedrals of the

1. But see H. M. Colvin, 'Gothic Survival and Gothick Revival' in *Architectural Review*, vol. CIII, 1948, 91, which shows that Gayfere probably had no connexion with traditional Gothic craftsmanship. The author shows that the tradition was more likely to have been maintained by local builders like Sumsion of Colerne and the Woodwards of Chipping Campden.

towns through which they passed. Above all, the antiquarians made Gothic ruins their quarry; they are the chief conveyors of Gothic sentiment.

Antiquarians appeared long before Gothic architecture had fallen into general disfavour. Perhaps they owe their origin to the Reformation, for they saw monasteries destroyed and libraries dispersed, and were moved to perpetuate their vanishing glories. Though there seems little of the crash and swagger of Elizabethan patriotism in these dull volumes, yet they too were written for patriotic ends, and boasted their country's treasures as poets did her wars. Hall and Holinshed, the untiring Leland, Camden himself, concern us only in so far as they founded a tradition of antiquarianism. Our interest lies more with the men who almost a hundred years later studied and depicted the monuments of medieval architecture, Sir William Dugdale and his collaborator Mr Roger Dodsworth. The first important result of their joint labours, the *Monasticon Anglicanum* (vol. I), appeared in 1655, obviously the result of many years' work. Anthony à Wood[1] has described his exquisite rapture on first reading Dugdale's *History of Warwickshire* (1656). He was evidently not alone. A small circle of antiquarians grew up, having its centre at the Bodleian Library, and from 1660 onwards there is a steady flow of County Histories and Local Antiquities. These need not be mentioned individually; the two later volumes of the *Monasticon* (1662 and 1673) and Tanner's *Notitia Monastica* are, perhaps, the most important.[2] As a sort of culmination to this movement the Society of Antiquaries, abolished under James I, was refounded in 1707.

The appreciation of Gothic was not confined to professed antiquarians. To multiply instances would be wearisome; I have selected two from the most celebrated diarists of the

1. I should not have mentioned Anthony à Wood and omitted the far more sympathetic antiquarian from whom he derived (to put it mildly) so much of his information, John Aubrey (1949).
2. Cf. *Cambridge History of English Literature*, vol. IX, chap. XIII, 2.

period. On 17 August 1654 Evelyn wrote of York Cathedral, 'A most entire and magnificent piece of Gotic architecture'; and though he occasionally grumbles at Gothic and speaks of architecture 'being newly recovered from its Gotic barbarity',[1] I could quote many instances of sincere admiration. 'But the Minister most admirable,' wrote Pepys of Salisbury, 'as big, I think, and handsomer than Westminster; and a most large close about it.'

Obviously Gothic is not forgotten. But what precisely were the feelings of these antiquarians and cultivated men towards the buildings they praised? It is dangerous to speculate upon the causes of aesthetic delight in a past age. The language of psychology is of recent growth, and our forefathers had but rude instruments with which to analyse their raptures. Nowadays our greatly enlarged vocabulary has enabled us to express new shades of feeling, and has made the language of the older art-criticism, with its vague, inherent values, seem empty and absurd. So we must often disregard their stated reasons and draw our conclusions more from the objects admired and the quality of the writers' enthusiasm. Vasari, for instance, was clearly a man of the greatest taste and insight, though his stated canons of criticism amount to little more than a naïve delight in representation; and Ruskin often seems to have been at pains to misrepresent his exquisite sensibility. Yet, making all allowances for their scanty means of expression, I cannot believe that Pepys, Evelyn, and the antiquarians admired Gothic from a very pure architectural standpoint. Pepys and Evelyn were cultivated men; but I have chosen them as typical children of their time, and as such they had the fashionable limitations. Their chief delight was the large or the ingenious; and they demanded that a work of art should possess an added intellectual interest, some impressive fact which could be stated in words. They admired York and Salisbury, which are, after all, very large, well-contrived buildings, and can only have been erected with much labour and expense. But how much

1. 6 November 1644.

more satisfactory had the gargoyles of York Minster totalled the Number of the Beast; though even so less interesting than a well-arranged collection of minerals. As remotely architectural was the admiration of the antiquarians; and perhaps the clearest exposition of their attitude may be found in the elaborate title-page to the 1682 edition of the *Monasticon*. The world of Gothic architecture is entered through an exuberant Renaissance arch; but this concession to taste is counterbalanced by the scenes depicted on the arch's panels. In one a lady is pointing to a Gothic cathedral, with the words *Pietas Prisca Fides*. In another a pious king is kneeling at an altar, with the words *Deo et Ecclesia* issuing from his mouth, and a large cathedral in the background; and contrasted with him Henry VIII points to a ruined monastery with the words *sic Volo*, while at a safe distance, a group of courtiers raise their hands in horror at the impious deed. Even in the seventeenth century it seemed impossible to divorce Gothic Architecture from Religious Controversy.

Is there a gap in the line of antiquarians? One very diligent inquirer believes there is: between the republication of the *Monasticon* (1722–3), and Buck's *Antiquities and Venerable Remains* (1774) he can find no antiquarian work worth noting.[1] True, there was Stukeley's *Itinerarium Curiosum*, which another scholar has used as a proof of a certain enthusiasm for Gothic.[2] But it is hard to take Stukeley's uncritical delight in anything large or old very seriously, and we may safely say that after the refounding of the Society of Antiquaries the output of antiquarian literature dwindles. I do not believe that interest in local antiquities ceased; it had become almost part of an educated country gentleman's equipment, and from the first

1. Haferkorn, *Gotik und Ruine*, 30. But Buck's plates were etched from 1720 to 1742, *Vetusta monumenta*, vol. I, appeared in 1747 and Perry's *Medals* in 1762.
2. Havens, *Romantic Aspects of the Age of Pope*, in Publ. Mod. Lang. Ass., New Series XX, 319. He collects every possible reference to nature or the Middle Ages made during the Augustan age, and thus stresses the exceptional at the expense of the general. Mr Howard Colvin tells me that Stukeley actually did some designs in the Gothic style, which were not carried out.

articles are devoted to the subject in the *Gentleman's Magazine*. Yet I think we may make this period the division between survival and revival. When antiquarianism reappears as a vital interest it is in the persons of Gray and Warton. Now Gray and Warton were poets. Their enthusiasm for Gothic springs from a literary impulse which first made itself felt as antiquarianism was beginning to decline. This literary impulse, if anything, can be called the true starting-point of the Gothic Revival.

Chapter 2

Literary Influences

Early in the eighteenth century poets began to exploit what we call the Gothic mood. Perhaps this date, like all others in the history of taste, is arbitrary: perhaps the Gothic mood in poetry had as continuous a life as the Gothic style in architecture. We can, if we choose, call the horrors and monstrosities of Elizabethan drama Gothic; and many critics apply the word to the convolutions of the Metaphysical school. But only two early 'Gothic' poets concern us, partly because they were exploiting the mood self-consciously, partly because it was on them that the eighteenth-century revival was based. They, of course, are Spenser and Milton. Spenser invented almost all the stage properties of Gothicism which were to furnish the scenery of later poets.

> Low in a hollow cave,
> Far underneath a craggy cliff ypight
> Darke, doleful, dreary, like a greedy grave,
> That still for carrion carcasses doth crave,
> On top whereof there dwelt the ghastly Owle
> Shrieking his baleful note.[1]

Milton's Gothicism is more restrained, and more artful.

> But let my due feet never fail,
> To walk the studious Cloisters pale,
> And love the high-embowèd Roof,
> With antick Pillars massy proof,

1. *Faery Queen*, I, xi, 33.

> And storied Windows richly dight,
> Casting a dimm religious light.[1]

If we wish for a date when the fashion for Milton and Spenser is definite and widespread, it is safe to turn to the *Spectator*, which was no pioneer in taste, and which did not praise an author till it was safe to do so. In December 1711, Addison announced his intention of writing a series of papers on Milton; and in November 1712, Steele published an article in praise of Spenser.[2] At the same time the earlier Gothic exercises began to appear; but I need not quote from William Harrison or from Anne Finch, Countess of Winchelsea. Only a very few examples are necessary; the conventional stimuli of melancholy were limited and all the possible combinations of ruins, ivy, and owls are soon exhausted. One of the earliest and certainly one of the best of these may be found in Pope's *Eloïsa to Abelard* (1717), and it has an additional claim in that Pope used to be considered the high priest of classicism.

> In these lone walls (their days' eternal bound)
> These moss-grown domes with spiry turrets crowned,
> Where awful arches make a noonday night,
> And the dim windows shed a solemn light;
> But o'er the twilight groves and dusky caves,
> Long-sounding islets, and intermingled graves,
> Black Melancholy sits, and round her throws

1. *Il Penseroso*. It was to this passage that Thomas Warton, who as we shall see, was one of the most ardent of all Gothic Revivalists, wrote the following note: 'Old St Paul's Cathedral ... appears to have been a most stately and venerable pattern of the Gothick style. Milton was educated at St Paul's School, contiguous to the church; and thus became impressed with an early reverence for the solemnities of the ancient ecclesiastical architecture, its vaults, shrines, iles, pillars and painted glass' (*Milton's Early Poems*, edited by Thomas Warton, 1785).

2. It seems probable that these dates have been over-emphasized. Serious readers, always a small minority, never ceased to admire both these writers; though it was possible then, as now, to be half-amused, half-irritated by Spenser's conscious quaintness. More truly significant numbers of the *Spectator* are those which contain Addison's essay on *Chevy Chase* (May 1711); but they are made a turning-point in every school text-book, and I need give them no prominence here.

A death-like silence and a dread repose:
Her gloomy presence saddens all the scene,
Shades ev'ry flow'r, and darkens ev'ry green,
Deepens the murmur of the falling floods
And breathes a browner horror on the woods.[1]

Pope's lines, for all their Gothic paraphernalia, have an August-
an ring, and it is worth quoting from Dyer's *Grongar Hill*
(1727), in which the material of Spenser is presented in the
measures of Milton.

'Tis now the Raven's bleak abode;
'Tis now th' apartment of the toad;
And there the fox securely feeds;
And there the poisonous adder breeds
Concealed in ruins, moss and weeds;
While, ever and anon, there falls
Huge heaps of hoary mouldered walls.[2]

I find Dyer's lines charming, and, in their kind, Pope's are
beautiful; but, like Spenser's, they are quite theatrical. As we
read we do not think of real Gothic buildings, but of old-
fashioned stage scenery; the moonlight streams down from the
wings, and the owl's eyes have an unnatural luminosity. The
sensationalist requires each dose to be a little stronger than the
last; and the 'browner horror', though vaguely disquieting,
provides but an anaemic thrill compared with the accumula-
tion of terrors in David Mallet's *Excursion* (1726).

Behind me rises huge an awful *Pile*,
Sole on this blasted Heath, a Place of Tombs,
Waste, desolate, where *Ruin* dreary dwells,
Brooding o'er sightless Sculls, and crumbling Bones.
Ghastful *He* sits, & eyes with Stedfast Glare
The Column grey with Moss, the falling Bust,
The Time-shook Arch, the monumental Stone,
Impaired, effac'd, & hastening into Dust,
Unfaithful to their charge of flattering fame.

1. *Eloïsa to Abelard*, 141–4 and 163–70.
2. *Grongar Hill* first appeared in 1726, but in a decasyllabic metre.

> All is dread Silence here, and undisturb'd,
> Save what the Wind sighs and the wailing Owl
> Screams solitary to the mournful Moon,
> Glimmering her western Ray through yonder *Isle*,
> Where the sad *Spirit* walks with shadowy Foot
> His wonted Round, or lingers o'er this Grave.[1]

Here is the essence of Gothic poetry, so rich in all the machinery of melancholy that further quotations are unnecessary. But it is important to remember the extraordinary amount of writing in this vein, and the length of time which it continued to be fashionable. Towards the end of the eighteenth century, when it had spread to historical romances, the Gothic mood must have seemed to many a natural and permanent thing and an inexhaustible subject for literature.

I need not emphasize the connexion between this love of dramatized decay and Gothic architecture. True, a public which delighted in Mallet was not bound to admire Salisbury Cathedral from a very strict architectural standpoint; but even to feel, in its crudest form, the thrill of Gothic architecture is an important beginning; and it is possible to find direct evidences of a connexion between literary and architectural taste. Some of these cannot be taken very seriously. Historians of the early romantic movement have piously collected every chance phrase on Gothic architecture which slipped from the pens of literary bigwigs. Addison, for instance, is quoted because he had heard much of the Cathedral at Milan,[2] a building which could scarcely be overlooked in any age. More important perhaps is his admiration for Siena Cathedral, 'which a man may view with pleasure after he has seen St Peter's, tho' it is quite of another make and can only be looked on as a masterpiece of *Gotic* architecture'.[3] But even this is really irrelevant, for Siena, with its touch of gay, Southern vulgarity, is at the

1. The *Excursion* was first published separately in 1728. I quote from this edition.

2. But his comments on it are not very favourable. Cf. *Remarks on Several Parts of Italy*, reprinted in Gutketch, *Addison's Miscellaneous Works*, 29.

3. *Addison's Miscellaneous Works*, 175.

opposite pole to the mysterious moss-grown ruins which delighted the Gothic poets. An owl would not be in place on that flashing façade.

We should look in vain for a convincing connexion between Gothic poetry and architecture among such casual appreciations. But some critical writings of the time draw a direct analogy between non-classical periods of literature and Gothic architecture. The first of these is Hughes's Introduction to his edition of Spenser (1715), in which he says,

> To compare it [*The Faery Queen*] therefore with the models of Antiquity, would be like drawing a parallel between the *Roman* and the *Gothick* architecture. In the first there is doubtless a more natural Grandeur and Simplicity; in the latter we find great mixtures of Beauty and Barbarism, yet assisted by the invention of a Vanity of inferior Ornaments; and though the former is more majestick in the whole, the latter may be very surprising and agreeable in its parts.

An even more important passage is to be found in Pope's preface to his edition of Shakespeare (1725):

> I will conclude by saying that Shakespeare, with all his faults . . . one may look upon his works, in comparison of those that are more finished and regular, as upon an ancient majestic piece of Gothic architecture, compared with a neat modern building: the latter is more elegant and more glaring, but the former is more strong and more solemn . . . etc.

These two passages have been much quoted by historians of literature to prove that Gothic architecture influenced literary taste, but I think that the reverse is true. We accept as almost axiomatic the generalization that in England a love and understanding of literature greatly exceeds, and indeed swamps, appreciation of the visual arts; and a new current of taste is likely to be first felt in a literary channel. Shakespeare and Spenser would be appreciated before a Gothic cathedral; and in fact it was the analogous forms of these great writers which shed lustre on the despised architectural style. Above all it was Shakespeare, so unmistakably great in defiance of all the rules

of Aristotle, who broke the back of Classical prejudice. If Aristotle's rules could be defied with success, why not those of Vitruvius too? Gothic architecture crept in through a literary analogy. It is at least remarkable that the analogy was felt; and this is perhaps another indication that the style was never quite forgotten.

So, with the expositions of Pope and Hughes before us, we may analyse the state of mind which began to feel the beauty of Gothic architecture. It included, surely, with an obvious surrender to the associative charms of Gothic, a vague understanding of its formal possibilities; but both literary in origin, the first expressed by the Gothic poets, the second by Hughes when he speaks of that variety of inferior ornaments, which may be very surprising and agreeable.

Literary this love of Gothic remained all through the eighteenth century, even in its most antiquarian phase; and this literary character was maintained by what seems a coincidence. During the first half of the century the two leading factors in the revival, the poets and the antiquarians, had made their ways separately. They were not even part of the same impulse, for antiquarianism declined as the revival of Gothic poetry began. But towards the middle of the century there appeared a group of men who unite poetry and archaeology, and who deserve to be remembered as the founders of the Gothic Revival.

The oldest and by far the most distinguished of this group was Thomas Gray. Mr Saintsbury has said that Gray's literary criticism was dominated by two qualities: the constant appeal to history, and the readiness to take new matter on its own merits. These qualities enabled him to appreciate the value of medieval literature; they also made him sensitive to medieval architecture. In addition he was a very learned man and a scholar with a disinterested love of research. Shut away in the ivory tower of his intense shyness, Gray's conception of Gothic was gradually transformed. He inherited the view that Gothic buildings were a haphazard jumble of ornaments which might,

at best, be individually attractive. He grew to have a serious love of Gothic architecture and an historical attitude towards it not very different from our own. Gray's earliest references to Gothic were made on his continental travels with Walpole in 1739. They are not very important. Amiens Cathedral he calls 'a huge Gothic building, beset on the outside with thousands of small statues, and within adorned with beautiful painted windows, and a vast number of chapels dressed out in all the finery of altar-pieces, embroidery, gilding and marble'.[1] These are the feelings, more attractively expressed, of any contemporary traveller; and like Addison he admired Siena, 'laboured with a Gothic niceness and delicacy in the old-fashioned way'.[2] Both quotations are from letters to Gray's mother, and it has been suggested that this explains their frivolous attitude to medieval art; a more serious description would have been meaningless to her. But I find it significant that during his journey Gray's only references to Gothic *are* in letters to his mother; there is none in the letters to West and Ashton, nor in his notebooks; it was not considered worth mentioning to men of taste.

For us the relevant thing about this continental tour is the admiration for wild, mountainous scenery which the two young travellers expressed. It is usually stated that before then the beauty of mountains was unappreciated, though this is, on the face of it, very improbable, and the extreme popularity of Salvator Rosa's pictures shows the statement to be definitely untrue. But expressed admiration for wild scenery was rare, and when Gray writes of the Grande Chartreuse, 'not a precipice, not a torrent, not a cliff, but is pregnant with religion and poetry',[3] he is expressing a romantic mood which was only just beginning to be felt.

For fourteen years Gray's published letters contain no reference to Gothic architecture. He travelled much, he stayed in York and Durham, but he never mentions a cathedral. We cannot find him using the word Gothic again till he comes to

1. *The Letters of Thomas Gray*, edited by Duncan Tovey, vol. 1, 17.
2. ibid., 30. 3. ibid., 44.

criticize his friend Walpole's plaything, the precious Strawberry; but we get the impression that he has been studying Gothic during the interval. He condemns Kent for not reading the Gothic Classics with taste or attention,[1] he is consulted by the Strawberry Hill committee and even trusted to select Gothic wallpapers. His taste is not ours; he found in Strawberry a 'purity and propriety of Gothicism (with very few exceptions) which I have not seen elsewhere', and for a time he admired Walpole's additions, even the gimcrack Holbein Chamber. 'But', said Norton Nichols, 'when Mr Walpole added the gallery with its gilding and glass Mr Gray said "he had degenerated into finery".'[2] The famous gallery of Strawberry was not completed till 1763, and by that time Gray had become absorbed in Gothic archaeology.

I suspect that Gray's interest in the architecture of the Goths grew out of his study of their literature, that study which led to *The Descent of Odin*. There seems little enough connexion between Valhalla and York Minster; and Gray was careful to distinguish between Celts and Goths. But in 1750 the middle age was still one dark welter from which the Goths alone emerged with a convenient name. And it was in 1785, when Gray was absorbed in the study of medieval literature, that he wrote, 'the drift of my present studies is to know, wherever I am, what lies within my reach, that may be worth seeing whether it be Building, ruin, park, garden, prospect, picture or monument, . . . and what has been the characteristick, and taste of different ages'.[3] For the first time since his Italian journey he shows signs of interest in antiquities. Soon poor Mason is writing him elaborately documented and very tedious letters about York Minster, and Gray is replying with more learning and a description of the 'good Gothic style'.[4]

It is easy to underrate the importance of Gray's archaeology.

1. *Letters*, vol. I, 246.
2. *Reminiscences of Gray*. By his intimate Friend the Rev. Norton Nichols. 18 November 1805. Cf. Tovey's *Letters*, vol. II. 291.
3. To Warton, 21 February 1758. *Letters*, ed. Tovey, vol. II, 23.
4. 3 February 1763; ibid., vol. III, 6.

Today, when a knowledge of the different Gothic styles is so diffused as to be almost intuitive, we can hardly imagine a time when pointed arches were believed to be Saxon, and Westminster Abbey the work of Edward the Confessor. Yet Batty Langley was not alone in thinking that most Gothic buildings dated from before the Danish invasions. The trouble sprang from the word Gothic. The Goths were known to have flourished at a very remote time, and the earliest attempts to discover the origin of the Gothic style tried to associate these half-mythical people with the pointed arch.

When the Goths had conquered Spain [wrote Bishop Warburton], and the genial warmth of the climate, and the religion of the old inhabitants had ripened their wits and inflamed their mistaken piety, *they struck out a new species of architecture*, unknown to Greece or Rome, upon original principles, and *ideas much nobler* than what had given birth even to classical magnificence. For this northern people having been accustomed to worship the Deity in groves, when their religion required covered edifices, they ingeniously projected to make them resemble groves as nearly as the distance of architecture would permit; at once indulging their old prejudices, and providing for their present conveniences, by a cool receptacle in a sultry climate.[1]

Compared with this, Gray's theories were scholarly and profound, and his methods of research scientific. Mason tells us that 'he did not so much depend upon written accounts, as upon that internal evidence which the buildings themselves give of their respective antiquity', and adds that he 'arrived at so very extraordinary a pitch of sagacity, as to be enabled to pronounce, at first sign, on the precise time when every particular part of any of our cathedrals was erected'.[2] We must make some allowance for a disciple's enthusiasm; but though very little of Gray's erudition was given permanent form, some stray references and contemporary opinion show that it really was considerable.

1. Note to *Pope's Works*, vol. III, 326.
2. *Works of Thomas Gray, with a Memoir of his Life and Writings* by W. Mason, M.A., 1807, vol. II, 239–40.

A few letters contain archaeological learning;[1] but the greatest part is to be found in the criticisms Gray wrote on the works of two friends – the chapter on early architecture in Walpole's *Anecdotes of Painting*, and Bentham's *History of Ely*. It is significant, of course, that the essays were sent to him for correction. It is still more significant that the account of Gothic architecture in Bentham's book, which Britton considered the most accurate of early accounts, was frequently attributed to Gray; and there is no doubt that Gray had a great influence on Bentham's judgements. He influenced other Cambridge archaeologists, too: he made Mason and Warton good Goths, and he probably encouraged James Essex. Norton Nichols, whose friendship with Gray dates from 1764, has left a full account of his hero's love of Gothic architecture in the *Reminiscences* already quoted.

Mr Gray's love of and knowledge in Gothic architecture [he says] are all known; he contended particularly for the superiority of its effect in churches; and, besides, admired the elegance and good taste of many of its ornaments. I remember his saying, though I have forgotten the building to which the observation was applied, 'Call this what you will, but you must allow that it is beautiful.' . . . He said that he knew of no instance of a pointed arch before the reign of King John, in which, I understand, Carter, the great Gothic critic, agrees with him. . .

This account suggests that as well as being learned, Gray was genuinely sensitive to Gothic architecture. It would be foolish to pretend that he appreciated it as we do; Norman (he called it Saxon) he found 'of a clumsy and heavy proportion, with a few rude and awkward ornaments'.[2] But appreciation of Norman was rare, even in the nineteenth century; and Gray was before his time when he reproved Walpole for making Henry IV's reign the highest point of Gothic architecture.

I beg leave to differ as to the era of Gothic perfection. There is nothing finer than the nave of York Minster (in a great and simple

1. *Letters*, Tovey, vol. III, 5–6.
2. G. to Mason, February 1763. *Letters*, vol. II, 6.

style) or than the choir of the same church (in the rich and filigrane workmanship). But those are of Edward the Third's reign, the first in the beginning, and the latter in the end of it. The Lady Chapel (now Trinity Church) at Ely, and the lantern tower in the same church, are noble works of the same time.[1]

And in a letter to Mason he praises the Gothic of an even earlier date, that of Henry III's reign. Before the time of the Camden Society there were few who denied the superior beauty of *Perpendicular*. Gray's taste for Gothic was of a very different order from that of country gentlemen who plastered their Palladian façades with stucco pinnacles.

Those histories of British architecture which touch on the Gothic revival always emphasize the importance of Walpole. None, so far as I know, mentions Gray. So it is worth quoting the note which Walpole added to his account of Gothic in the *Anecdotes of Painting*.

These notices [he says] can add no honour to a name already so distinguished as Mr Gray's; it is my own gratitude or vanity that prompts me to name him; and I must add that if some parts of this work are more accurate than my own ignorance or carelessness would have left them, the reader and I are obliged to the same gentleman who condescended to write.[2]

Despite his retired life Gray had some influence on the taste of his time; but he was too lazy, too sensitive, perhaps, to be a very effective champion of the Gothic Revival. The burden of the fighting fell on the brothers Warton.

As very young men they plunged in on the side of the new romanticism. At eighteen Joseph wrote a poem with the provocative title *The Enthusiast: or the Lover of Nature* (1740);[3] and his younger brother, Thomas, was even more precociously and emphatically romantic, for he was only seventeen when he

1. *Letters*, vol. II, 336.
2. *Walpole's Works* (Quarto ed.), vol. III, 98.
3. Not published till 1744. Later in the essay I give some examples of contemporary meaning of the word 'enthusiast'. They show how completely Joseph had thrown in his lot with the Romantics.

D

wrote his *Pleasures of Melancholy*. It was not at all an original work; Akenside's *Pleasures of the Imagination* had proved a popular form, and for a few years 'pleasures' of all kinds were published; Blair's *Grave* and Young's *Night Thoughts* had also had a great success, and to the imagery and range of responsiveness of these two authors Warton adds very little. Like them he has no other wish than to sit among ruins in the moonlight,

> While sullen sacred silence reigns around,
> Save the lone screech-owl's note, who builds his bow'r
> Amid the mould'ring caverns dark and damp,
> On the calm breeze, that rustles in the leaves
> Of flaunting ivy, that with mantle green
> Invests some wasted tow'r.

It is convincingly Gothic, but it is no more so than the work of other eighteenth-century poets; and would not concern us had not Thomas Warton also been a true lover of Gothic architecture and passionate archaeologist.

> Nor rough, nor barren are the winding ways
> Of hoar Antiquity, but strown with flowers.

Warton wrote these lines on a blank leaf of Dugdale's *Monasticon*; and the mass of antiquarian material which he has left behind him shows that they were written sincerely. In term and out Warton travelled, and wherever he saw a Gothic building he made a note. His observations were neither as entertaining nor as original as Gray's but they were more important because they were more numerous. He was a squat and sturdy man, impervious to the discomforts of travel and hardened to tavern life. While Gray attempted to subdue his melancholy with a little botany, Warton drank with Thames bargees, preferring low company to the comatose society of an Oxford common-room; his thirty years of archaeological travel would have been physically impossible to Gray.

His investigations were made with no apparent aim; perhaps Warton had in view a history of Gothic architecture, but

his huge mass of notes was never put into shape, much less published,[1] and it was as a young man that he publicly championed the Gothic style. His first expressed admiration for it is in his *Triumph of Isis* (1749), and a year later he published his *Account of the Antiquities of Winchester*, a small and very inaccurate book, which was later to receive rough treatment from Milner.[2] But his greatest contribution to the revival is in the 1762 edition of his *Observations on the Faery Queen*. There, in what purports to be a note to the lines

> – Did arise
> On stately pillours framed after the Doricke guise,

is the first published attempt to sketch the origin and development of Gothic architecture.[3] Naturally the details are inaccurate; but the general outlines are correct. At that date, to dissociate the Saxons from the pointed arch needed independence, and any such classification as Warton's needed real scholarship. His note was reprinted in 1800, and later historians of Gothic, Britton and Wilson, spoke of it with respect.

Warton's little essay has been called 'the real signal for the Revival of Gothic'; but the year it was published another appeared which has a far better claim to the title: for in 1762 Horace Walpole published his *Anecdotes of Painting*.

Walpole deserves his place as the central figure in every account of eighteenth-century medievalism. He was not an originator. To give a new direction to taste, to furnish men's minds with a new Utopia, requires more imagination and independence than Walpole could command. But to catch and intensify new ideas as they float from mind to mind requires gifts too; and these gifts Walpole had. Wit, curiosity, a graceful style, and a good social position were more valuable assets

1. A MS. of the tours 1759–73 is, or was, the property of Miss M. Lee, Church Manor, Bishop's Stortford; seven volumes of MS. for the tours are in Winchester College Library. There may be others.

2. *History of Winchester* by J. Milner.

3. John Aubrey's attempt to classify Gothic tracery also appeared in 1762 as an appendix to Perry's *English Medals*.

than passionate conviction or massive learning. Those brilliant qualities which enliven his letters give a savour even to Walpole's more absurd archaeological researches. Gray and Warton were good writers who happened to be archaeologists; Walpole wrote well about archaeological things. It is perhaps unfortunate that he chose a field in which a certain degree of accuracy is considered desirable, for accuracy bored him. From the ponderous county histories which were his chief sources he extracted rather what was amusing than what was probable. But light-hearted generalizations, a pleasant absence of dates and footnotes and capital letters, make his pages more acceptable to a lazy world than the encumbered columns of learned men.

The most important published work in which Walpole touched on Gothic is his chapter on the medieval architects in the *Anecdotes of Painting*. And its great interest lies in this, that though many books on Gothic architecture were published in the next fifty years they were all concerned with archaeological questions – the origin of the pointed arch and the like. In them Gothic is treated less as an architectural style than as a recognized field for pedantry; and their critical attitude is suggested only by the use of some such vague commendatory adjective as 'venerable' or 'sublime'. But Walpole makes a real attempt to estimate the aesthetic value of Gothic as compared with classical architecture, and arrives at remarkably just conclusions.

The pointed arch [he writes], that peculiar of Gothic architecture, was certainly intended as an improvement on the circular; and the men who had not the happiness of lighting on the simplicity and proportion of the Greek orders were, however, so lucky as to strike out a thousand graces and effects, magnificent yet genteel, vast yet light, venerable and picturesque. It is difficult for the noblest Grecian temple to convey half so many impressions to the mind as a cathedral does of the best Gothic taste – a proof of skill in the architects and of address in the priests who erected them.

Obviously Walpole's feeling for Gothic was far more advanced than that of his contemporaries. Gothic is not treated as

a kind of *chinoiserie*, tolerable as long as it is surprising, nor as a style suitable only for ruins, but as serious architecture, only differentiated from other styles by its strong emotional appeal. He was, of course, hampered by the universal belief that Gothic was the product of a dark and superstitious age, and admits that the cathedrals are the work of priests who 'exhausted their knowledge of the passions in composing edifices whose pomp, mechanism, vaults, tombs, painted windows, gloom and perspective infused such sensations of romantic devotion'. And in one passage he feels that he has ventured further in defence of Gothic than is prudent for a man of taste.

> I certainly do not mean ... to make any comparison between the rational beauties of regular architecture and the unrestrained licentiousness of that which is called Gothic. Yet [he adds, his courage returning], I am clear that the persons who executed the latter had much more knowledge of their art, more taste, more genius, and more propriety than we choose to imagine. There is a magic hardiness in the execution of some of their works, which would not have sustained themselves if dictated by mere caprice.

Similarly, in his reply to M. Mariette he hurriedly concedes the superiority of the classical style, but adds that though a schoolmaster can observe the Unities, 'it required a little more genius to write *Macbeth*'.

Fifty years after these words were written they probably represented the attitude of the average fashionable person who dabbled in medieval antiquities; fifty years later again, and they were considered very irreverent. Today Walpole's sentiments are once more acceptable. His language is unfamiliar – few of us would speak of Westminster Abbey as genteel; but many would agree that 'one must have taste to be sensible of the beauties of Grecian architecture; one only wants passions to feel Gothic'. The part in Walpole's criticism which is most foreign to our own attitude is his emphasis on the 'superstitious' elements in Gothic. He seems to imagine that a cathedral is a trap to catch converts to popery. We have long ceased to associate pointed arches and the Church of Rome, but for

years this connexion gave a sinister overtone to the solemn music of Gothic architecture.

In the June of 1764 Walpole dreamed that he was in an ancient castle ('a very natural dream for a head like mine filled with Gothic story'), and that on the uppermost banister of a great staircase he saw a gigantic hand in armour. When he woke he sat down to write, without knowing in the least what he intended to relate; and in two months he had completed *The Castle of Otranto: a Gothic Story*. The book was well suited to the uncritical romanticism of the eighteenth century. Nowadays we prefer our daydreams to have some faint colour of possibility, and Walpole's romance seems mere nonsense; but, as Johnson said of Sterne, 'his nonsense suited their nonsense'; and a whole impression of *The Castle* was sold in three months.

Naturally other authors adopted a form so popular, and all were compelled to borrow Walpole's more valuable properties – his haunted castle, his vaults, his alarming apparitions. Miss Clara Reeve confessed that her *Old English Baron*[1] was inspired by him, and Matthew Lewis worked on a story in the style of *Otranto* before publishing his famous *Monk*. Even Mrs Radcliffe, though she only once employs the supernatural, owes an obvious debt to Walpole. But he need not be made responsible for the whole monstrous brood. Exaggerated sensibility came from France, horrors and Wertherlike sorrows from Germany; and these stirrings and changings of spirit acted on a tradition older than *Otranto*. The Gothic novelists were the natural successors to the graveyard poets, and nearly all the paraphernalia of graveyard poetry – ruins, ivy, owls – reappears in the novels. But after half a century of hard wear these would have lost their flavour, had they not been seasoned with a new action, a new violence of passion alien to the eighteenth century. The Gothic poets had sung a faint discordant undertone to the Augustan harmony; the Gothic novelists screamed – screamed in complete reaction to every-

1. Strictly speaking it appeared in 1777 as the *Champion of Virtue*, and was only renamed *The Old English Baron* in the second and later editions.

thing stuffy and probable. Reaction was their chief impulse, and reaction is almost their only connexion with the architectural side of the Gothic Revival. For unfortunately it is impossible to show a smooth interaction, or even a close parallel, between eighteenth-century Gothic novels and buildings. The Gothicness, so to speak, of the romances consisted in gloom, wildness, and fear; and the eighteenth century was far too sensible to admit these qualities into domestic architecture. Indeed this Gothicness was not at all closely connected with architectural forms. Northanger Abbey seems to have been innocent of a pointed arch, yet its age and irregularity, its very name, bereft Catherine Morland of her good sense. Except in sham ruins, which precede the romances of Mrs Radcliffe by almost fifty years, and are directly associated with the melancholy poets, Gothic forms were used to create an atmosphere of lightness and variety, not of horror and mystery. Even the author of *Otranto* thought of his villa as pretty and gay, and not before Fonthill was architecture meant to make one's hair stand on end. The horror-romantics[1] have their place in the Gothic Revival because they show the frame of mind in which the multitude of novel-readers looked at medieval buildings. But if we search the second half of the eighteenth century for literary influences on the Gothic Revival we need not spend time on *The Castle of Otranto*'s offspring, but on those books which show a real interest in the middle age, a veneration for its arts and manners, and a serious study of its monuments. Nor is it his Gothic romance which makes Walpole so important to us. It is his Gothic castle.

1. Under this Germanic title the literary craze has been frequently described. Cf. *The Tale of Terror* by Edith Bankhead, *The Northanger Novels* by Michael Sadleir, and *The Haunted Castle* by Eino Railo.

Chapter 3

Ruins and Rococo:
Strawberry Hill

Strawberry Hill has been studied at least as much as it deserves.
Writers wishing to suggest the setting of Walpole's letters have
dwelt on the villa's pretty absurdities, or on things with a
purely associative interest such as the bowl in which pensive
Selima met her death. Even architectural descriptions treat
Strawberry as an isolated artificiality, and make no attempt to
relate it to the taste of the time. Yet to understand the import-
ance of Strawberry Hill in the history of taste, we must know
that it grew out of contemporary efforts to revive Gothic
forms; it was, in fact, no original venture, but the chief
example of a prevalent fashion.

Though Walpole bought Strawberry Hill in 1747, he did
not begin to gothicize his villa seriously till 1750, and the first
transformation was not completed till 1753. We can therefore
assume that any eighteenth-century Gothic mentioned before
this date was not influenced by Walpole, but represents rather
the fashion which influenced him. These references to Gothic
are scattered and contradictory; some occur in letters, includ-
ing Walpole's own, some in journals such as Mrs Delaney's
Autobiography, some in magazines such as the *World*. I cannot
pretend to have exhausted all the possible sources, for any
eighteenth-century correspondence might contain an import-
ant reference to this fashion. But those which I have studied
make it clear that Gothic was employed for two more or less
distinct ends; either to stimulate the imagination or as a light,
decorative form. The first of these needs was satisfied by sham
ruins.

The most humourless pedant could not discuss sham ruins

very seriously, but I must be excused a short digression on them because they form the simplest link between the Gothic mood in poetry and in architecture. No one interested in the eighteenth century can forget the high place held among the arts by gardening; and as the century went on it became clear that the object of a garden was to induce a mood – that same agreeable melancholy which delighted poets and dilettanti. To effect this, the wildness of unaided nature was deemed insufficient; solitary groves and tangled trees could only work this enchantment when contrasted with man's handiwork. The eye of fashion looked at landscape through a literary medium, and the emergence of the word *picturesque* shows that nature was also seen through the medium of another art, that of painting. There can be no doubt that the vision of eighteenth-century England was strongly coloured by the Italian landscape painters, especially Claude and Salvator Rosa, whose popularity and influence has been proved by an impressive accumulation of passages.[1] Now few of their pictures are without a ruin to stand as a melancholy reminder of the triumph of time. It was this 'projection of art into Nature', as it has been called,[2] this 'contemplation of Nature through the coloured glass of art, and from a consciously literary or pictorial point of view', which gave us those curiosities of architecture, sham ruins.

At first they were classical, since they were chiefly inspired by Italian landscape; and even Batty Langley, soon to be the champion of Gothic, suggests nothing but classical models in his *New Principles of Gardening* (1728). But there were reasons why fashionable taste came to prefer Gothic: for one thing authentic ruins were often as effective as sham ones and cost nothing to erect; and in England practically all the authentic ruins are medieval. Then Gothic was the fashionable melancholy, the melancholy of Blair and Young; with the help of a crumbling arch the admirer of *Night Thoughts* could contem-

1. Elizabeth M. Manwaring, *Italian Landscape in Eighteenth-century England*.
2. Logan Pearsall Smith, *Works and Idioms*, 82.

plate himself as a work of art. Indeed the reason lies in the very nature of Romanticism. Every Romantic style reflects the day-dream of its creators, some Utopia in which they live the life of the imagination. Now this ideal world must be, in some measure, complementary to the real world. When life is fierce and uncertain the imagination craves for classical repose. But as society becomes tranquil, the imagination is starved of action, and the immensely secure society of the eighteenth century indulged in daydreams of incredible violence. Their classical heroes seemed flat and unenterprising, and the medi-eval ballads, popularized by Addison, provided a new world of heroes, reckless, bloodthirsty, and obscure. Any ruin might inspire melancholy, but only a Gothic ruin could inspire the chivalry of a crusader or the pious enthusiasm of a monk. In a later chapter we shall find this need for self-dramatization grown monstrous, and whole houses built for its satisfaction.

It would be interesting to know when the first Gothic ruins were built. Walpole mentions one by Gibbs, which seems most improbable;[1] but we know that Kent used the style, and I am inclined to make him responsible, for it was he who rebelled against the formal garden and brought into fashion romantic irregularities. Kent died in 1748; by 1743 Young had published his *Night Thoughts* and Blair his *Grave*; and in 1748 Capability Brown had begun his picturesque transformation of the English park. From these general indications we can place the first sham Gothic ruins before 1745; but the earliest for which we have a date was built in 1746. It was the work of Sanderson Miller, an amateur architect of Radway, Warwickshire, and was built in his grounds at Edgehill.[2] Miller is said to have been a competent architect in the Palladian style, but he owes his fame to mastery of Gothic. It seems that he was popular in county society and great persons came to picnic beside his

1. Gibbs did in fact design a Gothic ruin for the Duke of Leeds at Kircton Park. The original drawing in the Ashmolean Museum is dated 1741.
2. For Miller cf. *An Eighteenth-century Correspondence*, edited by L. Dickins and M. Stanton.

castle. The place evidently amused them, and in 1747 we find Miller building the sham ruin at Hagley, perhaps his greatest success. By it even Walpole was swept off his feet. 'There is a ruined castle here,' he wrote to Bentley in 1753, 'built by Miller which would get him his freedom even of Strawberry. It has the true rust of the Barons' wars.'[1] Walpole was not alone in his enthusiasm; commissions for ruined castles poured in upon Miller; Lord Leicester wanted one and so did Lord Hardwicke; a whole sham medieval façade was erected in Allen's grounds near Bath.

For all their forlorn absurdity, Miller's sham ruins show knowledge of medieval architecture, and at least they are always of stone. His rich clients could afford this concession to realism. But the average country gentleman gratified his imagination more cheaply: his ruins were of plaster or canvas; and if more durable material was used, it was turned to utilitarian ends. 'Let every structure needful for a farm,' says Mason,[2] 'arise in castle semblance.' And he adds a few suggestions:

> Some tower rotund
> Shall to the pigeons and their callow young
> Safe roost afford, and every buttress broad
> Whose proud projection seems a mass of stone
> Give space to stall the heifer and the steed.

It was perhaps as well that the majority of sham ruins were built of ephemeral materials, for those which were of stone, surviving the fashion which created them, have been deserted and derided by a more critical age. Everyone who knows the English country can remember one or two of these monuments to a mood, now called follies.[3]

The architectural romanticism which was nourished on ruins

1. An important tribute, for Walpole was jealous of Miller, and when they met, Miller put him quite out of patience. W. to Chute, August 1758.
2. Mason, *English Garden*.
3. And so called from the first. Cf. the *World*, 14 February 1754. For the literature of sham ruins, cf. *A Dialogue on Stowe* (1748), and Joseph Haily, *Letters on the Beauties of Hagley*.

displayed itself in other and more frivolous ways, producing a quantity of work which it is not easy to classify. I have called it all Rococo, though this may be too light a word for the more lugubrious gazebos, and in some fanciful pieces it may seem that little of what we call Gothic has been preserved. The word has value because it conveys a purely decorative style – something self-conscious, a little far-fetched, and not too serious. On the Continent this style was attained by taking the line and movement of Baroque and giving it an extra twist. To diversify old forms and to satisfy fashionable thirst for the far-away, new motives were introduced from the East, then a sort of wonderland. The fashion for 'Chinese taste' spread to England and flourished there for half a century;[1] but England had no traditional baroque to travesty; instead she travestied Gothic.[2] This is not as odd as it seems. To the eighteenth century, Gothic was essentially a disorderly style, in which the parts were greater than the whole. The first edition of Neve's *Complete Builder's Guide* (1703) described Gothic as 'massive, combersome and unwieldy'; but in the third edition, published thirty-three years later, the editors added a note that this applied only to the ancient Gothic, by which I presume they meant Norman. 'The modern Gothick', they said, 'runs into the contrary Extreme, and is known by its Disposition, and by its affected Lightness, Delicacy, and over-rich, even whimsical Decorations.'[3] Even Gray, a serious lover of Gothic, described Rheims Cathedral as 'a vast Gothic building of a surprising beauty and lightness, all crowded over with a profusion of little statues and other ornaments'.[4] This is the stuff of which

1. Chinese came in a little later than Gothic; cf. *World*, 22 March 1753, quoted below.

2. Gothic Rococo can be found on the Continent, even in Italy, e.g. Giandomenico Tiepolo's frescoes at the villa Valmarana, Vicenza. These represent the people of remote times and places, and one of them is a medieval scene in a Gothic setting of the kind which was later to be called the *style troubadeur*.

3. *The City and Country Purchaser's and Builder's Dictionary: or the Complete Builder's Guide*, originally written and compiled by Richard Neve, Philomath, third edition, 1736.

4. Tovey, I, 30.

Rococo is made. And Gothic was exotic; if not remote in space, like *chinoiserie*, it was remote in time; it had an associative as well as a decorative value. Nothing else was so apt to tickle the eighteenth century's jaded palate.[1]

Yet the earliest exponent of Gothic Rococo had no such frivolous intentions. Batty Langley's *Gothic Architecture improved by Rules and Proportions In many Grand Designs* appeared in 1742; though the book ends with designs for varieties of summer-house, the earlier plates show that Langley was in earnest. He has been consistently misrepresented. It is stated that poor foolish Batty wished to give his own eighteenth-century rules to a despised and disorderly Gothic, and this ambitious attempt is usually made the subject of a joke.[2] No such misstatement is necessary, however, for Langley has added a preface to one edition of his book which makes his intention perfectly clear. I must quote from it at some length, as few documents throw more light on the eighteenth-century view of architecture.

The Rules by which the Ancient Buildings of this Kingdom were erected and adorned, having been entirely lost for many centuries; I have, therefore, for upwards of twenty years, in order to restore and publish them for the good of posterity, assiduously employed myself, as opportunities have happened, in making researches into many of the most ancient buildings now standing in this kingdom: and thence have extracted rules for forming such designs and ornaments in the ancient mode, which will be exceedingly beautiful in all parts of private buildings. By this unhappy devastation[3] posterity was deprived not only of the Saxon modes or Orders of Architecture, but also of the geometrical rules by which their buildings in general were adorned, for it cannot be supposed, but that there were many ingenious Saxon architects in those times who composed manuscripts of all their valuable rules, which with themselves were destroyed and buried in ruins.

1. As an extreme instance of how Gothic was considered as something frippery there is the young lady who had covered one of the porticoes of Battle Abbey with cockleshells (Walpole to Bentley, August 1752).
2. E.g. Eastlake, 51. He had not read Langley's preface, and says that there is no copy containing it in the British Museum.
3. He refers to the Danish invasion.

Finally I must quote his appreciation of the columns in Westminster Abbey:

> Every impartial judge will see by inspection that their members both as to their heights and projections are determined and described by those beautiful proportions and geometrical rules which are not excelled (if equalled) in any parts of the Grecian or Roman orders.

Obviously Batty Langley did not mean to give his own rules to Gothic. His more modest attempt was absurd enough, but it was inevitable. The Renaissance pruned away from medieval art the overgrowth of detail which was choking it. This work was done by rules. Vitruvius had given rules to architecture; Leonardo had tried, less successfully, to give rules to painting; and much later the Hotel Rambouillet gave rules to literature. We may not like Palladio or Malherbe, but we are at least spared the interminable conceits and digressions of medieval literature and the undigested detail of medieval building. Rules saved European art.

Batty Langley really admired Gothic. He therefore assumed that it was based on rules; these rules must be recovered before Gothic could be properly understood; still more were they necessary to a revival, and he set to work modestly and patiently to discover them. He made his attempt from a too Vitruvian standpoint and the result is disappointing; but his intentions were excellent and were shared by his chief detractors. All through the nineteenth century, men tried to find the rules of Gothic architecture, till the ecclesiologist imposed his canon, stricter than Batty's, and not less fantastic.

I have tried to justify Batty Langley's intentions, but I shall not try to justify his performance. After the attractive seriousness of the preface, the Grand Designs are a shock, and whatever enthusiasm we have begun to feel evaporates in their presence. Langley assures us that his eight varieties of Chimney-pieces are not to be matched in the world, and that his fourteen varieties of Umbrellos, Temples, and Pavilions are believed to come the nearest to the ancient Saxon architecture

of all that has been done since the Danish conquest. Yet it is disappointing to learn that the hardly re-won rules of Gothic are to be used for such light work, and when we look, for instance, at Plate LII in his book, 'An Octangular Umbrello to Terminate a View', we can understand why 'Batty Langley's Gothic' soon became a term of contempt.[1] As early as 1754 Gray blames Kent for having introduced 'a mixed style, w^ch now goes by the name of *Battey-Langley-Manner*'. 'He is an architect', he adds, 'that has published a book of bad Designs.'[2]

I have called Langley's book the earliest of its kind, but there may be others of the same date, for a shower of such books began immediately after its publication. 'A few years ago,' said a writer in the *World* in 1753,[3] 'everything was Gothic; our houses, our beds, our books, our couches were all copied from some parts or other of our old cathedrals.' And to support this statement we have record of a ball given by Mrs Delaney in 1752, where the room represented a wood with a grotto, extremely well expressed, and a Gothic chapel, which served as a sideboard.[4] The many books from which these designs were taken are uniformly foolish, smudgy and obscure. Only one of them has achieved immortality – Chippendale's *Cabinet Maker's Directory*,[5] and that is not due to the Gothic designs it contains. Few of Chippendale's draughtsmen were happily inspired, and their Gothic furniture was unusually misbegotten. If these monsters were ever executed (fortunately they were too elaborate and expensive to be in great demand), not even

1. Yet there was evidently a demand for his work as late as the nineteenth century, when Taylor put out a new edition.

2. *Letters*, ed. Tovey, 247. He was referring to the Chinese Gothic house at Esher. His statement that Kent invented the Batty Langley style seems to be literally true, as may be seen by comparing Kent's drawings for the embellishment of Westminster Hall, e.g. Jourdain, fig. 28, with any of Batty's designs. Kent's work at Westminster dates from 1739.

3. 22 March. The Author (W. Whitehead) is contrasting the fashion for Gothic with the newer one for Chinese.

4. Autobiography.

5. Published 1754: the designs are by several different hands, and a comparison of the original drawings, now in the Metropolitan Museum, New York, might disclose which designers were responsible for the Gothic pieces.

the fine craftsmanship, which redeemed so many bad designs, could have saved them. Chippendale's plates are interesting chiefly for their titles; some designs specified as Gothic disclose no known features of that style; anything extravagant was called Gothic or Chinese as fancy dictated.

It has not escaped your notice [wrote a contributor to the *World* in 1754] [1] how much of late we are improved in architecture; not merely by the adoption of what we call Chinese, nor by the restoration of what we call Gothic; but by a happy mixture of both. From Hyde Park to Shoreditch scarce a chandler's shop or an oyster stall but has embellishments of this kind.

It must have been in parody of such hybrid taste that Bentley proposed to build a garden-seat, Chinese on one side and Gothic on the other; for the passage I have just quoted shows that to mix Chinese and Gothic ornament was vulgar. A few presentable people slipped into this mistake; at Latimer's the house had undergone Batty Langley discipline; half the ornaments were of his bastard Gothic and half of Hallet's mongrel Chinese;[2] and Dickey Bateman's was as bad till Walpole took it in hand.[3] But such a mixture was usually the sign of a parvenu. Mr Atlas[4] described how Squire Mushroom covered his old house with Gothic spires; the walls were notcheted into battlements; uncouth animals were set grinning at one another over the gateposts, and the hall was fortified with rusty swords and pistols. But while one part was designed to give you the idea of an old Gothic edifice, the other half presented to your view slices of pilaster, balustrades, and other parts of Italian architecture. Carpenter's Gothic was a popular rather than an aristocratic craze, from which Walpole imagined that his Strawberry was far removed. Popular it remained long after he had taken it up. At Vauxhall the Rustic Music House was rebuilt in the Gothic manner,[5] and many of the books which

1. 14 February. ? Chesterfield. 2. Walpole to Bentley, 5 July 1755.
3. W. to the Earl of Strafford, 13 June 1781.
4. *World*, 12 April 1753.
5. Austin Dobson says 'about 1758'. I cannot find a more precise date.

came out during the rest of the century[1] contained Gothic ornament for the most modest houses, chimney-pieces or wooden porches, at most a temple, at least a little arch of wood set in the ordinary sash windows.

I wish I could find out how many of the queer suggestions in these books were put into practice. Gothic window-frames, the most insignificant, have also been the most enduring examples of the craze, and are to be met with in many old towns.[2] But gazebos were not built to resist the wrong of time, and few have survived into our own day. Sometimes one may see them in the suburbs of London, dragging out their lives as tool-sheds, and some, I expect, are decaying unseen in the damp copses of country parks. Their pinnacles are broken and their crockets deflowered; often little but a pointed arch is left to prove that they are the degenerate heirs of Westminster Abbey.

Why trouble about these freaks? Can we not agree with Eastlake's contention that the cause of medieval art would have been better forgotten than sustained by such a champion as Batty Langley? There seems to me good reason for believing that Rococo Gothic, if viewed historically rather than for its own sake, has a considerable place in the revival. In the history of taste, true understanding of an unfamiliar style is very often preceded by a period of ill-formed and uncritical enthusiasm, a period which provokes the amused wonder of more enlightened times, but is usually the healthiest and most natural path to real appreciation. One instance among many may help to make my meaning clear. We believe that the painting and sculpture of the early Chinese dynasties are important and serious examples of artistic activity. Yet the present taste for

1. E.g. Decker's *Gothic Architecture* (1759), Wright's *Grotesque Architecture* (1768), Crunden's *Convenient and Ornamental Architecture*, 1768. Most of such books are mentioned by Katherine A. Esdale in *The Small House and its Amenities in the Architectural Handbooks 1749–1827*, in Transactions of the Royal Bibliographical Society, vol. XV, or Wallis's *Carpenter's Treasure*, 1774.

2. They are generally of a later date, however. The commonest place to find them is in the almshouses built towards the end of the century.

E

this monumental art began with the enthusiasm of a few Parisian painters and writers for the most crude Japanese colour-prints. The gaudy sheets of Kunisada are as far away from Sung painting in time and in spirit as the Carpenter's Gothic of Vauxhall is distant from the nave of Durham Cathedral. We have come to see the importance of Chinese art very gradually, led on from the trivial to the graceful, and from the graceful to the serious. The parallel need not be insisted on in detail; but perhaps the analogy of a movement so much smaller and nearer to our own day will help us to understand the development of Gothic in the eighteenth century.

There is, I believe, an interest for us even in sham ruins; for the frame of mind which could find delight in canvas pinnacles is strangely different from our own. It is sometimes maintained that before the nineteenth century buildings were admired for their formal qualities, as opposed to any associations which they might awake. I need not labour the point that Gothic was from the first a literary style with an appeal which was purely associative. Yet what a curious change has come over our capacity for association! We might well be stirred by the sudden prospect of ruins, but once we knew them to be artificial our pleasure would evaporate. We are incapable of isolating the sensation and of enjoying a dramatic effect without the interference of truth, and there has come to be something shocking in the discovery that a seeming castle is only a disguised cowshed. It is a sham; it is telling a lie. Somehow, at some period since the eighteenth century, simple Romanticism has changed into a complex ethical position; our critical outfit is no longer complete without the weapons of morality.

Once we have some idea of the fashion for Gothic which preceded it, Strawberry Hill becomes an historical document of great importance. For we probably know more about Strawberry than about any other building of its age. We have Walpole's own detailed description of it, and we have the innumerable descriptions of visitors, we have eighteen volumes of his letters, and we have his own account-book, which has

been published with 170 folio pages of notes; we have a scrapbook containing the original drawings for it,[1] and we have Strawberry Hill itself.[2] From this rich material we should be able to learn how far Walpole followed fashion and what features were really his own; in short, exactly to what extent he influenced, not merely exemplified, the Gothic Revival.

In the preface to his *Description of Strawberry Hill* Walpole calls his house 'a very proper habitation of, as it was the scene that inspired, the author of the *Castle of Otranto*'. There were moments, it is clear, when Strawberry played the part of a sham ruin and inspired its creator with romantic excitement. The staircase, with its suits of armour, was an admirable aid to self-dramatization (there is always something dramatic about a staircase), and the monastic hall, with long saints in lean arched windows, was intended to induce a certain awe on entering. The whole house might help to sustain a Gothic melancholy if its author was in the mood; but this mood was rare. When Pope died, no mere love of rhetoric made Walpole say that poetry, too, was dead. He was a true Augustan and hated the Gothic poets.[3] Strawberry was not built to satisfy a literary mood, and reflects but indirectly the fashion for sentimental Gothic. The frippery Gothic which I have called Rococo was far more sympathetic to Walpole, and it is from this that his house takes the colour of contemporary fashion.

There would have been less Rococo at Strawberry had Walpole never met Bentley. The meeting must have taken place in 1752, for the first letter which passed between them dates from the August of that year. During the next ten years Bentley was the chief designer of Strawberry Hill, Mr Robinson, who had

1. In the collection of that great scholar and collector of Walpoliana, Mr W. S. Lewis, who published it, and much other Strawberry Hill material in *Metropolitan Museum Studies*, vol. v, 1934–6.

2. Strawberry has undergone two transformations, one in 1856–62 when Lady Carlingford built on a new wing, and one recently, when it was turned into a Roman Catholic training college; but in neither of these was the old house much altered.

3. Cf. W. to Cole, 9 March 1765.

been entrusted with the earliest alterations, merely carrying out his designs.[1] Richard Bentley was the third son of the great scholar. In no sense a solid man, he had a fanciful invention, which makes his designs to Gray's poems the most graceful monument to Gothic Rococo. 'He drew the ceiling of the library at Strawberry Hill,' wrote Walpole in an account of Bentley, 'designed the lanthorn, staircase North Front, and most of the chimney-pieces there; and other ornaments,' so he was in great part responsible for giving Strawberry Hill its character. In all Bentley's designs there is a taste of Rococo, and they are successful in proportion as this flavour predominates. In the lanthorn, the 'other ornaments' and in a few of the chimney-pieces, Bentley could let himself go and create fantastic forms which only the accustomed eye can recognize as Gothic. But this light touch was not adapted to the larger works; in these, moreover, he was not a free man.

Walpole had formed what he called the Strawberry Hill Committee, consisting of Chute, Bentley, and himself. Together they were supposed to decide on alterations, to choose originals from which to copy, and to censor designs when made. But their aims were divided. Chute and Walpole fancied themselves as archaeologists, and liked to display their Gothicism by copying fireplaces from medieval shrines. Bentley employed Gothic because its name licensed any extravagant invention. For a time the arrangement worked because Bentley lived in Jersey; he could not interfere at Committee meetings and his designs could be turned down without argument, though not without rhetoric.[2] There were quarrels over the library shelves and the black Gothic chairs of the Great Parlour; but since Bentley was the only member of the Committee

1. William Robinson, an architect from the Board of Works. He had worked under the supervision of Chute and Walpole, but had given no satisfaction. His chimney-piece and window in the Breakfast Room, for instance, 'were not truly Gothic' (*Works*, vol. II, 421). He was employed at Strawberry till 1773.

2. 'For this time,' wrote Walpole when rejecting his designs for the library, 'we shall put your genius in commission, and, like some other regents, execute our plan without minding our sovereign' (W. to Bentley, 19 December 1753).

who had any competence as a designer, the connexion might have lasted had he not come to live at Twickenham. He was lazy and continually in want of money; and his wife was insufferably dull. Close at hand these defects outweighed his talents, and by 1761 Bentley was in disgrace. For a time his place was taken by Mr Thomas Pitt, a neighbour who drew Gothic with taste; but the majority of designs were laboriously extracted from ancient folios by Chute, and Walpole himself watched over their execution, not liking to trust a hammer or a brush without his own supervisal.[1]

Bentley's frank eighteenth-century frivolity is more attractive than Chute and Walpole's archaeological endeavours. But it is less important in the history of the Gothic Revival. The future did not lie with the adapters, but with the pedants, and I believe that Walpole was the first patron of Gothic to insist on copying ancient work. We should call his copies 'interpretations'. Only a very free rendering of the original could be made from the plates in Dugdale's *Monasticon*; and even when special drawings of the original were used, difference of aim and difference of material made the copies unrecognizable. Gray believed that the chimney in the Holbein Chamber was a copy of the high altar in the Cathedral of Rouen;[2] Walpole has recorded that it was taken *chiefly* from the tomb of Archbishop Warham at Canterbury. A fireplace which comprised details of shrines, altars, and tombs from different places, and of different epochs, cannot be called a pedantic copy.[3] The ceiling of the Holbein Chamber, too, 'coved and fretted in star and quatrefoil compartments, with roses at the intersections, all in papier mâché', can have borne little resemblance to any Gothic original, though the learned and critical Gray pronounced it to be in the best taste of anything Walpole had yet done.

For though Walpole's archaeological researches are a new feature in the revival, he uses them solely in accordance with

1. W. to Montagu, 25 March 1763.
2. Gray to Wharton, 18 September 1759.
3. There was a similar mixture of styles in the library fireplace.

the taste of the time. It is still the light and genteel in Gothic which appeals to him; and though a recess may be copied from a tomb of undoubted antiquity, by the time it is finished with gold network overlooking glass[1] it will be as Rococo, as far from the spirit of the original, as Bentley's wildest designs.

This blindness is excusable; later architects, more pedantic and more learned than Walpole, were guilty of plaster groining;[2] and fifty years passed before men realized that in the actual materials employed lay the essential character of the Gothic style. Nor was it mere blindness that made Walpole depart from his Gothic originals. In the preface to his *Description of Strawberry Hill* he tells us that he did not mean to make his house so Gothic as to exclude convenience and modern refinements of luxury. Gray had supported this sensible course, 'for it is mere pedantry of Gothicism to stick to nothing but altars and tombs, and there is no end to it, if we are to sit upon nothing but Coronation chairs'; and nobody, as he said, could expect the inhabitants of an ancient house to wear ruffs and farthingales.[3] The piece of Gothic at Strawberry which approached ancient models most closely was the chapel in the woods. It was built by a man who may have had some traditional connexion with Gothic, Gayfere, the master-mason of Westminster Abbey,[4] and belongs to a later period (1771) when Gothic had begun to be better understood. But its more accurate medievalism may also be due to the fact that comfort and convenience play no part in the design of a chapel. We might infer that Walpole knew more about Gothic than he showed in Strawberry Hill. But no inference is necessary; for we have Walpole's own statement, 'every true Goth must perceive that they [my rooms] are more the works of fancy than imitation'.[5]

1. Cf. description of the Gallery.
2. For example, Carter, in Milner's Chapel, cf. p. 89.
3. Gray to Walpole, 13 November 1761. He is writing of his failure to find suitable Gothic wallpapers; cf. *Strawberry Hill Accounts*, 39 et seq.
4. He held his post from 1776 till his death at ninety-one in 1812.
5. W. to Miss Berry, October 1794.

These words were written at the end of Walpole's life. By that time the taste for Gothic had spread from a few eccentrics to the mass of fashionable country gentlemen. Walpole, as the unconscious instrument of Romanticism, was largely responsible for this diffusion; if diffusion it can be called, for he did not so much popularize as aristocratize Gothic. In 1750 the taste for pinnacles was associated with parvenus and Chesterfield could dismiss it as such, but when the exquisite, cultivated Walpole took up Gothic, society began to feel that there might be something in it. Vauxhall was forgotten and the dowagers, as plenty as flounders, who inhabited all around Strawberry, notcheted their walls into battlements as though Squire Mushroom had never existed. Walpole gave Gothic social standing. It was perhaps his greatest contribution to the revival.

But it was not, as has sometimes been maintained, his only contribution. We have seen how Walpole introduced the fashion of copying ancient models; and the title of the next chapter shows how much this taste spread. Of the mass of Gothic country houses built in the last half of the century, one group – the castles – is a product of Romanticism quite uninfluenced by Walpole. But for the rest he must be made, in part, responsible. It is a responsibility which he would have disclaimed. He always abominated Carpenter's Gothic. 'I want to write over the doors of most modern edifices, "Repaired and beautified; Langley and Hallet, Churchwardens."'[1] And late in life his taste in Gothic became more severe, too severe, indeed, for the earlier part of Strawberry. But he could not disclaim details of whole rooms definitely copied from his house, Arbury (1778),[2] for example, and Sheffield Place (before 1779); nor could he disclaim parentage of that necessary concession to the spirit of medievalism – a sham chapel or oratory. The chapter in his *Anecdotes of Painting* showed the importance Walpole attached to the superstitious element in Gothic, and

1. W. to Montagu, 13 April 1763.

2. But the Gothicizing of Arbury had begun as early as 1750, probably after Sanderson Miller, and was continued by Henry Keene in the 1760s.

in recognition of this he constructed the Cabinet, which was to have all the air of a Catholic chapel. For a time Walpole feared that its gaudiness was a little profane; but the sable mass of the altar and the painted glass in the dome, which gleamed down in all the glory of popery, were convincingly Catholic, and the old Duc de Nivernois, when carried into the Cabinet, pulled off his hat. Perceiving his error he said, '*ce n'est pas une chapelle pourtant*', and seemed a little displeased.[1] But the Duke's action was prophetic, and Mass is said in Walpole's chapel now.[2]

Walpole's influence was not needed to introduce a mock religious element into eighteenth-century Gothic. The middle age was universally associated with popery, and in England the monuments of Gothic architecture were almost exclusively religious. Strawberry was the parent of many monastic mansions, but we cannot trace the pedigree of Fonthill solely to Walpole's little Cabinet.

Walpole would have more important connexion with Fonthill if it were true that he turned Wyatt's attention to Gothic. The evidence for this is not quite complete. We know that he always admired Wyatt and considered the Pantheon the most beautiful building in England.[3] When an old friend of Walpole's, Mr Thomas Barrett, began to enlarge his house, Lee Priory, near Canterbury, he employed Wyatt, working in the Gothic style. Walpole was in the habit of recommending Wyatt; he would have been eager to see his favourite architect try Gothic, and his part in the appointment is made even more probable by his delight at the result. 'The Gothic parts', he said, 'are classic.'[4] Finally, we know that he speaks of Lee

1. W. to Mann, 30 April 1763.

2. Strawberry Hill is now a Roman Catholic training college. It was enlarged for this use by the firm of Pugin and Pugin.

3. W. to Mason, 29 July 1773. The motives of Walpole's admiration may not have been pure. It seems that Walpole had tried to employ Adam, but had quarrelled with him; and that he thereafter gave exaggerated praise to Adam's chief rival. Cf. Bolton, *The Work of James and Robert Adam*.

4. W. to Harding, 1785. This use of the word classic may be of use to the students of language.

Priory 'as a child of Strawberry prettier than the parent'.[1] No number of probables make a certainty; if Walpole really made a Goth of Wyatt, he has much to answer for.[2]

There is something disarming about Strawberry Hill. 'It is set in enamelled meadows,' said Walpole, 'with filigree hedges.' Who could take seriously the bespangled Gothicism of the Gallery or the papier-mâché rosettes in the Holbein Chamber? Who could have the heart to break this little plaything out of Mrs Chenevix's toy-shop? 'Yet let me flap this bug with gilded wings': to the chilly and humourless historian of taste Strawberry Hill is not merely absurd; it is a ghastly portent.

Bad art flourishes in every epoch, but art may be healthily or unhealthily bad, and Strawberry was bad in a peculiarly ominous way. Walpole's taste seems to have found satisfaction in just those things which were to bring about the collapse of architecture in the nineteenth century. He introduced a romantic style, and instead of using his borrowed forms freely, as the Renaissance used classical forms, he insisted on copying them. If his Gothic shows a little more style than Gilbert Scott's, it is because he was an incompetent copyist, and a little eighteenth-century feeling crept into his medievalism. Worse still, he seems to have been instinctively opposed to anything made of its right material,[3] and Strawberry is full of new devices to render craftsmanship unnecessary – new wallpaper which was stamped to imitate stuccowork, and new artificial stone which allowed the architect to order his detail wholesale.[4] Nothing

1. W. to Miss May Berry, September 1794.

2. But he always deplored Wyatt's restorations at Salisbury. W. to R. Gough, August 1789.

3. By a curious paradox the use of artificial materials in classical architecture made him furiously indignant. Cf. his letters to Bentley on the church at Mereworth, 1752.

4. The earliest mention of stucco paper is in February 1751; cf. *Strawberry Hill Accounts*, 39 *et seq.*

Artificial stone was first used in the 1760s. It was called 'lithodipra' and was made at Lambeth. The piers of Walpole's garden gates were made of this material, and taken from the tomb of William de Luda, bishop of Ely, in that Cathedral; cf. ibid., 154, and *Description*.

in that house was simple, natural, and solid; nowhere had the workman followed his own bent. Instead of good workmanship he introduced the quaint – a word which covers everything silly and unnecessary in style. Walpole killed craftsmanship: it was reserved for later Gothic revivalists to resurrect it.

Chapter 4

Romanticism and Archaeology

From the first the new taste for Gothic architecture was no more than a symptom of a great change of ideas which we call the Romantic Movement. No one can define this change; but any definition must suggest that the Middle Ages took the place of classical times as an ideal in art and letters.[1] The taste for Gothic is therefore an essential expression of Romanticism, so closely related to every other expression of the same impulse that it is difficult to write on the Gothic Revival without plunging into the history of the Romantic Movement. This difficulty grows as the movement gains strength. At first a taste for Gothic was the clearest symptom of Romanticism;[2] examples of the impulse in literature were rare and could all be brought into relation with Gothic without serious digressions. But towards the end of the eighteenth century Romanticism begins to touch every department of life and art; and in literature, above all, causes a violent fermentation. An intoxicating cup of poetry, coming after the barley-water of the Augustans, blinds our eyes to other features of Romanticism; the taste for Gothic seems an insignificant example of a movement essentially literary, and one hardly to be understood without a quantity of literary allusions.

But though some knowledge of Romantic literature is necessary to a full understanding of the Gothic Revival, it would

1. Cf. Heine's definition of the Romantic school, '*die Wiedererweckung der Poesie des Mittelalters, wie sie sich in dessen Liedern, Bild- und Bauwerken, in Kunst und Leben, manifestiert hatte*'.

2. Cf. the chapter headings in any history of English Romanticism or such a title as Haferkorn's *Gotik und Ruine in der englischen Dichtung des achtzehnten Jahrhunderts*.

obviously be unwise for me to blunder into this huge contro-
versial subject. This short essay would swell with 'isms' and
'ologies', groan with definitions and qualifications; in my
effort to lay deep foundations I should dig a pit and fall into it
myself. I must therefore be allowed to assume in my reader a
knowledge of the Romantic Movement in general; and I shall
confine myself to those books which have direct and special
bearing on the Gothic Revival.[1]

First comes a group of books written under an impulse
which we saw at work in the last two chapters, the desire for
the picturesque.[2] Love of the picturesque is an amplification of
mood of the Gothic poets, and was reflected in the erection of
sham ruins. From 1740 to 1760 the letters of Mrs Delaney and
of Mrs Montague and her circle are full of ecstatic references to
horrid rocks and roaring torrents, scenes adapted 'to raise the
imagination to sublime enthusiasm, and to soften the heart to
poetic melancholy', and the only places for a tea-party. But the
first important published work on the picturesque was Mr
Brown's Letter on Keswick (1767).[3] Two years later Gray
visited the Lake District. He found it already a prey to artists,
and when his enthusiastic notes were published in 1775 they
did no more than reinforce a prevalent fashion. From 1776 to
the end of the century many popular Guides to the Lakes were

1. This rule has forced me to exclude one famous landmark of Romanticism,
which seemed, at first sight, to concern me: the Ossianic poems. They appeared
from 1760 to 1763, and have this superficial connexion with our subject, that
both look back to a remote non-classical past. But equally the Ossianic past is
non-Gothic; it is not Christian, nor does it call up associations with any Gothic
monuments; and in style it is, as Walpole saw, more akin to Oriental rhapsody
than to anything medieval. Ossian was very popular on the Continent, and had
an important effect on Goethe; it also impressed Chateaubriand and through
him may claim a vague influence on the revival. Through Goethe it had a more
definite influence on Scott. Nevertheless Ossian belongs less to his side of
Romanticism than to the wild, inflated Romanticism of Byron and Napoleon.

2. Mr Christopher Hussey's admirable book The Picturesque came out just
too late for me to profit by or refer to it in this chapter.

3. It must have been written much earlier, perhaps before 1756. Cf. Man-
waring, loc. cit., 175. Miss Manwaring also quotes a published reference to the
picturesque from the British Magazine of June 1761.

published, one of which went into seven editions;[1] and in addition the district was mentioned in most books of picturesque travels. Of the innumerable picturesque travellers, I need only mention two. Arthur Young and Gilpin. Young's *Tours*, though they may be called the first picturesque voyages to be published,[2] were in intention economic; we may gauge the strength of the fashionable infection when we find Young, the author of an 'Essay on the Management of Hogs', turn from a field of turnips to apostrophize the distant prospect or to reflect for three pages on the awful melancholy of ruins. In the works of Gilpin the craze reached its height. To the usual ecstasies he added a technical jargon of landscape painting by which his readers could impress the uninitiated; and his works were widely read. Ultimately the fashion died of its own popularity. Exquisite and awful sensations cannot be shared with the vulgar, and the appearance of *Dr Syntax*[3] showed that picturesque beauty was no longer a subject for the polite.

It is easy to see how this craze is connected with the Gothic Revival. Opinions might differ as to the exact definition of the word 'picturesque', but all agreed that nothing was so undeniably picturesque as Gothic architecture. Picnickers, following in the wake of some sentimental traveller, sought the shadow of a Gothic abbey; many who were young in the last quarter of the eighteenth century must have associated these buildings with sweet and poignant moments, and through life Gothic must have kept for them some perfume of their poetical youth.

There is another group of books with a far more direct bearing on our subject, for they show how the word Gothic, with all that it implies, ceased to be a synonym for 'barbarous' or

1. Hutchinson's *Excursion to the Lakes* (1776), West's *Guide to the Lakes* (1778) (7th edition 1799), Clarke's *Survey of the Lakes* (1787), and Budworth's *Fortnight's Ramble to the Lakes*.

2. *Tour Through the Southern Counties* appeared in 1768, *Tour Through the North of England* in 1770.

3. *Tour of Dr Syntax in Search of the Picturesque* by William Combe, 1812. Clearly a satire on Gilpin.

'violent' and became associated with the poetry and chivalry of the middle age. This process, too, was at work before 1760, and any break between the works of Gray and Warton, and the books I am about to consider, is artificial, and occasioned solely by the intrusion of Strawberry Hill. This artificiality is the more regrettable since Bishop Hurd, the first author I would mention, was a member of Gray's circle. Hurd, 'the last man who wore stiff-topped gloves', was perhaps the most curious of those unconscious Romantics, at once the most 'donnish' and the most revolutionary. His *Letters on Chivalry and Romance* (1762) carried the war between Goth and Grecian into the enemy's camp; for he not only claims a place for Gothic art, but actually suggests that Gothic manners were superior to Classical as a subject for poetry. Gray and Warton would have agreed that 'if you judge Gothic architecture by Grecian rules, you find nothing but deformity, but when you examine it by its own the result is quite different'; but they would have hesitated before saying that Gothicism furnished the poet 'with finer scenes and subjects . . . than the simple and uncontrolled barbarity of the Grecian'.

Hurd's belief in the appeal of chivalry and the poetical value of ballads was soon to have popular confirmation.

In 1765 appeared Percy's *Reliques of Ancient English Poetry*. It was not the first book of its kind; ballads of a sort were popular in the early eighteenth century, and since Addison had patronised Chevy Chase at least two collections of medieval ballads had appeared.[1] Thus the ground was prepared for the *Reliques*. Like many pioneers of medieval art, Percy was a pure antiquarian who liked old things solely on account of their age and quaintness; he had no faith in the aesthetic qualities of his collection and 'was long in doubt whether, in the present state of improved literature, they could be deemed worthy of the

1. *A Collection of Old Ballads*, vols. I and II, 1723, vol. III, 1725; and Allan Ramsay's *The Evergreen*, 1724. In addition there were collections of scurrilous popular songs like d'Urfey's *Wit and Mirth; or Pills to Purge Melancholy*, which sometimes contained an old ballad.

attention of the public'.[1] He need have had no qualms. The *Reliques* were a great success; a new edition was needed within a year, and they were several times reissued during the rest of the century. Hurd's Letters cannot be made to account for their popularity. Still less can Percy's preface; and the success and influence of his *Reliques* remains a clear instance of the general taste making its way spontaneously and unled.

This diffused feeling for the poetry of the Middle Ages was focused in one intense and passionate expression, the work of a man whose life itself has become a kind of symbol of early Romanticism. Before the *Reliques* appeared, the boy Chatterton was spending his summer days by St Mary's, Redcliffe, picturing in his mind the antique life which once moved there. And from 1767 to 1770 he produced the pseudo-medieval poetry which was published after his death as the *Rowley Poems*.[2] It was not mere love of deception or need of money that made these take the form of 'forgeries'. Chatterton's feeling for the Middle Ages was too strong to be content with medieval forms and subjects; he must actually write medieval poems.

Chatterton inspired a school of poets which does not concern us; but Percy's *Reliques* and the other collections of old songs which followed it were to have important consequences for us, for they nourished the imagination of Walter Scott. Cardinal Newman, to the end of his days, mentioned Sir Walter in his mass as the man who made the Catholic Revival in England possible; and Eastlake devotes four pages to him: 'It would be difficult', he says, 'to overrate the influence which Scott's poetry has had . . . in encouraging a national taste for medieval architecture.' However, it would be quite easy to overrate the influence of Scott's poetry, and Eastlake did so. *Marmion* appealed to a public which was already devouring every collection of old poetry, including Scott's own *Border Minstrelsy* (1802). The influence of this, and of Scott's other pseudo-bal-

1. Cf. the opening paragraph of his preface.
2. By Thomas Tyrwhitt in 1777.

lads, cannot have differed in kind from that of real ballads, and careful research would be needed to prove that it was greater in extent.

The Waverley Novels were, of course, far more important than the poems, not only because they were more popular, and spread Gothic sentiment to every class of reader, but also because they gave more solid nourishment to the imagination. They described real historical events and associated them with clear descriptions of Gothic architecture. Eastlake, though he certainly does not underrate the influence of Scott's novels,[1] remarks that his ignorance 'may raise a smile from those who have studied the real and structural beauties of old English architecture'. But Scott was a more reliable guide to the Middle Ages than previous Gothic poets and novelists; for, like Gray and Warton, he combined literature with archaeology. It was the wealth of archaeological detail in Scott's novels which made his picture of the Middle Ages so satisfying, and so much more influential than the mere melancholy of the poets.

For all this, the influence of the novels has been overrated. We forget how late the chief of these appeared. *Ivanhoe* was published in 1819, *The Abbot* and *The Monastery* in 1820, *Woodstock* in 1826, and long before the first of these dates Gothic archaeology had become popular. It is hard to believe that so dry a subject could become popular in any sense in which *Ivanhoe* was popular. But we know from our own day how the most abstruse subjects can suddenly strike the public imagination; and from 1800 to 1820 a flood of pamphlets shows that Gothic archaeology was a craze, as widespread as Relativity[2] and far more sustained. Of all the literary by-products of Romanticism this craze for archaeology is the most important to the Gothic Revival.

1. 'The fortunes of the Disinherited Knight, the ill-requited love of poor Rebecca, the very jokes of Wamba and the ditties of the Barefooted Friar did more for the Gothic Revival than all the labours of Carter and Rickman' – *A History of Gothic Revival*, 115.

2. In 1949, for 'Relativity' read 'Existentialism'.

To the eighteenth century the middle age was a foggy sea with but one landmark – the Norman Conquest – round which the Gothic cathedrals drifted like rudderless ships. We have seen how Gray's erudition and Warton's bleak footnote shone before a background of profound ignorance; and for a long time they were quite alone. Though amateurs like Chute and Jerningham, and at least one professional architect, Essex, must have been studying Gothic during the 1760s, nothing was published till Bentham's *History of Ely* (1771). Two years later Grose's *Antiquities* began to appear, the first of those huge books whose names – Carter's *Specimens* or Gough's *Sepulchral Monuments* – conjure up for us the tallest and dustiest shelves in a library, and whose perusal is a physical achievement. These books usually contain a list of subscribers, which shows that they appealed to the leisured and aristocratic; and we might assume that before 1800 the taste for Gothic archaeology was confined to a small clique, could we not refer to that inexhaustible treasury, the *Gentleman's Magazine*.

From 1780 onwards this magazine is gradually transformed; Giant Fungi and Greek Inscriptions begin to yield to Gothic architecture as a subject of the illustrations; and in the 1783 volume there is an article on Gothic practically every month. These articles, it is true, show no very high standard of learning. A contributor to the October number, 1782, gives an account of the rise of Gothic. We have few buildings in this style, he says, anterior to the reign of Henry III; then 'this *Gigantic* Spurious production made great strides for many centuries till it sank leisurely into the *Modern* Gothic (a refinement upon the Ancient. It began about the fourteenth century)'. This is strange enough, for since Henry III reigned from 1216 to 1272 the 'many centuries' of Ancient Gothic can only have been eighty-four years at most or twenty-eight at least. But stranger was to follow, for in Edward III's reign 'a fondness prevailed for the revival of the *Grecian* mode, and modern Gothic was the blossom to which that fruit succeeded'. No wonder that a public which accepted these statements was un-

critical of sham ruins. After 1790 a Gothic building was illustrated and described in almost every number of the magazine;[1] and perhaps these articles show a little more science. But they are still remarkable as evidences of enthusiasm rather than as archaeology.

The passage just quoted shows that some archaeological research was really necessary before the Gothic Revival could progress; and it must excuse the prominence given here to a very dull subject. There was some real archaeological learning in Milner's *History of Winchester* (1798) and in Bentham and Willis's *History of Gothic and Saxon Architecture in England* (1798); but these were bulky and expensive volumes, and the first popular book on the subject appeared in 1800. This was a reprint of four essays on the history of Gothic architecture, those of Warton, Bentham, Grose, and Milner, with an introductory letter by the last named. A great many copies were printed and the book started the craze. Unfortunately this was not due to any unusual love of architecture, but to the familiar love of controversy.

The study of medieval antiquities raised two disputable points: first, where did the pointed arch come from? and second, what should the architecture which introduced it be called? Sir Christopher Wren had provided the orthodox solution of both these questions. He called the pointed arch Gothic, and believed that it was brought back from the East by the Crusaders. These views were accepted by Warton and Bentham, but they were obviously distasteful to later admirers of Gothic, and Milner, in his *History of Winchester*, objected to both. He called Gothic 'pointed'; he claimed that arches of this form were suggested by the intersection of two round arches; and these views were republished with Warton's and Bentham's in the volume we have mentioned.

The appearance of two conflicting theories in the same vol-

1. Despite the statement of a correspondent to the *Gentleman's Magazine* for that year that 'Gothic architecture is hastening out of fashion at Coventry as well as all over the kingdom'.

ume proved irresistible. Upwards of a hundred unoccupied persons wrote pamphlets on Gothic archaeology, beginning with the ominous words, 'Though a sworn foe to controversy, I feel it my duty to state . . .' Britton gives a list of sixty such pamphlets;[1] and there were others, to say nothing of articles in *Archæologia*, county histories, and various magazines. The question of Origins, which allowed of a greater display of learning, was the more popular, and produced a number of new and curious theories. The pointed arch was traced to the intersection of boughs in a forest, to the forms of Solomon's Temple, to the ingenuity of Bezaleel and to the inverted keel of the Ark.[2]

At least these improbable theories show a real admiration for Gothic in their desire to trace it back to some early and respectable original (who could be more respectable than the Designer of the Ark?) and though they never approached the truth,[3] some of the less entertaining show signs of valuable research.

The nomenclature controversy was far more barren, and less influential on the course of the revival. There were two questions at issue, one concerning the differentiation of the various medieval styles, the other the term 'Gothic'. The first of these questions is quite interesting, and I only mention it to warn any reader of early books on Gothic that the terms used in them are not ours. Saxon may imply a pointed arch, and at best means our Norman. Their Norman was our Early English, and their modern Gothic our Perpendicular. Fortunately the

1. Britton's *Architectural Antiquities*, vol. v, 81 *et seq*. This chapter contains a short account of the Gothic Revival before Britton's time.

2. 'All the imaginable formulae of the pointed arch are reducible to three, and are nothing else than the oblique, the perpendicular, and the horizontal sections of one and the same boat, ship or Ark. In all three the point is made by the keel,' (Rowley Lascelles, *The Heraldic Origin of Gothic Architecture*, 1820).

3. The most probable solution was suggested by the architect James Essex about 1770, but not published till fifty years later. 'He conceived that the Gothic architects were induced, or rather driven, to the use of the Pointed Arch by their practise of vaulting upon bows, and sometimes covering with such vaults spaces which were irregular; that is, not square, but longer in one dimension than another.' Quoted by Kerrich in *Archæologia*, XVI, 314, 315, probably from a MS. now in the British Museum.

terms used in Rickman's *Attempt to Discriminate the Styles of English Architecture*, 1819, were almost universally accepted, and by 1820 this dull controversy was at an end.

The disputes which raged round the word Gothic were more interesting. Though the word had appreciated in value during the last half of the eighteenth century, it was still tainted by its philological associations with the barbarous Goths. Admirers of medieval art found the term misleading and damaging; and they suggested synonyms according to their tastes. The unadventurous suggested 'Pointed'; the pretentious 'Plantagenet'; the pious 'Christian'; the official and self-assertive 'English'.

It was this last which proved most popular. That national feeling, which was the most disastrous consequence of Romanticism, found satisfaction in claiming a national origin for all the arts; and the Napoleonic wars saved antiquarians from the troublesome discovery that the pointed arch existed on the Continent at an early date. 'English' was adopted by the Society of Antiquaries, supported by the vociferous Carter, and finally confirmed by Rickman. Subsequent proof that the pointed arch originated in France[1] did nothing to shake the faith of English antiquarians,[2] and the ultimate triumph of 'Gothic' is a philological mystery.

Evidence of the craze for Gothic archaeology is not confined to pamphlets. If we return to our precious *Gentleman's Magazine* we find that after 1800 engravings of Gothic buildings are reproduced and discussed in every number; and after 1805 these form practically the only illustrations. The text shows a similar progress. We left antiquarian matters in very unskilful hands, but after 1798 they were entrusted to Carter, who, with all his absurdity stands for the best service which antiquarianism did to Gothic architecture. Carter was a trained architect and

1. This was first suggested by Mr Sayers in his *Guide to Ely Cathedral* (1805) and repeated by Whittington (1811); Cotman and Turner's *Architectural Antiquities of Normandy* (1822) was the first book to deal with continental Gothic.

2. As will be seen in the disputes over the Houses of Parliament; cf. p. 99.

had gained for himself, by his *Specimens* and *Ancient Architecture*, a position of some authority. But his learning is far less remarkable than his emotion; and both were employed to denounce contemporary methods of Restoration.

Carter was not the first man to do so. Wyatt's work at Salisbury had caused widespread alarm, and Gough had written to Walpole asking him to protest. There had been some scandalized letters on the subject in the *Gentleman's Magazine*,[1] and Milner had been provoked to write an eloquent Dissertation on the *Modern Style of Altering Ancient Cathedrals*. But all these protests were as nothing compared with Carter's unweariable trumpetings. Throughout two hundred and twelve articles he sustained a violence of temper rarely met with outside religious controversy; indeed his writings have a theological flavour and he often has recourse to a frenzied biblical style. Even an age which swallowed Ossian found Carter's language indigestible and his violence provocative.

May I not venture to suggest [wrote a correspondent to the *Gentleman's Magazine* in August 1801] that 'somewhat too much of this' is obvious in the controversy between the Greeks and the Goths? Although I highly respect both parties and *side* with the Goths *toto animo*, I would have both recollect that they are not vindicating the being of a God, not impugning the Socian heresy; that the principles upon which a cathedral is built are not the same with those by which a religion may be overturned; and that when we see the words *abominable, odious, monstrous, degrading, unnatural*, etc. staring us in the face we are apt to be reminded not of pointed arches and ill-mended screens, but of profligacy, robbery and murder.

The correspondent wrote wiser than he knew; his protest became more apt as years went by, till what he had written as hyperbole became literal truth.[2]

But there can be no doubt that strong language was needed.

1. Though one correspondent signing himself 'Antiquarian' stated that he could see no reason for preserving a parcel of old walls and trumpery.

2. The choice of the Socinian heresy as an example was to prove particularly happy; cf. 143.

The great Gothic buildings had been neglected for almost two centuries, and when once more they became a subject of interest, they were found to have decayed. This discovery was met in two ways: either the buildings were restored, or they were closed and utterly deserted, that their collapse might not endanger human life. The former course was certainly the more disastrous, even when a building was really in danger of falling down; and often restoration took place where none was needed. These restorations were called improvements, and arose from the fact that the eighteenth century's conception of Gothic did not always agree with the evidence of actual examples. It was felt that a certain amount of fretwork, a certain number of pinnacles, were essential to true Gothic style; and where these were deficient they were added. Plain surfaces, like those of the old Oxford colleges, were enriched with shrines and canopied niches,[1] and pinnacles were added to the towers of Bath Abbey. In the wealthier and more enlightened dioceses restoration had begun in the 1780s, and when Carter began to write in the *Gentleman's Magazine*, the movement of which Wyatt is the eponymous hero was in full swing.

'Goad on, ye mental stings,'[2] says Carter, in one passage, addressing, it seems, his own remonstrances; and for almost twenty years they goaded; goaded country parsons into clearing rubbish out of their side chapels, goaded Deans and Chapters out of ambitious improvements, goaded everybody concerned with restoration except Wyatt. Undoubtedly his articles helped to prevent neglect; and there is good evidence that when Carter died in 1817 churches were being better cared for. Already before 1820 local enthusiasts and cultivated clergyman were scraping away whitewash and emptying the chancels of rubbish; and in 1825 there appeared an attack on casual restoration which foreshadows the controversial methods

1. This is clear from old prints. At University College, for instance, two canopied niches, complete with saints, were added on either side of the chapel gate. They have since been removed.
2. *Gentleman's Magazine*, March 1801.

of Pugin and the attitude of the Camden Society. This pamphlet[1] suggests and illustrates ways in which churchwardens may best desecrate and make ugly their churches. For instance, 'a very beautiful, and what may be termed a full-fronted vestry, may be so cunningly placed as to make one of the windows of the chancel its entrance into the church, still preserving a part of the arch to which the vestry will give an agreeable contrast'. Twelve coloured plates show Gothic churches with red-brick vestries and porches at every corner, yellow shutters on the windows, and enormous black stove-pipes running all over the gables and the tower. But the impulse to improve, so strong in every department of life at that date, no rhetoric could crush. 'Our gentry and clergy,' wrote Britton with satisfaction, 'instead of defacing those venerable and interesting works of former times, restore, preserve and adorn our ancient Cathedrals and Churches.'[2] They continued to do so unchecked, though always deploring the restoration of their predecessors, throughout the whole course of the Gothic Revival.

There remains one more group of books which appeared as a result of the antiquarian craze and which were of real importance to the revival, books containing good illustrations of Gothic architecture. We have seen that books of Specimens and Examples appeared in the eighteenth century, but were too sumptuous to be counted as influential. The man who popularized engravings of Gothic by publishing them cheaply and in great numbers was John Britton. Britton was no archaeologist and had no natural interest in architecture,[3] but he had all the gifts of a great newspaper owner – industry, persistency, a fine instinct for changes of fashion and perfect shamelessness in exploiting it. After trying various disreputable trades, he pub-

1. It was called *Hints to Some Churchwardens, with a few Illustrations relative to the Repair and Improvement of Parish Churches.* I have not been able to find the author's name.

2. *Gentleman's Magazine,* 1818.

3. This is clear from his fragment of *Autobiography,* written with the egotism of a millionaire.

lished a book on *The Beauties of Wiltshire* (1801) which succeeded. Britton thrust home his success with a whole series of books on the *Beauties of England* which lasted till 1816. But in 1805, feeling that fashion was deserting 'beauties' for the more solid joys of archaeology, he launched a series of *Architectural Antiquities of Great Britain* in forty quarterly parts; and when this was completed, in 1814,[1] another series of *Cathedral Antiquities* which appeared almost yearly till 1835. Britton deserved his success. His text was painstaking and his illustrations, especially those by Mackenzie and Le Keux, achieved an accuracy and detail never before attempted. Though Britton's volumes were a commercial venture, they did not merely feed a craze; they gave the average cultivated man a far truer idea of Gothic forms than he had hitherto had, so that after their publication the old fantastic parodies of Gothic were no longer possible. Britton killed Ruins and Rococo.

What Britton's *Antiquities* did for the amateur, Pugin and Willson's *Specimens of Gothic Architecture* did for the professional architect. The earlier books of specimens, bent chiefly on showing the sublime and picturesque effects of Gothic, had avoided too great precision of detail. Pugin's book gave sections of every cusping and geometrical measured drawings of every crocket and finial reproduced. Thenceforward Walpole's dream of correct Gothic was realizable.

A dead fashion can hardly be made credible; but I must ask the reader to believe that Gothic archaeology was once a popular subject, and that the few books I have mentioned are typical of many others, all published before 1820. Not that the craze stopped at that date; on the contrary, the number of books on Gothic increased. But by taking 1820, the year of *The Abbot* and *The Monastery*, it has been possible to show how easily Scott's influence may be overrated. If we turn to the

1. A fifth supplementary volume appeared in 1818, but was no part of the general scheme. It contains a short account of the Gothic Revival up to that date which may be of use to anyone who wishes to follow up this sketch with a detailed study.

Gothic architecture built before that date, we shall see to how great an extent it grew out of the whole Romantic Movement. In most changes of taste the artist dictates to the public; but in its early stages the Gothic Revival was uninfluenced by architects. Literary men with no particular architectural bent had started a demand for Gothic which was largely satisfied by amateurs. When professional architects employed the style, they did so purely at the dictates of their patrons. But there was one way in which purely architectural motives affected the revival, and at least one architect who adopted Gothic from conviction.

By 1760 the strict and stuffy classicism of the Burlington school had grown dull, and some architectural reaction was inevitable. The leaders of this reaction were the brothers Adam; and though we cannot compare the Gothic Revival to their exquisite Hellenistic art, we may see in both a revolt against heavy formalism and a desire for a lighter, more variegated style. We may allow ourselves the broad distinction that one is architectural and the other literary; but the Greek revival was not free from a literary overtone, and Gothic forms gave a certain satisfaction to an eye bored with Palladian monotony. Certainly eighteenth-century Gothic had as little formal appeal as architecture could well have. But we must remember that men will change a good shape for a bad one from no other motive than the desire for change.

The only professional architect of any importance who seems to have had a natural preference for Gothic was James Essex. This is an indecisive statement, but the first we hear of Essex is that he drew the plates of Bentham's *History of Ely* in 1757; and whether he was employed by Bentham because he had studied Gothic, or vice versa, we do not know. Much of his time was spent in restoration at Ely, Lincoln, and Winchester. In doing this work he evidently learnt the grammar of medieval art, and the little original work which he did is much in advance of his time. He was the first professional architect to treat Gothic seriously, and if some day the Gothic Revival is

studied in detail, we may find that Essex was an important figure in the history of English architecture.[1]

Now that we have done our duty to these purely architectural influences we can return to our main impulse, Romanticism, with a clear conscience. I have already mentioned the influence of self-dramatization on the history of taste, and what was said of Ruins applies in even greater measure to the Castles and Abbeys of the 1790s. The feeling should be easy for us to understand, as, by a curious twist of fashion, we have romanticized the eighteenth century very much as it romanticized the middle age; and in our eighteenth-century drawing-rooms we enjoy sensations comparable to those of an earlier dilettante in his plaster oratory.

This desire for a dramatic setting produced a curious and, I believe, unprecedented situation. Towards the end of the eighteenth century there were a number of architects, some very gifted, all respectable, working in the classical style and regarding it as the only possible style for serious architecture. Yet their patrons were so drunk with Romanticism[2] that, at one time or another, every one of those architects was compelled to employ a style which he disliked and despised and of which he was completely ignorant.

As might be expected, the amount by which these architects sacrificed their convictions to fashion varies inversely to their merits. There appears to be only one sham castle designed by Chambers, and there are very few by Adam;[3] there are more by Dance, still more by Smirke; and Nash, that shameless time-server, built his patrons Gothic castles to their hearts' content. As any detailed study of these buildings would hinder the

1. Mr Goodhart Rendel says that we shall not, but I leave the sentence because, as far as I am aware, nobody has studied James Essex, and it might be interesting. Another professional architect to use Gothic was Henry Keene, cf. *Country Life*, March and April 1945.

2. One of them, Sir Charles Mills, went so far as to build a Gothic mansion on the Palatine itself, an astonishing example of fashion triumphing over circumstances.

3. Adam in his youth made a measured drawing of Winchester Cross. But there is no evidence that he showed any love of Gothic in maturity.

movement of this essay to no purpose, the reader is referred to Eastlake, who records the gothicizing of over twenty-five great country seats. The list shows two distinct classes which we may call the Windsor class and the Fonthill class; and it is hard to say which includes the greater number of bad buildings. The Windsor class had more justification. It is fitting that a Duke should live in a battlemented castle, and Arundel, Wilton, Belvoir, Knowsley were understandable demonstrations of immense pedigrees. When these castles, like their archetype, Windsor, were well placed, they became effective parts of the landscape, as effective, at a distance, as if they had been old. The Fonthill class was more adventurous and more amusing; Fonthill itself must have been far the most exciting building of its time, and even Eaton Hall,[1] as huge and as spiky as Milan Cathedral, surprised with a fine excess where Belvoir merely bores.

Only one of the classical architects who employed Gothic deserves individual study – James Wyatt. He differs from the others, for though his first and, to our taste, his best buildings were classical, there can be no doubt that he really loved Gothic. It was a pity, said Walpole in a moment of rapture, that William of Wykeham was no longer alive to employ Mr Wyatt; and this remark is not quite as absurd as it sounds. Like Vanbrugh, whose work he was almost alone in admiring, Wyatt was an essentially romantic architect. His strength lay in scenic effect rather than in detail, and his imagination found freer play in towers and battlements than in garlands and cameos. Had Gothic been the natural language of his time Wyatt would have been a greater architect; failing that he needed a tradition of Baroque. He might even, like Vanbrugh, have found some way of adapting classical motives to his Gothic dreams, had there been no Gothic Revival to tempt him. As things were his failure was inevitable.

James Wyatt was born in 1746, the son of a timber merchant

1. The original building, by W. Porden, was entirely remodelled by Waterhouse in 1870, and surprises no longer.

at Weedford, near Tamworth. At the age of fourteen he was sent to Rome, and soon after his return he was commissioned to rebuild the Pantheon in Oxford Street. The work was a great success, and from 1772 onwards Wyatt was much employed in the classical style. We do not know exactly what turned Wyatt's attention to Gothic. I have said that Walpole's share in the matter is doubtful. The usual story is that Walpole induced his friend Barrett to employ Wyatt in gothicizing his house, and the work at Lee Priory is dated 1782. But there is no absolutely certain evidence for this date,[1] and we know that Walpole did not see the *plans* for Lee Priory till 1785, and did not visit it till 1788; the earliest outside account of the house is 1790. It seems to me inconceivable that Barrett should have waited three years after his house was built before sending Walpole the plans, if Walpole had recommended the architect. We do know for certain that Wyatt began his work at Salisbury in 1782, and until we get a more definite date for Lee Priory, we must assume that his first experience of Gothic was gained at the expense of Salisbury Cathedral.

From 1780 onwards Wyatt poured out clubs, colleges, mansions, castles, abbeys in an unceasing stream; he was also employed on restoration, and from 1796 onwards he was Surveyor-General of the Board of Works. Obviously no man could accomplish so much unaided, and we must imagine Wyatt, like Rubens, making the first sketch and putting in the finishing touches, but leaving the drudgery to pupils. Even so his output was enormous, and we know that he was a very rapid worker, making many of his drawings in his coach as he rolled across the country from one commission to another. One day in 1813 his coach upset and Wyatt died of the shock. 'And thenceforth', said Eastlake, 'a new era began to dawn for the Gothic Revival.'

This statement is quite clearly untrue and probably Eastlake never supposed that it would be taken literally. He was simply

1. I cannot trace it earlier than Britton, *Architectural Antiquities*, vol. v, 80, who gives no evidence for it.

taking advantage of a rhetorical opening to express conventional contempt for Wyatt. Within twenty years of his death Wyatt had become a recognized Gothic Revival bogy, a position which he has continued to hold, in common with Oliver Cromwell, to the present day. 'All that is vile, cunning and rascally,' said Pugin, 'is included in the term Wyatt.'[1] An arch-devil is necessary to any cult, but now that the Gothic Revival has lost some of its religious character, it is no longer impious to ask whether Wyatt deserves his position.

We have said that soon after 1780 men began to notice that the old Gothic buildings were falling down. Of all those who tried to prop them up, or who rebuilt them, Wyatt's name is familiar to us. Like the great masters of pre-Morellian art-criticism his name shelters work not even done in his lifetime. This is no place to discuss Wyatt's restorations, but if he is worth studying at all the following questions must be answered. First, what cathedrals did he restore? Attacks on Wyatt usually include a list of the buildings he destroyed, but the lists vary, and the attacks are so heavily charged with emotion that they seldom contain evidence or details. Secondly, in those cathedrals which he certainly restored, what exactly did he do?[2] Thirdly, we might study those restorations which he did late in life, when no longer subject to the authority of a cathedral chapter. His work at Henry VII's chapel was as competent and conscientious as any modern restoration. And finally we might remember the classical defence of the devil: that God has written all the books. We do not know Wyatt's side of the story. But we have a letter from Walpole which implies that Wyatt did not approve of the destructions at Salisbury;[3] we have Wyatt's own statement that he deplored the restorations at Durham, and was not responsible for them; and we know

1. *Recollections of A. Welby Pugin*, by B. Ferrey, 80.

2. A sexton at Salisbury once said to me, 'We say that any restoration is by Wyatt, but I know that those [indicating various restorations] were done much later.'

3. Walpole to R. Gough, August 1789.

that he expressed concern that any Gothic building should be destroyed.[1]

These investigations would not leave Wyatt with a stainless character. But if we abandoned the idea that he destroyed for destruction's sake and confined our studies to restoration which we know was done by Wyatt, we might be able to see the real motives of his work.

In Wyatt's time Gothic was considered as essentially picturesque, and he himself was a scenic artist. He believed that Gothic should have a sudden, overwhelming, emotional effect, and that this was best achieved by an unimpeded vista. At Salisbury Cathedral he found that this was prevented by the choir screen and the untidy disposition of the tombs. He therefore removed the screen to a side-chapel and placed the tombs parallel to the nave, between the piers of the nave arches.[2] A screen has since been replaced, and the nave is filled with chairs, so we can no longer judge of the success of Wyatt's plan. Nor can we condemn it *a priori*, though such regular disposition is false to our ideas of Gothic; for these are based on buildings encumbered by the accretions of time. This at least is certain: if we were asked to choose between Wyatt, who altered the internal arrangements of old buildings in order to get a better pictorial effect, and Eastlake's contemporaries, who pulled old buildings down in order to rebuild them in a purer and more correct Gothic, we should not hesitate.

The scenic effect for which Wyatt strove at Salisbury he achieved at Fonthill. That wonderful building concentrated in itself all the Romanticism of the 1790s, and was the epitome of eighteenth-century Gothic. Scarcely a stone of it remains, but I do not think that is to be deplored. Fonthill always appealed primarily to the imagination, was always an Arabian Nights' dream. Contemporaries who saw the huge tower rise in the

1. *Farington Diary*.
2. The wonder is that he did not pull down the choir. Cf. a reference to chancels in the *Gentleman's Magazine* of 1782, 'by such *shapeless* contrivances as these, the perspective is broke and the uniformity destroyed'.

distance, shut in by eight miles of twelve-foot wall, seriously believed that a coach and six could be driven from that tower's base to its summit and down again without inconvenience. That was the way to look at Fonthill; it was a mistake to penetrate the twelve-foot wall, and we may be glad that we know Fonthill chiefly through romantic engravings. We have, however, some more prosaic witnesses – plans, elevations and measurements;[1] and Wyatt's Ashridge,[2] in the same style and on almost the same scale, still stands. From this basis of fact our imagination may take its flight.

Fonthill Abbey originated in a ruin. Ever since he was a boy William Beckford had hated his father's classical mansion. Suitably heavy for the old lord mayor, it was a poor setting for the Ossianic attitudes of his son, who, oppressed by the grosser pomps of humanity, would often plunge into the dark and dripping woods, seeming to himself a kind of Denys de l'Auxerrois, a wild, moonstruck troubadour. Such unusually intense power of self-dramatization required an unusually large and elaborate ruin; and in 1796 Beckford asked Wyatt to design him a ruined convent of which the chapel parlour, dormitory, and part of a cloister alone should have survived. The design, we are told, was elegant, appropriate, and intelligible, but it did not satisfy Beckford's megalomania, and during the next few years a great wing and an octagon tower were added to the plan, though the place was still no more than a monstrous summer-house. Then in 1807 Beckford decided to make the Abbey his permanent residence. The building had been designed for no such purpose, and must have been one of the least convenient houses ever inhabited; it consisted of an octagon tower more than 276 feet high with a hall 120 feet high; from this stretched, north and south, two wings about 400 feet

1. The best accounts are: *Delineations of Fonthill and its Abbey*, by John Rutter, 1823; *Illustrations, Graphic and Literary, of Fonthill Abbey, Wiltshire*, by J. Britton, 1823, and *A Description of Fonthill Abbey*, by James Storer, 1812.

2. Built for the Earl of Bridgewater; begun by Wyatt in 1806 and finished by his nephew, Sir Jeffry Wyatville, between 1813 and 1817. Much of the work must be Wyatville's. Cf. *English Homes*, Period VI, vol. I, 339.

long, and 25 feet broad; the wings to the east and west were of more ordinary proportions, though the western hall was surprising enough.[1] The plan, as has often been pointed out, was not at all Gothic; far from being subordinated to construction and convenience, it had an eccentric symmetry typical of the bored late eighteenth century.[2] 'A closer view', writes Mr Avray Tipping of Ashridge,[3] and his words apply equally to Wyatt's earlier building, 'reveal forms and outlines that are not medieval, but are Georgian bodies dressed up in Plantagenet clothes.' Well, even a distant view of an eighteenth-century classical house reveals forms and outlines not used in ancient Rome, Georgian bodies in togas. The successful borrower of style takes only as much as is effective; and it is no virtue in the later Gothic Revivalists that they borrowed archaeologically, not architecturally, for correctness, not for effect. Fonthill must be judged on its effectiveness.

In so far as we can judge from prints, two faults detracted from the effect of Fonthill: the detail was bad, and it looked insecure. Some idea of the detail may be gained from Ashridge, but the detail of Ashridge is probably better, for during the ten years that separate the two houses, Wyatt had restored King Henry VII's chapel; and he had been employing a number of assistants who travelled all over the country drawing Gothic ornament for him to reproduce. As for its insecurity, Fonthill was, of course, even more insecure than it looked. Historians love to dwell on the speed with which the immense house was built; how whole villages of workmen – often five or six hundred – were encamped round the site; and how not even a hard winter could check Beckford's millionaire impatience, for, by the light of huge bonfires, the work went on all through the freezing nights. No wonder Wyatt could not give the building minute personal attention; no wonder the contractors made no

1. Cf. Plate 5. None of the descriptions gives the actual dimensions of Fonthill, and what figures they do give vary in each description.

2. Compare, for example, the ground-plan of Ickworth, Suffolk, illustrated in *English Homes*, vol. VI, 321.

3. Described ibid., 339.

effort to resist obvious temptations. The full instability of Font-hill was only realized after Beckford had sold it to an eccentric Mr John Farquhar. Beckford was summoned to the death-bed of a man who had been clerk of the works at Fonthill. This man confessed that the solid foundations under the central tower, though specified and paid for, had not been provided. It was a wonder, he said, that the house had stood so long. Beckford immediately informed Mr Farquhar, who replied that the house would probably last his lifetime. He was mistaken. One night in the year 1825 the tower quietly subsided; and little trace of the huge structure now remains.

For this ultimate and total collapse Wyatt is not to blame. But if Fonthill had stood unshaken till today it would always have looked thin and insecure. Wyatt's ignorance of Gothic methods of construction inevitably falsified the general effect, and Fonthill can hardly be considered as more than stage scenery.

As scenery it is superb. All that the eighteenth century de-manded from Gothic – unimpeded perspectives, immense height, the sublime, in short – was present in Fonthill, and present more lavishly, perhaps, than in real medieval buildings. Even we, who pride ourselves on classicism, cannot be quite dead to this sudden outburst of romantic rhetoric. We know very well that the plaster tower is mere trumpery, but its sudden vehemence sweeps away our judgement; as Berlioz may suddenly sweep us away from Haydn, and El Greco's nightmare vision of Toledo seduce our eyes from the judicious Poussin.

To those who think of Wyatt as the Destroyer, the imagina-tive power displayed in Fonthill is a puzzle. How could the mere fashionable architect who defaced Durham and hob-nobbed with George III at Windsor conceive that enchanted structure? And the answer, they say, lies in Wyatt's patron; for Fonthill immediately suggests the dark glamorous figure of William Beckford.

Restless, half-sincere charlatans, like d'Annunzio, have an

undying attraction for those whose daydreams need stimulating; and myth always gathers round very rich men. Beckford has both appeals, and it is not surprising that fascinated historians have made him an influence on the Gothic Revival. This suggestion was made in Beckford's day, and was not well received. 'No,' he said, 'I have enough sins to answer for without having that laid to my charge.' The answer is typical. Beckford, of course, could not have designed Fonthill if he had tried. He had no special knowledge of architecture, and his only influence on the construction of Fonthill was to menace its stability by his impatience. I cannot even find evidence that Beckford was unusually interested in medieval art. His collection contained some fine fifteenth-century pictures; but Mantegna and Bellini are not medieval in spirit, and before Beckford's time collectors were already buying the truly medieval pictures of the fourteenth century. Not only were these special students like the Frenchmen d'Agincourt and de Montor. A casual collector like that eighteenth-century eccentric, Frederick Harvey, the Earl-Bishop, was buying the works of 'Cimabue, Giotto Guido da Siena, Marco da Siena and all that old pedantry of painting which seemed to show the progress of art at its resurrection',[1] before Beckford's time. Beckford's correspondence with the unfortunates who were commissioned to buy books and pictures for him contains an occasional reference to manuscripts and early printed books; but Johnson had ridiculed collectors of black-letter fifty years before;[2] and for the most part Beckford's taste was that of his time, though his wide knowledge and sensibility are rare in any age.

Beckford built Fonthill almost fifty years after Horace Wal-

1. Cf. *English Homes*, Period VI, vol. I, 333. Nor was Harvey by any means the first Englishman to collect primitives. Artaud de Montor, in describing his collection of *trecento* and early *quattrocento* pictures, says that many of them once formed the collection of an Englishman in Florence, who had collected them over sixty years earlier. As de Montor published his description in 1808, his shadowy Englishman must have been buying about the time that Walpole was in Florence.

2. *Rambler*, 177, for 26 November 1751.

pole had bought Strawberry; and naturally his feeling for Gothic shows an advance on that of his predecessor. He no longer thinks of it as a form of Rococo; he is Romantic all through, whereas Walpole had an Augustan core; and instead of Walpole's old-maidish pedantry, he had a fearless imagination. Beckford despised Walpole and called Strawberry Hill 'a Gothic mouse-trap'. But, perhaps from his very limitations, Walpole had the more sustained and genuine interest in medieval art. Before he built Fonthill, Beckford had satisfied his imagination in Oriental rooms; and after he had sold the place and retired to Bath, he built himself another fantastic habitation, but this time in the classical style.[1] Such changes show that Beckford was no convinced medievalist, they suggest rather that he adopted Gothic as the most effective Romantic setting, as a form of exoticism to satisfy his dramatic sense, as an eccentricity to ease his pride.

If Beckford is to have a place in the Gothic Revival it is as the patron of Wyatt. He is a more interesting man than Mr Barrett of Lee Priory, or than the Earl of Bridgewater, but his importance in the revival is only greater than theirs because, by involving Fonthill in mystery, he made it a brilliant advertisement for the Gothic style.[2]

1. Lansdown Tower. 'Classical' simply as distinct from 'Gothic' or Oriental. The interior decorations of Lansdown Tower were what we should call Victorian.

2. This chapter should have been brought to a less dramatic close with a page about Thomas Rickman. I have already alluded to his archaeology; his romanticism may be seen in the new buildings of St John's College, Cambridge, designed in 1827. Although fundamentally in the manner of Ashridge, they are considerably more learned. Cf. Marcus Whiffen in the *Architectural Review*, vol. XCVIII (December 1945), 160.

Chapter 5

Churches

Fonthill and Windsor spring from an impulse similar to that which produced Napoleonic classicism, the idealization of a past way of life. But the Gothic Revival did not long preserve its first buoyant Romanticism; it was soon to be ashamed of its careless, extravagant youth. For the stream in which Walpole dabbled and Beckford splashed so exuberantly was to wash away the sins of the English Church. When Gothic was applied to ecclesiastical architecture, the change from a vaguely romantic mood to a specifically religious mood had begun.

Although many Gothic restorations were carried out in the eighteenth century, few whole churches were built in that style. In 1753 Walpole noticed Sanderson Miller's church at Wroxton 'new, but in a pretty Gothic taste, with a very long window of painted glass, very tolerable'.[1] The tower was in a good Gothic, plain and solid, as Miller's first tower, Walpole was glad to say, had fallen down. There is the beautiful Gothic church at Hartwell, built between 1753 and 1755; and in 1754 the parishioners of Tetbury decided to pull down their incommodious church and erect another 'in the most regular and elegant Gothic taste'. The work was entrusted to Francis Hiorne, one of a family of Warwick builders who had carried out Sanderson Miller's designs, and perhaps it was from Miller that Hiorne had learnt the Gothic. Tetbury was begun in 1777; it is not devoid of a certain distinction, and is typical of ecclesiastical Gothic for the next fifty years. In eighteenth-century translation a Gothic church became very slim, very elegant, and extremely insecure. We feel that Tetbury would collapse at

1. W. to Chute, 4 August 1753.

a push. At the time it was admired, and Hiorne was employed on other Gothic churches, though I can only trace one of them – Stony Stratford, which was the subject of Carter's lurid abuse in 1800.[1] In 1780 he sent in designs for the nave of St Nicholas' Church, Warwick, which were rejected, 'though far superior to those chosen'.[2] Of the successful designer of St Nicholas, Job Collins, almost nothing is known, and of the builder of the earlier and better tower (1750) not even a Christian name has survived. Finally, I may mention East Grinstead parish church, of which the tower (1789) is solidly and traditionally Gothic, and even the nave (1800) less flimsy than usual.[3]

These churches by little-known builders suggest that there may be other examples of eighteenth-century Gothic.[4] Probably my list could be doubled, but it would still be short; and if we take a period extending to 1820, the proportion of new Gothic churches to Gothic mansions and villas would be very small indeed. There are many obvious reasons why the Gothic style is more suited to churches than to any other branch of architecture; and anyone who has thought of the matter must have been surprised to find that until 1820 the Revival was practically confined to private houses. But the fact is easily explained. For one thing admiration for Gothic was common only among the upper classes. They alone had leisure to cultivate a new taste and indulge the dramatic sense; and they built Gothic as a parvenu buys family portraits – to suggest that their pedigree stretched to remote antiquity. But the parishioners who decided on the style of new churches were moved by no

1. *Gentleman's Magazine*, 1800.
2. Cf. Field's *History of Warwick*, 131. Those chosen were not, as stated in the next sentence, by Job Collins, but as Mr Colvin informs me, by Thomas Johnson (1949).
3. As a matter of fact the tower of East Grinstead was designed by James Wyatt. A Gothic tower is obviously much easier for uninstructed workmen to build than a Gothic nave. The towers of seventeenth-century churches are perfectly sound Gothic, and in the eighteenth century Gothic towers are solid and convincing when tracery and vaulting are still absurd.
4. There were many more than I supposed, cf. H. M. Colvin, *Gothic Survival and Gothick Revival* in *Architectural Review*, vol. CIII (March 1948), 91.

cultural or snobbish motives. On the rare occasions that they chose Gothic they did so from conservatism. The old church was too small, as at Tetbury, or was burnt down, as at East Grinstead; and the parishioners wanted a new one which would remind them as far as possible of the old. They seem to have associated Gothic far more with the decorative forms than with the shapes and arrangements of the old churches. It was pointed arches and tracery that they wanted, not chancels and side-aisles; and the churches I have mentioned are weirdly unorthodox in plan.[1] But though quite untraditional in construction, they were old-fashioned, not forerunners of a new craze. The only ecclesiastical buildings in which Gothic was used consciously as something new and suitable, were the private chapels of great country houses. Before 1820 if a vestry meeting wished to show enlightenment it suggested the Grecian style, and this resolution was supported by the architect employed, who could easily make a fine show in Grecian, whereas Gothic was notoriously troublesome. The coincidence of the Greek and Gothic revivals may be taken as another reason for the scarcity of Gothic churches at that date.

But undoubtedly the chief reason why so few Gothic churches were built between 1760 and 1820 is that very few important churches of any kind were built during that period.

In the Middle Ages the country had been overstocked with churches, and the increase in the rural population during the seventeenth and eighteenth centuries was not so great as to demand much new building. This is not true of the towns; London had been admittedly in want of churches at the very beginning of the eighteenth century, and fifty were to have been built there in Queen Anne's reign. 'A most Heathenish sight,' said Sir Roger, looking towards the west end of London, 'there is no Religion at that end of the Town. The fifty new

1. None of them has a chancel, St Nicholas is practically square and Tetbury is built like a theatre, the false aisles being flanked by an external passage (north, south, and west) which gives access to the inner pews in each bay through separate doors.

Churches will very much mend the Prospect; but Church-work is slow, Church-work is slow!'[1] It was. Few of the churches were ever erected. Between 1760 and 1820, a period in which the urban population grew very rapidly, only twelve churches were built in London, and the new towns of the north were even worse off. In an age in which the upper classes regarded religion as a collateral security, and the more fervid of the lower classes belonged to dissenting sects, money for new churches had been hard to find. But during the unrest which followed the Napoleonic wars the Government came to connect godlessness and revolution. Fear of Jacobinism made churches seem of real value. Moreover, there had grown up a powerful, church-going middle class, of which the most godly members, the Saints, had a widespread influence. In 1818 there appeared the Church Building Society, and the extraordinary success of this pious enterprise shamed the Government into action. A Bill was passed which granted a million pounds to be spent on building churches in populous districts, and from 1818 to 1833 it is calculated that at least six millions were spent on church building.

Two hundred and fourteen churches were erected as a result of the Church Building Act (1818); and of these a hundred and seventy-four were in a style then described as Gothic, and which it is perhaps impossible to classify in any other manner. Most of them had pointed arches, and the pointed arch is, at this period, the only workable distinction between Gothic and the other styles. But these figures are misleading; they suggest an admiration for medieval architecture which the Commissioners did not feel. Their motive was economy. A Minute had been circulated among prominent architects, asking them to suggest 'The most economical mode of building churches, with a view to accommodating the greatest number of persons at the smallest expense, within the compass of an ordinary voice.' The results of this questionnaire were favourable to Gothic for it was agreed that the cheapest medium was brick.

1. *Spectator*, 383.

'No greater quantity of stone should be used,' wrote Sir John Soane, 'than is required to assist their [the churches] construction';[1] and in the classical style a great deal of unnecessary stone was used on porticoes and pediments. So the Commissioners advised Gothic; and the Church Building Society suggested how the style should be employed. The pillars of the gallery were best made of cast iron,[2] though in large churches this might want grandeur; ornament was to be neat and simple, yet venerable; and if there were a vault or crypt, it should be designed to hold coal or the parish fire engine. These are very sensible suggestions. Clearly a considerable change has overtaken the Gothic Revival. Examined in the light of Sir Henry Wotton's three conditions, Fonthill Abbey wanted commodity. The Commissioners' churches wanted delight. Both were deficient in firmness; but whereas the fall of Fonthill was a calamity, few of us can regret the frequent collapse of early nineteenth-century church architecture.

All the leading architects of the time sent designs to the Commissioners. Nash and Smirke sent four each; and even Soane did a large drawing in which a Classical church stands flanked by churches in medieval styles, one Gothic the other a weird Soanite Norman, so that the Commissioners might take their choice. But very few of the designs executed and now standing deserve individual mention. The most important, perhaps, and the most accessible to Londoners, is St Luke's, Chelsea, by J. Savage, designed in 1819 and completed in 1824. St Luke's is a large church, very tall and thin, and with a stone groined roof, the first, it is said, of the Revival. It was much praised in cultivated circles, and even now there is something distinguished in its slim tower, something almost exciting in its perverse flying buttresses. But the building suffers from that meagreness of construction which we notice at Tetbury, and

1. *The Life and Work of Sir John Soane* by Arthur T. Bolton.
2. Soane also recommended this (ibid.), adding: 'If it be suggested that the use of Iron alone has not sufficient character and appearance of Stability, it may be enclosed in the manner best adapted to prevent obstruction.'

which gives a cardboard look to almost all the Gothic churches of the time; nor is the detail any less mean than was usual. The *Gentleman's Magazine* praised St Luke's unrestrainedly; but regretted that the style chosen was eclectic perpendicular, when Early English was both purer and more national.[1] At the time Early English churches were less popular than perpendicular, but they exceeded them in quality, and Theale, by E. Garbett,[2] is probably the solidest and most satisfactory church of the whole period. Only one other group of buildings is worth mentioning, Barry's four Gothic churches. One of these, St Peter's, Brighton, is in the 'middle pointed style', the rest, all in Islington, were of the usual perpendicular. Despite their plaster ceilings and 'strange Commissioners' ritualisms', Gilbert Scott found them wonderfully advanced works, and doubted if anything so good was done (except by Pugin) for ten years later.[3] But we could hardly guess that they were by a good architect and the designer of the Houses of Parliament.

By 1830 Gothic had been widely applied to ecclesiastical architecture, and the results seem to us very bad. They seemed disappointing even to contemporaries, and the new Gothic churches were severely criticized. 'Mere carpenter's Gothic', 'pure Batty Langley' – these terms are to be found in most volumes of the *Gentleman's Magazine*; and sometimes criticism was more explicitly abusive. Pugin could have added little to this attack on Somers Town Chapel, St Pancras.[4] 'The win-

1. March 1826, 201. St Luke's is the subject of a frontispiece and a leading article.

2. It was built in 1826–8 (cf. *Quarterly* for 1828) and has been called the earliest Early English church of the Revival. Early English was a favourite style for chapels before that date, e.g. St George's, Battersea, by Blore, and Downside Old Chapel, by H. E. Goodrich, which Pugin called 'extraordinarily good for the date'. Later Early English churches are Southborough, Kent, by D. Burton, 1830, and St Michael's, Bath, by G. P. Manners, 1835.

3. Barry's churches were building between 1826 and 1830. A list of churches built at the time is given in Eastlake, op. cit., 374. It is incomplete and badly selected.

4. *Gentleman's Magazine*, 1827, ii, 393.

dows, being destitute of tracery, remind the spectator of the "Gothic and Chinese designs" which may be seen in many a tea garden and summer house in the environs of this building.' And he would have approved the criticism that a would-be thirteenth-century church is almost square in plan and that the ribs of the vaulting were obviously not strong enough to support the roof. In ecclesiastical architecture intelligent opinion was certainly in advance of practice, a state of things which did not hold when Gothic was applied to private houses; and it is remarkable that an ecclesiastical style was more successful in lay buildings than in churches. One reason for this was obvious: churches had usually to be built from limited funds, whereas a Beckford or a Bridgewater could be as lavish as he chose. The majority of the Commissioners' churches cost £4,000 or £5,000; even St Luke's, with that extravagant stone roof, cost £40,000; and Beckford is said to have spent over half a million on Fonthill. Yet this is not the whole reason, for a simple church can be both cheap and effective, and none of the Commissioners' churches is that. The reason is that architects knew what was needed for a Gothic mansion and did not know what was needed for a Gothic church. A Gothic mansion was an eighteenth-century country house with just enough of the scenic elements of Gothic – pointed arches, battlements, and towers – to convince the owner that he lived in an ancestral home. There were no medieval mansions; the Gothic mansion was an eighteenth-century form, which grew out of the romantic demands of its eighteenth-century owner. Whereas there were a great many medieval churches; the Gothic church was a medieval form and grew out of the religious demands of the Middle Ages. The absence of old models for country houses left the architect free to adapt Gothic according to the needs of his time; but the large number of models for Gothic churches was most embarrassing; for religious needs had changed. Like it or not, these old churches proclaimed a popish origin. Every niche, every screen, every chancel spoke of a time when the English Church was steeped

in error, and arrangements which delighted antiquarian eyes were, if viewed correctly, none other than the sinister machinery of Rome.

Eastlake, speaking of 'the vulgar superstition which then, and long afterwards, identified the pointed arch with the tenets of Rome', implies that it accounts for Gothic being seldom used for ecclesiastical architecture before 1820. We have seen that this idea can have little foundation, because for a time no churches of any kind were built, and when churches were built again the majority were Gothic. In Eastlake's time this Romanist taint was far more dangerous, and he is simply endowing the previous age with a current prejudice. But since the connexion between Rome and Gothic architecture did have a certain influence, even on the Commissioners' churches, and since it soon afterwards changed the whole course of the Gothic Revival, we must examine its origins and its earliest developments.

Amusing pictures of the eighteenth-century church have been a familiar resource to historians of that period. The worldly, free-thinking clergy have been treated with suitable irony, and grave writers have found witty things to say on this subject. The picture has often been overdrawn. Travellers in the eighteenth century need not leave the highways of its literature – Boswell's *Life of Johnson*, for instance – to discover a body of respected and respectable clergy whose religion was something more than the dry bones of morality, and whose seriousness is often alarming. But even supporters of the eighteenth-century church (and it has received generous support from unexpected quarters) agree in stressing one weakness: its dread of spiritual excitement and of its display. This attitude has been illustrated by the history of the word [1]*enthu-*

1. The word first appeared in print in 1608. It then had a meaning akin to 'possession', well illustrated in Hobbes's *Leviathan*, 56. 'Sometimes in the insignificant speeches of madmen, supposed to be possessed with a divine Spirit which Possession they called Enthusiasm.' It preserved the taint of its origin till the end of the eighteenth century, when it still meant something akin to our *hysteria*.

siasm, and though the illustration is unfair, it is valuable for our present purpose.

'If ever Christianity be exterminated it will be by Enthusiasm.' We may take these words of Henry More, the platonist, as representative of an attitude which was preserved till a much later date, and of which there is evidence in the eighteenth century. In 1752 Bishop Lavington published his famous treatise on the subject, *The Enthusiasm of Methodists and Papists Considered*, and in 1766 Walpole found his enjoyment of Wesley's dramatic gifts marred by the preacher's 'very ugly enthusiasm'.[1] Throughout the century 'Prosperity to the establishment and confusion to enthusiasm', was a favourite toast of the orthodox clergy; and the French Revolution extended the word's meaning from a religious to a political sphere. In 1806 the Earl of Westmorland, speaking in the House of Lords, gave solemn warning against 'Atheists, enthusiasts, Jacobins and such description of persons'. In short it was as easy to be called an Enthusiast in 1800 as it had been to be called a 'saint' two hundred years earlier; and to the orthodox, enthusiasm seemed as subversive – as dangerous to religion, to the constitution, to society – as Puritanism had seemed to Archbishop Whitgift. In its infancy the Gothic Revival was disfigured by a faint blush of enthusiasm. Early romantic literature, like Ossian, displayed a kind of dangerous exaltation, and Warton actually wrote a poem called *The Enthusiast*. Admirers of the Picturesque, above all, seem to have lived in a continual ecstasy, and spoke of scenery in language which even we might consider too enthusiastic. Now a Gothic cathedral produced the same sublime sensations as horrid rocks and savage prospects; but with it the sublime took on a special colour. 'Let any impartial observer', writes a correspondent in the *Gentleman's Magazine* for November 1785, 'seriously contemplate on the view of some of our distinguished cathedrals, and tell me if it affects him not with a kind of reverential awe which throws the mind into a solemn and religious state,' and after an apologetic reference

1. *Letters*, VII, 50.

to Gothic sculpture, he adds, 'I speak here only of the Gothic taste in smaller objects; their noble and stupendous works of architecture I shall always admire and even acknowledge my-self an enthusiast.' When such unwholesome emotions and such a distressing word were associated with religion, we can-not blame the more prosaic members of the Church for their alarm. Gothic architecture not only provoked religious en-thusiasm, but excited it in a particularly dangerous form. We have seen how Walpole stressed the popish element in Gothic, saying that Gothic churches infuse superstition, Grecian ad-miration. As the Revival progressed, this sense of the super-stitious, popish element in Gothic grew more widespread and predominant. On the Continent the new taste for medieval art and literature was immediately connected with a Roman Catholic revival; and the connexion was sealed by Chateau-briand's *Génie du Christianisme*. In England this dangerous element in Gothic took shape in the opinions of its most learned living apologist, Bishop Milner.

John Milner is an important figure in the Gothic Revival. He was a Roman Catholic, and during the Revolution he estab-lished at Winchester a convent of Benedictine nuns who had fled from Brussels. He later became bishop of Castabala and vicar apostolic to the western district of England. In 1792, during his stay at Winchester, he built the chapel which is usually considered the first instance of Gothic applied to ecclesiastical architecture during the Revival, and which is certainly the first chapel built in that style from what we may call Gothic Revival motives.

Instead [says Milner] of following the modern style of building churches and chapels, which are generally square chambers, with small sashed windows, and fashionable decorations hardly to be distin-guished, when the altars and benches are removed, from common assembly-rooms, it was concluded upon to imitate the models in this kind which have been left us by our religious ancestors, who applied themselves with such ardour and unrivalled success to the cultivation and perfection of ecclesiastical architecture. If the present chapel of St

Peter really has the effect of producing a certain degree of those pleasing and awful sensations which many persons say they feel on entering into it, the merit is entirely due to the inventors of the Gothic style of building.[1]

The chapel was designed by Carter, after a sketch by Milner, and is thus the work of the two most learned students of Gothic architecture then living. The manner in which they followed the letter of medieval art and their curious interpretation of its spirit may be gauged from Milner's charming account in his *History of Winchester*.

The altar-piece is enclosed in a Gothic cinque foil arch, supported by double pillars and flanked with elegant buttresses, which are surmounted with pinnacles that terminate in pomegranates. The canopy of the arch, springing from the said buttresses, tapers up to the crown of the vaulting, where it ends in a lily. In the open space, between the top of the arch and the point of the canopy, immediately over the head of our Saviour in the altar-piece, is a quatre-foil inscribed in a circle, containing a transparent painting upon glass of a Dove, which, by means of a light that is let in upon it from behind, produces a surprising and pleasing effect.[2]

I have quoted this passage at length because it is typical of Milner's splendid enthusiasm. Every detail is described with equal zest: the tabernacle ('as it is now exclusively called'), which was peculiarly rich and elaborate, being a model of the west end of York Minster; the doors, also rich, with elaborate Gothic carving, and their canopies supported by gilt cherubs; even the ground glass of the windows, which, most ingeniously, 'admits the light, but prevents any object being seen through them'. Rich, elegant, gorgeous, Gothic, gilt – they occur again and again, till the reader is overwhelmed with a surfeit of magnificence.

Unfortunately St Peter's Chapel still stands.[3] The gilt

1. *The History of Winchester* by John Milner (1798), II, 230.
2. ibid., 235.
3. Or stood when these words were being written.

cherubs are a little tarnished, and the mouldings – 'of a straw colour, while the body of the church is of a French cast' – have grown rather dirty. But otherwise it is exactly as Milner left it, and it cannot but increase our admiration for his idealism. He himself, so dazzled by the religious aims of the building, the glory of the Transfiguration, or the saintly virtues of St Peter, was no doubt sincerely moved by its beauties. We, who have no such advantages, may fail to experience the pleasing and awful sensations which the chapel was designed to impart. The luminous Dove, it is true, has not ceased to surprise; but the all-pervading shabbiness of the general effect is familiar. This small room may once have been tawdry; it is only squalid now. Thus far Carter and Milner may be said to have succeeded; their Gothic is not at all like the cheery Rococo Gothic of the eighteenth century, with its conscious artificiality and its unexpected charm. Theirs is the grubby Gothic of the Commissioners' churches, perhaps the most completely unattractive architectural style ever employed.[1]

Had this chapel been Milner's only contribution to the Revival, his influence might not have been great. But Milner's religion naturally led him to dwell on the Roman Catholic origin of Gothic, and the manner in which it expresses a Catholic purpose. And his most important writings on Gothic architecture are included in his *History of Winchester*, a work which leaves one in no doubt as to the author's religious opinions.

Nowadays we are accustomed to Catholic historians. We can support attacks on Henry VIII, we are prepared to believe that Elizabeth's persecutions were as cruel as her sister's, and we are not greatly concerned for the good name of Bishop Hoadley. Milner's *History* is less extreme than many. But to the orthodox clergy of 1800 it was terrible.

1. The squalor of Bishop Milner's chapel is understandable; but it is surprising that Carter could include gilt cherubs' heads, sham groining, and painted marbling in his ideal Gothic chapel. When we remember his actual practice, the theories propounded in his *Letters on Architectural Innovation* lose some of their weight.

I was surprised [said the Rev. John Sturgis in an open letter published in 1799], I was surprised and concerned when you first mentioned to me the extraordinary manner in which political and religious opinions were treated, and characters entitled to our affection and respect misrepresented in Mr Milner's *History of Winchester*, lately published. . . . For in fact, it is made so much the vehicle of an Apology for Popery and a Satire on the Reformed Religion in general, especially that of the Church of England, that this seems to have been the object predominant in the Author's mind.[1]

The Rev. Sturgis was not alone in his protest. Milner's *History* was widely read and ran into at least ten editions. In some of these the more controversial statements were expunged, but the tone of the book could not be altered, and most reviewers treated Milner as a popish wolf in the clothing of an antiquarian sheep.[2]

Gothic architecture excited religious enthusiasm, and its undeniable connexion with popery was emphasized in the works of Milner. Yet when churches like St Luke's were built, no one protested. This was partly because the Commission was known to be innocent of Roman Catholic intentions – to be, in fact, strongly influenced by the evangelicals; and partly because Commissioners' Gothic did not display the features which spoke most clearly of Rome. Some of these features were omitted by accident, the architect simply not knowing that they were usual in a Gothic church. Economy, too, was a great bulwark of protestantism. A small book of advice to church builders published at the time suggests many ways in which the cost of church architecture might be reduced, mentioning a portable font (14s.), which might be placed on the altar to save the price of a stand, and a set of sacramental plate in Britannia metal (£3 19s.). Clearly there was no room for

1. *Reflections on Popery, occasioned by Rev. John Milner's History of Winchester* by John Sturgis, LL.D., 1799.

2. E.g. *Quarterly*, III, 363. Sturgis's letter is one of many tracts, attacking, defending, counter-attacking, and ending with an inevitable victory for Roman Catholic dialectic. The controversy may be studied in the *Gentleman's Magazine*, LXIX and LXX *passim*.

superfluous and superstitious symbolism in the Commissioners' churches.

But sometimes the Catholic features of Gothic architecture were omitted intentionally. Barry's son has left us a clear apology for the 'strange Commissioners' ritualisms' noted by Gilbert Scott in Barry's churches. His father, he says,

felt strongly that the forms of medieval art, beautiful as they are, did not always adapt themselves thoroughly to the needs of a service which is essentially one of 'Common Prayer'. Deep chancels, high rood screens, and (in less degree) pillared aisles, seemed to him to belong to the worship and institutions of the past rather than the present. [And these he would have put aside] even at the cost of sacrificing features beautiful in themselves, and perhaps interfering with the dim religious light of impressiveness and solemnity.

Barry's views were shared by most of his contemporaries. The passive orthodox and the active evangelicals joined in condemning Catholic arrangements and Catholic superfluity. Indeed Barry's position seems to me unassailable; the arrangements to which he objected were anachronisms, for the sole need of a protestant church was that all could see and all could hear. The difficulty lay in the application of Gothic to this new ideal of a preaching house. The constructive elements of Gothic were intended for a special plan – pillared aisles, a vaulted roof, and so forth – and decorative elements were so wedded to the constructive that a divorce was dangerous. The ideal protestant church was a square box, and the Gothic style was not suitable to a box. If the box were shallow, Gothic lost its 'soaring' character; if it were tall, the building looked flimsy, with side-aisles and transepts to support it. In either case a vaulted or a high-pitched roof was impossible, and the whole aim of Gothic construction was lost. Similarly, chancels were a most valuable architectural feature in a Gothic church, for they broke a monotonous line and gave the architect an opportunity of striking a happy proportion of masses. By throwing over traditional arrangements, Barry and his contemporaries gave themselves an almost insoluble architectural

H

problem. This problem had arisen in the fifteenth century and had been partially solved by brilliant workmanship; but even so King's College Chapel is not completely successful and would be less so if it were a church and stood alone.[1] The architects of 1820, without trained workmen and without a 'royal saint', were not likely to succeed.

It would be unwise to describe these churches. Even if we did so by an accumulation of contemptuous adjectives, our language could never be as rich in abuse as that of Pugin and the Ecclesiologists. For these poor shoddy buildings were not only contemptible as architecture; they were uncanonical in arrangement, and however strongly we may feel about bad architecture, our aesthetic indignation cannot compare with religious fervour. As the subject of rhetoric, ugliness pales before heresy. The chief importance of the Commissioners' churches lies in the reaction they provoked, in the wild sparks they shook from Pugin's burning brain, and in the Camden Society's grave call to rubrical exactness.

1. I forget now (1949) why I thought it grand to be so critical of King's College Chapel.

Chapter 6

The Houses of Parliament

On the night of 16 October 1834 the citizens of London were treated to a magnificent spectacle. The Old Palace at Westminster was irrecoverably in flames. After the usual bewilderment a parliamentary committee was appointed to consider the question of rebuilding; and in the following June they announced a competition for a new design. The site was to be that of the Old Palace; the style Gothic or Elizabethan. It was just over two hundred years since a similar body had decided to rebuild old St Paul's in the Classical style.

The most important public building in England was to be Gothic. Obviously this decision is a central point in the early history of the Revival; and it is worth pausing to see what motives influenced the committee in their choice, and how Gothic stood armed for the battle of styles which this decision inevitably provoked.

The chapter which I have called Romanticism and Archaeology took a survey of Gothic forces down to about 1820, and during the next fifteen years the general appreciation of Gothic followed the same lines, save that it expanded with the expansion of society. The only new development, church architecture, we have just examined. Romantic literature was still a strong influence. Sir Walter Scott was at the height of his popularity, and the knowledge that he himself lived in a modern Gothic building, that the author of *Ivanhoe* found Abbotsford[1] sufficiently romantic, may have predisposed his readers to their Gothic villas. Medieval antiquities, too, were as popular as ever; dispute still raged round the origin of the

1. Built by William Atkinson in 1812; he also designed Scone Palace.

pointed arch; and the public thirst for steel engravings of cathedrals seems to have been unquenchable. Britton's enterprise had provoked many rivals – Blore, Cottingham, and the like – but there seems to have been room for them all, and room for a whole series of handbooks in imitation of Rickman, giving the dates and character of the chief Gothic styles.

Moreover, interest in medieval art was no longer confined to Gothic architecture. Fifty years before the burning of Parliament, d'Agincourt had begun his *History of Art*, in which, for the first time, painting in the centuries before Raphael was given a prominent place; and during the intervening period a study which may have originated as an offshoot of the new historical consciousness had begun to change men's vision. Dr Montor did not collect his fourteenth-century paintings[1] purely as historical curiosities, and Ottley published his 'Giotto' drawings as works of art.[2] Very few books on the subject appeared, but slowly, unconsciously, the sensitive minority imposed its vision on the apathetic mass, so that in 1836 a select committee on Arts and the connexion with Manufactures could report that the pictures sought for in our National Collections should be those of the period antecedent to Raphael, 'such works being of a purer and more elevated style than the eminent works of the Caracci'.[3]

As these interests became more widespread, Gothic architecture became more democratic. Of course Gothic villas were built during the eighteenth century. Milner refers to those 'in the neighbourhood of the metropolis, where our citizens are accustomed to term every architectural whim which is not reducible to any order or rule whatsoever the Gothick style'.[4] But since Walpole had brought it into good society, Gothic had become rather a snobbish style, a style that loved a title. This period of social success culminated in 1830, when the

1. First published 1808; republished in 1811, 1825, and, with illustrations, 1843.

2. In his *Italian School of Design*, published in parts 1808–23.

3. Quoted from the *Architectural Magazine* for 1836, 546.

4. *Gentleman's Magazine*, May 1802.

works at Windsor were completed. By that time most of the ducal castles, in which the medieval style could be used, had been restored or rebuilt, and though a few Gothic mansions were erected after that date,[1] the works most typical of the revival are to be found in the vast, irregular army of villas.

The fashion for Gothic villas, like the fashion for the picturesque of which it is really a part, did not spring solely from a literary or a snobbish impulse. However much we prefer simplicity to over-elaboration, we must admit that the average non-Gothic villa built between 1800 and 1820 is rather too plain. Partly because extreme simplicity was (and still is) supposed to be beyond any charge of vulgarity, and partly for economic reasons, the villa of the time was reduced to a box, often undecorated by the simplest moulding. And as the medieval mansion was part of a reaction against Palladian formalism, the picturesque villa was a reaction against the meat-safe style of Aikin, Gandy, and Laing.[2] The starved eye turned to glut itself on gables, and individual taste, so long repressed, could cut a dash in the Gothic style.

This second appeal, which Milner noticed, was skilfully used by the architects of the time.

In this age [wrote Goodwin in 1835], when classic architecture is so universally understood, whoever, thinking for himself, determines to build in the old English style, may be pronounced a person of independent notions, superior to prejudice, and by inference a man of taste. Notwithstanding the predilection for the classic or Italian style, he adopts that which poets and painters have always admired.[3]

We know the results of this craving for individuality. It has

1. Among the most important are Canford Manor, partly rebuilt by Blore, 1832–6, and the greater part by Barry, 1848. Dunrobbin Castle (for the Duke of Sutherland), designs by Barry, 1844–8.

2. *Designs for Villas* by Edmund Aikin, 1808, one of the severest collections. *Designs for Cottages or Rural Buildings*, by Joseph Gandy, 1805. *Hints for Dwellings, consisting of Original Designs for Cottages, Farm-houses, Villas, etc.*, by David Laing, 1800, also contains some very plain designs, and none approaching Gothic.

3. *Rural Architects* by Francis Goodwin, 1835, No. 12.

survived into our own day, and is still satisfied by huge gables, gibbous windows, and crockets blossoming in strange places. For different reasons Gothic was considered suitable for parsonage houses.

The practice of designing the residence of a clergyman with reference to the characteristics of the church to which it belongs, is desirable, not only as relates to a tasteful advantage, but as it becomes another and visible link of connexion between the church itself and the pastor who was devoted to its duties; and also leads the spectator very naturally from contemplating the dwelling to regard the pious character of its inhabitant.[1]

Country clergymen were already keen students of Gothic archaeology; many were cleaning and restoring their churches, and a few, like Tennyson's father, carried their enthusiasm into their homes, and adorned the rectory with Gothic detail.[2]

The demand for small houses in this style can be shown by a single instance – the works of Mr P. F. Robinson. In 1822 he published a book of designs for rural architecture containing ninety-six plates of houses, almost all in a sort of Gothic. A second edition of this work was published in 1826, a third in 1828, a fourth in 1836. Meanwhile Robinson published *Designs for Ornamental Villas* (1827), *Village Architecture* (1830), and *Designs for Farm Buildings* (1830), some of which went into second editions. Robinson deserved his success. He was, perhaps, too fond of elaborate bargeboards and curling chimneys; and sometimes his antiquarian taste led him to inconveniences, such as the chairs and tables of his Norman villa with their dogtooth moulding. But he had a real sense of the picturesque, and his designs would have been scarcely distinguishable from genuine Tudor buildings had they been built by good craftsmen.

Unfortunately we can assume that they were not. In studying the many books of designs for Gothic villas published

1. *Rural Residences* by J. P. Papworth, 45. See also Goodwin, No. 6.
2. The dining-room at Somerby was very thoroughly gothicized about 1820. Cf. *Tennyson* by Harold Nicolson, 38, 39.

during those years,[1] we must always imagine the finished building considerably less attractive than the drawings. For by 1825 almost all Gothic mouldings or ornament could be bought wholesale. Since Walpole ordered his garden gates in lithodipra many wonderful new processes had been invented.

There is scarcely an ornament or a necessary part [wrote a contributor to the *Gentleman's Magazine* in 1818] but what might be cast at our iron foundries; even to the highest wrought filigree Gothic; and as nearly all the tracery and ornaments in this style are produced by a repetition of a few simple parts, the plan would be found perfectly practicable. As lightness and elegance are the leading and most desirable characters in this class of building, these might be carried to a much higher degree of perfection than they ever were capable of with so fragile and destructible a material as stone ... and the ironwork ornaments, being covered over with an anti-corrosive of stone-colour, would be rendered indestructible for ages.[2]

The 'conductor' of the *Architectural Magazine*[3] was as enthusiastic in praise of Mr Austin's Artificial Stone. His Gothic ornaments, if supplemented with those of Mr Bielfield[4] in papier-mâché, provided a selection of Gothic detail in which the most fastidious might find something to his taste. Were they not copied from the most approved specimens? and, as Dallaway had said, 'A happy imitation is of much more value than a defective original.'[5] The Gothic villa of 1830 was solider, perhaps more Gothic, than the silly summer-houses of the preceding century. But though there was little to be said for Rococo Gothic as architecture, it was not utterly unsuitable to its ephemeral purposes. When the paint was fresh Vauxhall

1. After Robinson's books the following are the best: Papworth's *Rural Residence*, 1818, Goodwin's *Domestic Architecture*, 1833, and *Rural Architecture* (a sort of reissue of the Domestic), 1835, Brooks's *Cottage and Village Architecture*, n.d., c. 1835–40, and Brown's *Domestic Architecture*, 1841.

2. *Gentleman's Magazine*, 1818, 507.

3. *Architectural Magazine*, 1885, 123.

4. Mr Bielfield was responsible for the Gothic enrichments of the temporary House of Lords after the fire; cf. his work, *On the Use of Improved Papier-mâché*, 1840.

5. Dallaway, *Anecdotes on the Arts in England*.

must have been rather gay; whereas a villa in the Norman style can never have been pleasant.[1]

The pleasantest buildings which Gothic produced from 1820 to 1830 were the most modest: the rustic lodges and cottages which sprang up round the parks of great Gothic mansions. These are agreeable frauds, practising a less pompous deception than the Gothic mansion, and less gloomy than the Gothic villa. They have something of the frippery grace of Rococo Gothic, and some hint of a new mood which was to be very important in the Revival, the self-consciousness of 'vernacular' architecture. Where the local architecture was plain and dull, the architect of 1830 felt bound to substitute something more picturesque, and half-timber, that horrible and apparently incurable disease, ravaged the country independent of tradition. But where the local style was itself picturesque, the architect was prepared to use it, with a few embellishments, a few twirls and twiddles, which, though they are rather laughable, give the buildings a feeling of period, like the echo of a lively tune. These cottages are not serious architecture. Their chief importance is historical, the foreshadowing of that school of architects which turned to local styles for a guide. But they are not without a sentimental charm of their own; and sometimes, as at Eridge,[2] near Tunbridge Wells, they fit into the countryside harmoniously enough, and seem to express very happily an enviable world of romanticism.

Though Gothic was the popular style for villas and churches, no one had ever suggested that a large secular public building should be designed in that style. 'For civil purposes, public or private,' wrote Goodwin, 'the town hall, exchange or senate-house; the Greek, Roman or Italian styles are universally admitted to be applicable.'[3] And the committee for rebuilding

1. *Architectural Magazine*, 1835, 333, as well as Robinson, *Ornamental Villas*, Pl. 9.

2. Most of the lodges and cottages on this estate seem to have been built at about the same date, between 1810 and 1830, by a local architect named J. Montier.

3. Goodwin, No. 5; cf. also Papworth, 34.

the Palace at Westminster would never have chosen Gothic had they not had special reasons for doing so. One of these was the selection of the ancient site. The destroyed buildings had themselves been Gothic, and the fragments that were left – Westminster Hall and the ruins of St Stephen's Chapel – could scarcely have been incorporated into a classical design. The neighbourhood of Westminster Abbey alone made Gothic desirable, though the Gothic of Westminster Hospital, erected a year earlier, lessened the force of this argument. Another reason was the important belief that Gothic was essentially an English style. Even when it was most out of fashion, men had looked at Gothic with a sentimental and patriotic eye. 'Let the Italians deride our English, and condemn them for Gothish buildings,' Fuller had written defiantly in his *Worthies*, and in 1739 a writer in the *Gentleman's Magazine* finds 'something respectable in those old hospitable *Gothick* halls. . . . Our old Gothick constitution', he continues, 'had a noble strength and simplicity in it, which was well enough represented by the bold Arches and solid Pillars of the Edifices of those Days.'[1] This architectural piety had over-ridden fashion; no wonder it was powerful when taste turned in its favour. And how could a few pedants, who insisted that Gothic originated in France, stand against the flood of romantic nationalism? Gothic must be used because it was the national style. Everyone liked an argument which could be put so clearly, so shortly, and with so few technicalities.

For six months the committee's choice of style seems to have provoked no comment. During a period when ninety-seven architects were preparing fourteen hundred drawings, all those likely to protest were too busy to do so, and too buoyed up with hope for themselves and their friends. But on 29 February 1836 the Commissioners announced that Mr Charles Barry's designs had been selected; and ninety-six disillusioned architects were free to voice their dislike of Gothic architecture.

There is no need to waste time on the many foolish writings

1. *Gentleman's Magazine*, IX, 641; cf. also Burke.

which this controversy provoked. No important competition can be decided without rumours of favouritism; and we may ignore all those writers who hinted that Barry had friends in Parliament. We may also ignore the interminable letters of Mr Peter Thompson, carpenter, who believed that his designs were rejected solely on account of his humble trade, and wrote long protests beginning 'If a *mere* carpenter may *humbly* beg leave, etc.'

Even more serious criticisms are hard to analyse because they use such vague terms. Every age has its own vocabulary with which to express the feelings aroused by a work of art. Originally these words reflect some ideal standard of excellence, and imply some sort of limitation; but as they become current they lose their original severity and become mere noises of approbation. The extent to which a critical vocabulary may be emptied of meaning is shown in the battle of the styles, when both Gothic and Classical architecture were praised and blamed in exactly the same words. Of these words the favourite, undoubtedly, was *nature*; and no word could have been more invitingly vague. To begin with, the critic who first made 'nature' the centre of his system, Aristotle, used the word in three different senses. Aristotle's *nature* reached the eighteenth century at second hand through Pope's *Essay in Criticism*; yet this bewigged word was called in to justify the doctrines of Wordsworth. If confusion occurred in literary criticism, to which the word belonged, how unpromising was the attempt to use nature as the touchstone of architecture! Yet so great was the word's authority that no critic felt strong enough to reject it, and nature justified Pugin and Ruskin as it had justified Athenian Stuart.

Most meanings of nature occur in the disputes over the Houses of Parliament. Mr Hamilton, whose letters to Lord Elgin are the longest and most polished attack on the Gothic style, cannot write many pages without repeating that art is essentially the imitation of nature. In what ways Greek architecture imitates nature more closely than Gothic he does not

explain; but other supporters of classical architecture are more definite. 'If it be necessary to copy, why not copy from Nature, as did the ancients before us? The first pillar of the Grecians was the trunk of a tree; and the leaves of the acanthus are said to have originated the Corinthian order.'[1] These arguments were equally convenient for their opponents, who could add that Gothic was based not on hewn trunks, but on avenues of living trees.

There were other arguments which both sides could employ with equal effect. *Manly* was a fine vague word which anyone could use without fear of a logical refutation. The chaste plainness of classical architecture was undeniably manly;[2] so was the gloom and strength of Gothic.[3] In so far as the controversy was conducted on these lines – and few of the arguments used were more concrete – it was uninteresting and might well have been interminable.

But when the reviews and pamphlets of this confused debate have been read and half-forgotten, one finds that the trees are not so haphazard as they seemed, that the wood, in fact, has a pattern which is of importance in the history of taste. In the eighteenth century most of the gentlemen who undertook building had a sound knowledge of the rules of architecture; they and the professional architects dictated style. With a few exceptions, we may say that the more they knew about architecture the less likely they were to build Gothic. In 1785 a writer who wishes for a favourable judgement on Gothic appeals to any '*impartial* observer, *artists* and such only excepted who may be bigotted to the Grecian or Roman orders'.[4] With the artists he would have had to include all architects but Wyatt; with the 'such' almost all *conoscenti*. By 1830 a great many people of all classes looked with pleasure at pointed arches; but though Gothic was almost universally fashionable,

1. *London and Westminster Review*, 1836, xxv, 420.
2. *Works of James Barry*, I, 23.
3. Cf. *Oxford Dictionary*, under Manly.
4. *Gentleman's Magazine*, November 1785.

it was still a non-professional style. No architect of talent had used it with conviction, save the discredited Wyatt; even the architect of the Houses of Parliament 'never wavered in his allegiance to Italian'.[1] Gothic had no rules, no principles, no professional standing. But this amateurishness was unimportant, for after 1830 we meet with the belief that neither knowledge nor experience is necessary to criticize a work of art, and the 'impartial' middle class, with no tradition of culture, becomes final arbiters of taste. Naturally such an audience welcomed criticism from which technical terms were excluded, and simple human values took their place. Time might be wasted in learning to pronounce Chiaroscuro; whereas the appeal of *Dignity and Impudence* was instantly felt.

It is the emergence and triumph of these non-technical values which makes the disputes over Parliament so important. Had the opponents of Gothic been free to choose their ground they could have won a dialectical triumph. The only accomplished architects then living were accustomed to work in the Classical style, and good proportion and detail were more likely to be secured in a style which was well understood. Even on the score of convenience, a classical building would have been preferable, and would have been far more economical both to erect and to keep in good repair. But these arguments had no popular appeal, and the classical party were forced to introduce literary or human values, which almost always turned against them. Imitation of nature, in so far as the phrase can be given any definite meaning in relation to architecture, was more a character of Gothic than of Classical.[2] Still less could the Grecians claim that their style alone was suitable for a free people; nor was it characteristically English. On such grounds every skirmish ended in a Gothic victory; and the Grecians were safest when their mild, persistent champion quoted Pindar and Winckelmann or made statements – 'The invention of printing opened the mind of man' – un-

1. *Life of Barry*, 128.
2. *Architectural Magazine*, 1835, 509.

connected with architecture but incontrovertible; or when more robust supporters used the simpler weapons of controversy – sarcasm and personal abuse. The bishops had conspired to turn Parliament into a monastery; the members were to wear monk's habit; visitors would mistake the new buildings for the Abbey; indeed, the Abbey itself might have been used and would have spared much expense – it was to such arguments that the admirers of Vitruvius and Palladio had been reduced.[1]

Half the importance of the Houses of Parliament in the development of this essay lies in these disputes, and in the gradual formation of doctrines on which the Revival could be based; and half lies in the impetus given to craftsmanship. Barry had resolved to carry the medieval style right through the building, down to the minutest detail, down to the inkpots and umbrella stands. By this means, we are told, he 'hoped to raise up a school of carvers guided, but not servilely confined, by the examples of Gothic antiquity',[2] and to some extent his hope was fulfilled. The thousands of square feet of carving, both in and outside of the building, were executed by men who had been trained to copy ancient models; and in woodwork, ironwork, encaustic tiles, and painted glass a similar if less thorough study of medieval craftsmanship took place. The movement which culminated in the foundation of the South Kensington Museum as a store-house of copyable technique began with the decoration of Parliament.

Nowadays we believe that this period of imitation was disastrous, for it destroyed all hopes of a spontaneous original style. The trouble, of course, lay in the nature of Gothic; once committed to Gothic there was no avoiding elaborate detail and no way of training craftsmen to execute such detail, save by making them copy medieval work. Inevitably these copies were dead, and Parliament is a great necropolis of style. Yet these dead forms are respectable; and I doubt if any respectable

1. *London and Westminster Review*, xxv, 409.
2. Barry, 193.

style would have sprung spontaneously from the early Victorian world. Craftsmanship had reached a low level before mass production gave it a death-blow, and by 1830 all ornament was subordinated to utilitarian ends save where the amateur, with her beads and feathers, kept alive an effete provincial Rococo. Copies of medieval craftsmanship are less amusing than this fancy work, less suggestive of a world which time has made legendary. But to copy something well made requires at least a good technique, and perhaps the study of medieval art was the only road away from the *style coco*, from flimsiness and perversity, to solid workmanship and a respect for materials.

Apart from the impetus given to craftsmanship, the Houses of Parliament had surprisingly little influence on architecture in general. The huge, elaborate building took many years to erect, and during those years the Gothic Revival developed very rapidly. It was no longer the old haphazard Revival, growing up here and there as the whims of amateurs or some economic need dictated, unsubdued by dogma, unhampered by principles. After 1845 Gothic architecture was revived with a religious severity of purpose; and the architect who adopted that style worked under one of the most rigorous systems of taboo that have ever oppressed the inventive spirit. Almost every article in this system was violated by the Houses of Parliament. The plan was symmetrical, the style perpendicular, the architect practised in the Classical style; and we shall see how any of these things alone would have been fatal. Long before the building was completed no serious Gothic Revivalist dared to praise it. Even Eastlake could only stress its historical importance – as good a work as was possible in that benighted time, but poor stuff compared to anything Mr Waterhouse would have produced.[1]

But today most people interested in architecture are thankful that the Old Palace of Westminster was burnt down before 1840; indeed, Barry's building is probably more admired now

1. Eastlake, 184–6.

than it has ever been, and this recent admiration is suggestive. The Gothic Revival divides itself very clearly into two periods. The first of these we may call the Picturesque period, for reasons which I hope I have made obvious. The second we may call the Ethical period, and for reasons which I shall try to explain in the next three chapters. Of these two periods the first is certainly the less distressing; if men must revive a dead style, let them use it for effect and not to satisfy the demands of some obscure, forgotten dogma.[1] In time the Houses of Parliament stand midway between the two periods; but in style and general effect they belong to the first. They are a triumph of the Picturesque.[2] The long, straggling line, the disproportionate tower, the monotonous detail – admit them all; but we cannot rid our imagination of that extraordinary building which seems to embody all that is most characteristic and most moving in London. Though the Palace of Westminster is always surprising, it is perfectly at home. Nor are these qualities due solely to size or sentiment or familiarity, for Buckingham Palace seems no essential part of London. And I doubt if the most anti-Goth would exchange our parliament building for the correct and imposing classical senate houses of the Continent.[3]

1. See my introductory letter for what I now (1949) think about this pronouncement.

2. In the strictest sense of the word, for no painter can resist them, and they have inspired Monet and Sisley among the great landscape painters of the last century, Derain and Kokoschka among moderns.

3. In this chapter I have not given a detailed account of Barry's designs or of the difficulties he experienced in carrying them out; this would have raised a controversial question which belongs, as we shall see, to the next chapter. Such details may be found in E. Barry's *Life of Barry*, referred to above.

Chapter 7

Pugin

When we reviewed the forces which the Gothic party brought to the battle of styles, we noticed one great strength and one weakness. The strength lay in the new body of human values by which men had begun to judge architecture; the weakness in the fact that Gothic had no architectural principles and that the architects who employed it were all trained in the classical style and used that style for preference. The strength grew; and even before the foundation stone of Parliament was laid the weakness had begun to disappear. A few years later Gothic was fortified with principles stricter and more comprehensive than those on which classical buildings were based; and architects had come to look on Gothic not as a style, but as a religion. A change had taken place in the whole nature of the Revival. The man who brought about this change was Pugin.

Augustus Welby Pugin was born on 1 March 1812.[1] His father, Auguste Charles, Comte de Pugin, came of an old Freiburg family, and retained throughout his life the manners and prejudices of an aristocrat. He had fled from France during the Revolution, and had taken a position in Nash's office at a time

1. Most of the facts in this chapter were taken from Ferrey's *Life of A. N. W. Pugin*, which contains a good deal of information very badly arranged. Since then there has appeared Mr Michael Trappes-Lomax's *Pugin* (Sheed & Ward, 1933) which adds much useful material, including a list of his works. It is, however, concerned with Pugin the Catholic rather than Pugin the Architect. I have perhaps underrated the part played by Pugin's two patrons, Lord Shrewsbury and Ambrose March-Phillipps. Cf. also Dennis Gwynn, *Lord Shrewsbury, Pugin and the Catholic Revival*. On the architectural side there have been articles on Pugin's two residences both in the *Architectural Review*, John Piper on St Marie's Grange (vol. XCVIII (1945), 81, and John Summerson on St Augustine's, Ramsgate (vol. CII (1948), 163).

when the demand for gentlemen's residences in the castellated style was at its height. Nash was almost wholly ignorant of Gothic detail and had no time to spare for it: 'I hate this Gothic style,' he said; 'one window costs more trouble in designing than two houses ought to do.' He therefore commissioned his pupil to study the troublesome style and to collect examples. The elder Pugin became an authority on Gothic design; architects in difficulties frequently applied to him; and it is even recorded that George IV sent him Monsieur Vilmet, his *chef de cuisine*, that the royal table might be decorated in a true Gothic taste. He must be given credit for the various books of *Specimens* and *Examples* which I have already noticed, though the illustrations are almost entirely the work of his pupils; and he has achieved a sort of immortality through his collaboration with Rowlandson in the *Microcosm of London*, so that today the elder Pugin is better remembered than his son.[1]

I need not dwell on Pugin's childhood. At this period of their lives, it seems, men of talent are all much alike – the same solitary school-time, the same violence of temper, the same omens of a brilliant future. Pugin's first drawings, preserved in the British Museum, are no better and no worse than the scribbles of many gifted children; and for us his life has little importance till 1826. By that time his gift for drawing and his passionate love of Gothic architecture had become apparent; he had measured Rochester Castle, hanging perilously over the moat, and had done many drawings for his father's *Specimens of the Architectural Antiquities of Normandy*. In the following year he was discovered copying Dürer engravings by the head of a firm of goldsmiths,[2] and employed by them to make designs for plate; and for another firm he designed new furni-

1. Incredible in 1949; but strictly true in 1927 as anyone will remember who then tried to buy books by A. N. W. Pugin.
2. Messrs Rundell and Bridge, Royal Goldsmiths. Five designs for church plate are preserved in the Victoria and Albert Museum. Four are signed *A. Pugin Jnr. Invent. et fecit. 1827, J. C. Bridge*. They are not to our taste, but wonderfully accomplished.

ture for the restored Windsor Castle. It was in the unrestrained style of Fonthill, which he afterwards deplored. 'A man', he wrote, 'who remains any length of time in a modern Gothic room and escapes without being wounded by some of its minutiae, may consider himself extremely fortunate.' He published a drawing of such a room, and it certainly looks very uncomfortable; the chairs are covered with spiky pinnacles and even the foot-stools have crockets. 'I myself', said Pugin, 'have perpetrated many of these enormities in the furniture I designed some years ago for Windsor Castle.'[1]

It was while working at Windsor that Pugin fell in with George Dayes. Ferrey describes him as 'a person of inferior position, who, amongst other occupations, was employed at night in a subordinate station in the management of the stage scenery at Covent Garden Theatre'; and perhaps this was the only way a decent man could describe anyone connected with the theatre. But Dayes seems to have been a man of charm, for he fired the serious and industrious Pugin with a passion for the stage. A whole floor of the old Count's house was turned into a model theatre; and for two years Pugin worked at Covent Garden, inventing devices to heighten the effect of those operas the scene of which was set in the middle age. His triumph came in 1831, when his correct and gorgeous scenery made a success of the opera *Kenilworth*.

In these years the restless, ardent young man seems to have tried every method of alarming his parents. His connexion with the stage was regrettable enough; and when it was at its height he suddenly developed a passion for the sea. 'There is nothing worth living for,' he said, 'but Christian architecture and a boat.' And he bought a fishing-smack. Ferrey calls this section of his Life 'Bad effects from associating with low society,' and he says,

The life he had hitherto led was, as may be imagined, a source of much pain and anguish to his parents and friends, more especially to

1. *True Principles*, 35.

the refined tastes of his father, who on meeting a friend exclaimed with much grief, 'God bless my soul, it was this morning I met my boy Auguste in the disguise of a common sailor, carrying on his shoulder a tub of water which he had took from the pompe of St Dunstan.'

Certainly his dress was eccentric, and remained so all through his life; but low company can never have been very congenial to him, for he had a horror of beer and tobacco. More disturbing were his sudden disappearances into the North Sea. At last he was shipwrecked near Leith; completely destitute, he applied to an Edinburgh architect, Gillespie Graham, who forced from him a promise to return to architecture. The promise was kept, but at first proved disastrous. Pugin set up a business in Gothic carvings, which failed, and he was imprisoned for debt. A rich aunt released him; whereupon he married. His wife was the daughter of his old friend the scene-shifter.[1] She died, and Pugin was broken-hearted. A year later, while still under twenty-one, he married again.

The year 1834 was the turning-point of Pugin's life. For some time he had been growing more and more discontented with the English Church, and a tour of the western counties filled him with horror at the apathy of the Protestant clergy. In a series of letters to his friend Osmond he describes their callousness to beauty, their meanness, and their apparent pride in the most shameful restorations.

I assure you [he wrote], that after a most close and impartial investigation, I feel perfectly convinced the Roman Catholic Church is the only true one, and the only one in which the grand and sublime style of church architecture can ever be restored. A very good chapel is now building in the North, and when it is complete I certainly think I shall recant.

And that year recant he did.

Friends and enemies joined in tracing his apostasy to his love of Christian art, and Pugin himself never denied that this was

1. Ferrey only refers to her as 'grand-daughter of Dayes the artist'.

the first cause of his change. To Ferrey the motive seemed inadequate, and he makes fumbling efforts to excuse it. Naturally there were other causes, among them Pugin's mother, whose puritanism provoked a reaction in her ardent son. But to us it may seem that a passionate love of beauty, and a conviction that beauty springs from a way of life and a temper of spirit, is a better reason for a change of faith than most.

The consequences of Pugin's conversion were far more serious than we today can realize. Of course all enthusiasm was distasteful to decent folk; but in addition the Roman Catholic Church controlled they knew not what sinister machinery; and the Inquisition was still terrifying, like a thing under the bed. A lady alone with Pugin in a railway carriage saw him cross himself, and cried, 'You are a Catholic, sir! Guard, let me out – I must get into another carriage.' Pugin must have known what chances of employment he was sacrificing; and he must have known that there was no counterbalancing gain of seemly and beautiful church services, for the Roman Catholics of that date worshipped in makeshift assembly-rooms. 'What a place to celebrate the mysteries of religion in!' said Pugin. 'Why, it is worse than the Socialists.' Yet on the whole he suffered little for his change of faith. All his life he was overemployed. The recent Act of Catholic Emancipation had led to a demand for new Catholic churches, and for a time the most important of these were entrusted to him. Before his conversion he had met the Catholic Earl of Shrewsbury, who remained throughout his life a generous and long-suffering patron.

He received commissions from the English Church too;[1] and if he was sometimes rejected by the more stubborn Protestants, we cannot wholly blame them, for he did little to conciliate their feelings. It is sometimes held up against the Fellows of Balliol that they refused to allow Pugin to rebuild the col-

1. And his influence travelled even further than Rome. Cf. *Chapel and School Architecture, as appropriate to the Buildings of Nonconformists* by F. J. Jobson, which is entirely based on Pugin's principles.

lege owing to his religion.[1] But four years earlier the proposed Martyrs' Memorial had drawn from Pugin a flaming pamphlet in which the Reformers were spoken of as 'vile, blasphemous imposters pretending inspiration while setting forth false doctrines', and the innocent subscribers to their memorial as 'foul revilers, tyrants, usurpers, extortioners and liars'. I do not think we can blame the Fellows of Balliol. No doubt religious feeling should not sway architectural judgements: nor should political; but a bolshevist architect who applied Pugin's language to the rich would have a poor chance of employment in Oxford today.[2]

It is impossible to compress the incidents of Pugin's life otherwise than in a table of dates. In 1833 he had built himself a curious Gothic house near Salisbury; the following year had been largely occupied in travel and conversion; then in 1835 a stream of books of designs – for Gothic furniture and every form of metal work – began to pour from his pen.[3] In the same year he had written his *Contrasts*, the first extraordinary fruit of his conversion. No publisher could be found for such explosive work, and in 1836 Pugin published it at his own expense. He lost heavily, but the book made his reputation. Commissions came for chapels, churches, colleges, and private houses. Pugin executed them all; and he designed much that was not commissioned. One had but to suggest that a church was needed here or a college there and he would immediately produce a bundle of detailed drawings for it. He also wrote continually; in 1837 he had been appointed Professor of Architecture and Ecclesiastical Antiquities at Oscott College, and the lectures delivered were republished as the *True Principles of*

1. My friend, Mr Roger Mynors of Balliol, recently discovered Pugin's original drawings for the college, and a little book of drawings and descriptions, bound and illuminated like a medieval missal, which Pugin evidently sent to the Fellows of Balliol as a prospectus. It is a pathetic instance of his enthusiasm.

2. Perhaps true in 1927, but not in 1949.

3. In the same year began his connexion with Mr Barry, which, on account of its complex nature, I must discuss later.

Christian Architecture (1841); this was followed by his *Apology* (1843) and a *Glossary of Ecclesiastical Ornament and Costume* (1844), a work of great learning which would have kept an ordinarily industrious man employed for many years. Yet during this time he had designed over a dozen churches, including St George's Cathedral, Southwark. He had also moved from Salisbury to Ramsgate, and had built for himself not only a house, but a private church, St Augustine's, which he later considered his only satisfactory work.

There, in his strange conventual house, he passed his life in nightmarish industry. He worked unaided. 'A clerk!' he said; 'I should kill him in a week.' His sole recreations were the reading (and alas! writing) of theological works and the conduct of church services. There was one fierce, but honourable, matrimonial storm; and ultimately he married a third wife. But to men possessed of a devil[1] human beings seem clumsy tools with which to realize ideals, and to Pugin they seemed mere obstacles to the re-establishment of Christian architecture. In St Augustine's he could put on his velvet cloak and shut himself away from the world and work like the monkish builders he worshipped. Or, best of all, drifting sailless in his crazy fishing-boat, he could execute his precise and intricate designs unenraged by human intercourse.

In 1851 Pugin was commissioned to arrange the medieval court at the Great Exhibition. He was already overworked and quite unsuited to a labour which involved committees, commissioners, and all the paraphernalia of concerted human endeavour. The nervous strain of dealing with foolish or unsympathetic public bodies inflamed Pugin's mind. His letters began to show more than his usual violence; once or twice his behaviour was dangerous. But no one could restrain his furious industry or calm his impatience. In the spring of 1852 he suffered an attack of what he called nervous fever; by summer he

1. I now recognize that diabolical possession is a reality, and the phrase is inadmissible, unless I was thinking of the Devils in Blake's *Marriage of Heaven and Hell* (1949).

became definitely insane and was removed to Bedlam; on 14 September he died.

Pugin was forty years old when he died, but his doctor said he had done a hundred years' work. Of this hundred, almost half, and that the most successful, was done anonymously. I have already said that the details and execution of the Houses of Parliament raise a controversial question. To revive dead controversies is seldom profitable. Yet I must do so here, not only because the truth seems to be indisputable, but because the whole incident throws a strong light on Pugin's character.

Soon after Barry's death Edward Pugin published a pamphlet in which he claimed that his father, and not Barry, was chiefly responsible for the success of the great building. Unfortunately for the cause of truth, he was answered by Barry's son, and the debate was made unseemly by the intrusion of a family feud. Pamphlets and furious counter-pamphlets, all the resources of eloquence and the sharp swords of personal abuse, were brought into action; yet, as usual, we cannot avoid the tame conclusion that both sides were wrong. For both assumed that if they were right the Houses of Parliament owed nothing to their opponent's man; whereas it is clear that each architect could have acknowledged the other's share and his reputation have been none the poorer. The difference is that Pugin did acknowledge Barry's share; while Barry was more reticent about Pugin's.

'I could not have made the plan,' said Pugin; 'it was Barry's own. He was good at such work – excellent; the various requirements conveyed by the plan, and above all the Fine Arts Commission, would have been too much for me.' And once, while sailing past the Houses of Parliament, he said to a friend, 'All Grecian, sir; Tudor details on a classic body.' These two sentences are convincing. We have only to consider the general design, with its forced symmetry, its sham windows, and its numberless artificialities, to see that it must have pained Pugin, whose every principle it violates. But perhaps it is a

more imposing plan than any which he could have conceived; it is a mistake to say that 'whatever artistic merit the building possesses is mainly due to Pugin'.[1]

When we have conceded this to Barry, I believe we can say that every visible foot of the Houses of Parliament is the work of Pugin. The evidence for this was badly presented by Pugin's supporters, but it is conclusive.

First there is the stylistic evidence. Barry's churches, and above all King Edward's School, Birmingham, designed the year before the burning of the old Houses of Parliament, are the flattest, thinnest 'Commissioners' Gothic', without any pretence at the rich detail of perpendicular. In these years Pugin had made a book of designs for an imaginary college, which, when I first saw them, I took to be drawings for the Houses of Parliament, though actually they were done before the old building was burnt down. For those who object that stylistic evidence must always be a matter of opinion, there are diaries. These prove that Pugin was working for Barry before the fire; immediately after it Barry visited Pugin, and the next day we get the entry in Pugin's notebook, 'Worked all night Parliament H.' Barry's designs were accepted, and from September 1836 to January 1837 every day of Pugin's diary contains direct reference to designs made for Parliament. In 1837 there is a lull. Pugin has become known and was too busy to be Barry's 'Ghost'. During this period we find letters from Barry imploring Pugin to help him; in 1844 he expresses a desire to meet Pugin 'to consult you generally and to enter into some permanent arrangement that will be satisfactory to you'. At last Pugin complied, and was given the official appointment of Superintendent of the wood-carving.

The evidence of drawings is equally conclusive. No single drawing of Barry's for an elevation could be found, and his supporters were forced to say that he had destroyed them, and

1. Robert Dell, 'Who was the Architect of the Houses of Parliament? New Light on an Old Controversy', *Burlington Magazine*, March 1906. I have drawn much of what follows from this article. (Too much. Dell was unreliable (1949).)

that Pugin's were either copies of Barry's or were never used. At last Alfred Barry discovered a drawing for the throne-room, which, he claimed, was undoubtedly his father's. The drawing was in Pugin's style, and was signed with the familiar monogram A.W.P.; nor need we be shaken by Alfred Barry's claim that these initials stood for Albert Prince of Wales, then a babe unborn.[1]

Unfortunately we cannot produce the evidence of letters. Barry stated that he always destroyed his letters; but, curiously enough, five letters from Pugin were preserved. They were the five letters of 1844 in which Pugin, whose practice was already too great, refused to renew his ghostly connexion with the Houses of Parliament. Of Barry's letters to Pugin a still more curious story is told. It was first told by Mrs Pugin, and its authenticity might have been doubtful had it not since been confirmed by documents. In 1858 it was decided to publish a life of Pugin. Naturally Sir Charles Barry was consulted and asked for particulars concerning the building of Parliament. 'My dear fellow,' said Sir Charles, 'there are no particulars; what particulars could there be?' Thereupon Mrs Pugin stated that she had recently discovered a large number of letters written by Sir Charles to her husband during the years 1835-6. Sir Charles Barry exclaimed, 'Good heavens! I thought he had destroyed all my letters.' Ultimately he asked Mr Edward Pugin to dine with him and bring the letters, so that they might look through them together. Mr Pugin kept the appointment and the letters were not mentioned during the evening; but as he was leaving, Sir Charles Barry said, 'Oh, by the by, did you bring those letters with you?' Mr Pugin replied that they were in his greatcoat pocket; whereupon Barry said that it was too late to look through them that night, and asked that they might be left with him. Mr Edward Pugin left the letters, and they have not been seen since.

I confess I do not know how to interpret this story. As it

1. Or, if the drawing belongs to the second Pugin group, a babe of two years.

stands it is really too melodramatic; respectable architects do not procure their colleague's letters on false pretences in order to destroy them. And yet – the letters *were* handed to Barry, and though the Pugins requested and demanded and challenged, they were never returned. I suppose they were lost.

The truth is that Barry had bad luck. The work involved in a large and elaborate building is inevitably beyond one man's powers, and Barry was perfectly justified in employing a 'ghost'. In 1835 he did not need to acknowledge that his work was done for him by a young and comparatively obscure architect; but when his 'ghost' suddenly materialized into a very distinguished architect, whose genius was universally recognized, the relationship became difficult. Barry was, perhaps, a little too discreet, and though grateful in private, he did not go out of his way to make Pugin's responsibility known. All parties were half-ashamed of this uncouth renegade, this lob who did ten men's work while they slept, and allowed them to claim it as their own.

Pugin seems to have borne them no grudge. His grievance was against the world, and left no room for grievances against Barry and the Commission. But for Barry the partnership must have been embarrassing. At critical moments Pugin would suddenly vanish; it would be known that he had loaded his smack with bread and water, paper, pencils, and etching-plates; and for months – months perhaps of terrific weather – there would be no word of him. Then, as suddenly, he would reappear, and stride into Barry's office in his outrageous sailor's clothes with an armful of exquisite drawings.

I have dwelt on this tasteless controversy because no other incident of Pugin's life brings out his vivid personality so clearly. The silly question 'Who was the architect of the Houses of Parliament?' is well forgotten; but it is worth remembering that every inch of the great building's surface, inside and out, was designed by one man: every panel, every wallpaper, every chair sprang from Pugin's brain, and his last

days were spent in designing inkpots and umbrella-stands.[1]

The Houses of Parliament is the first neo-Gothic building which we can call great. Until Liverpool Cathedral is completed it will remain the largest building the movement inspired; and it is pleasant to know that so much of it is Pugin's work, the more pleasant because most of his architecture is disappointing. Though we make every possible allowance for the conditions under which he worked, it is hard to recognize in Pugin's churches the gifts he shows so lavishly in his writings.

I can truly say that I have been compelled to commit absolute suicide with every building in which I have been engaged, and I have good proof that they are little better than ghosts of what they were designed; indeed, had I not been permitted by the providence of God to raise the Church of St Augustine's, I must have appeared as a man whose principles and works are strangely at variance.[2]

There is truth in this complaint. Some of Pugin's best buildings were marred by lack of funds, foolish conditions, or the speed at which they were erected. And there was the even more serious lack of a tradition; Pugin, of course, saw the need of craftsmen who understood the old forms. He, more than anyone, was responsible for the revival of craftsmanship which we noticed in the last chapter, not only through his drawings, but also through the enthusiasm with which he charged his craftsmen. No one could enter the room in which Pugin worked, 'with no tools but a rule and rough pencil, amidst a continual rattle of marvellous stories and shouts of laughter',[3] without catching some spark of his medieval vehemence and whole-heartedness. But the impulse which once made gargoyles so fierce and saints so unearthly was beyond recapture. Even in his own drawings Pugin's figures are too prim; as

1. The drawings for these still exist in the collection of Pugin Powell, Esq. A tiny fraction (eight huge portfolios) of Pugin's designs for Parliament are in the Victoria and Albert Museum. Some of these were made under Pugin's direction by Mr Powell.

2. *Remarks on Articles in the Rambler*, 1850. Ruskin quotes and demolishes a similar passage from this pamphlet in *The Stones of Venice*, I, Appendix 12.

3. *Life of Barry*, 196 *n.*

realized by his carvers they are very insipid. When the devils disappeared from Gothic detail, the saints lost half their saintliness.

Finally, there is the simple fact that most of his best buildings went where the need was greatest, in industrial regions. It is hard to appreciate the most venerable building surrounded by squalor. Few have the imaginative power to refresh Pugin's besmutted finery or to see his grimy pinnacles rising from a cathedral close.

> But if the time does arrive that I am allowed to build a church without harassing restrictions, and a reasonable sum to carry it out, I will undertake to produce such a building that, for effect, *true economy*, and convenience, will reconcile even the Rambler men [his most dogged opponents] to pointed architecture.[1]

Looking at those of his churches which he considered comparatively successful one is doubtful. Above all, his favourite St Augustine's shakes one's faith. The masonry is solid and the whole building has no obvious faults, but it has none of those qualities which may often be found in the simplest traditional parish church, none of the repose, much less the thrill of great architecture. The exterior is undistinguished, the interior crowded; the masses are uncoordinated, the proportions are bad. Pugin lacked the essential quality of a great builder – he did not think in volume; his wonderful dreams were wasted because he did not dream in three dimensions. 'I have passed my life in thinking of fine things, studying fine things, designing fine things and realizing very poor ones.' That is true, though not as Pugin meant it.

Pugin was essentially a dreamer and a designer; and for these reasons it is appropriate to study his architecture not in his finished buildings, but in those exquisite etchings which, published with appreciative comments by himself, formed the substance of his later books. We must judge these drawings by a particular standard. They were intended to stimulate, not to

1. *Remarks, etc.*

inform; and on many we can pass no architectural judgement. Even if we discount the unusually fine weather which prevails in architectural drawings, the detail is too sketchy and we are ignorant of the materials employed. Look at the frontispiece to Pugin's *Apology*. It represents twenty-two churches and chapels, chosen from his work,[1] ranged like a Gothic New Jerusalem before the rising sun.[2] The dramatic effect (largely obtained by the expedient of suppressing cast shadows) is tremendous. Our spirit is exalted by the aspiring pinnacles and soars high above architectural details to the promised land beyond. Were we on earth walking about among these buildings the effect would be less agreeable. And though it may be objected that this plate is an unfair instance, being in intention symbolical and not instructive, the same is true of other designs. Downside Priory and St Bernard's, Leicestershire,[3] are impressive groups of buildings; each is seen from a neighbouring hill in such a way that its magnificent setting is apparent. Unfortunately the detail is invisible.

Yet with all their faults these romantic prospects show an imaginative power and a knowledge of the true spirit of Gothic unprecedented in the revival. To appreciate Pugin's range turn from his stark, solid St Bernard's to the design for a hospital at Alton, as unpretentious and charming as a small Oxford college. No one else had this power of making his designs look natural and solid. His buildings are never antiques. In them he follows his own maxim, 'Architectural skill consists in embodying and expressing the structure required; and not in disguising it by borrowed features.' Were these exteriors the only things reproduced in Pugin's books we might lament that conditions had deprived us of a great architect.

1. The plate, however, is simply entitled 'The Present Revival of Christian Architecture'.
2. At least I suppose it is rising. I originally wrote 'setting', because we see the central building from what would normally be the east end.
3. *Present State*, Pls. XIII and VII. Elaborate plans were made for Downside and the stone was cut, but nothing further done. St Bernard's was almost completed.

But, unhappily, a number of plates in Pugin's *Ecclesiastical Architecture* are of interiors; and many pages are concerned with interior decoration. The badness of Pugin's interiors is rather surprising, for, as I have said, he was primarily a designer. He invented ornament as easily as the wind blows clouds into a thousand fantastic shapes, and those books of his designs for metal work or stencilled patterns prove how often his inventions were successful. Even the severest of his critics praised his detail. 'Expect no cathedrals from him,' wrote Ruskin, 'but no one at present can design a better finial. That is an exceedingly beautiful one over the Western door of St George's, and there is some spirited impishness and twisting of tails in the supporting figures at the imposts.'[1] But in the use of these details Pugin showed his weakest side. This is not because he preferred elaboration to simplicity, for neither elaboration nor simplicity is necessarily disastrous. But of the two, elaboration is perhaps more dangerous; for it demands a higher standard of craftsmanship, and where uncoordinated simplicity is merely bleak and negative, a mass of uncoordinated detail gives a distressing sense of wasted labour. Pugin could not put his details together; nor was his love of detail purely architectural. He was one of those truly religious men to whom ritual gives sensuous pleasure. The mere names of articles of church furniture were to him like choice wine to an epicure; often the point of an argument is lost while he rolls them round his tongue – 'the stoups are filled to the brim; the rood is raised on high; the lamps of the sanctuary burn bright; the saintly portraiture in the glass windows shine all gloriously; and the albs hang in the oaken ambries, and the cope chests are filled with orphreyed baudekins; and pix, and pax, and chrismatory are there, and thurible and cross'.[2] It was this spirit which dictated much of Pugin's church architecture; and it was a spirit disastrously sympathetic to the other Gothic Revivalists. If we look at

1. *Stones of Venice*, I, Appendix XII, on Romanist Modern Art (Cook and Wedderburne, IX, 436).
2. *Remarks.*

almost any of Pugin's interiors we are struck by the flimsiness of the piers and arches, which not even the flattering medium of etching can disguise, and above all by the extreme meanness of the roofs. For these we find little compensation in the fussy ornament of the rood screen, still less in those piles of tawdry treasure, the painful embodiment of the passage I have just quoted. A few of his contemporaries felt this and blamed him for 'starving his roof-tree to deck his altar';[1] but to many this richness of decoration was the most important part of his work and the most influential. Pugin's finery found immediate imitators; his principles of construction played little part in the revival till long after his death.

There is a malicious footnote in Fergusson's *History of Modern Architecture* which must always distress Pugin's admirers. 'The true bent of Pugin's mind was towards the theatre, and his earliest success achieved in reforming the scenery and decorations of the stage; and throughout his life the theatrical was the only branch of his art which he perfectly understood.' I used to think this part of an elaborate Protestant sneer, for the note goes on to say, 'It is, no doubt, very beautiful; but as protestants we may be permitted to ask whether all this theatrical magnificence is really an essential part of the Christian religion.' But I am afraid it is shrewd criticism. Pugin's etchings, with their brilliant lighting and their well-placed figures, are primarily dramatic, and his buildings belong to the old Wyatt tradition of scene-painting. My point, that he did not think in volume, is only an amplification of Fergusson's remark; and his most satisfactory design known to me was drawn in his Covent Garden period – an imaginary cathedral raising its gorgeous, impossible towers unembarrassed by the laws of gravity.

'Why', it may be asked, 'spend so much time on a mere scene-painter?' There are many answers. For one thing, I have judged Pugin's work as he would have wished it judged – by the very highest standards. I have not compared his Gothic to

1. Cf. *Ecclesiologist, passim.*

any that was built during his life or for thirty years after his death; I have compared it to the Gothic of the middle age; and in some instances – the Houses of Parliament is one of them – it will stand the comparison. If we judge Pugin's architecture by historical and not absolute standards, our estimate will be very different. We have only to think of the average church before Pugin's time to see how far his work is removed from the drab and flimsy buildings of his predecessors. His churches are not well proportioned, but they are solid; his ornament is dead, but at least he understood its importance, and in sheer knowledge of medieval detail he has never been surpassed. After all, the chief reason why we are hard on Pugin's buildings is because they do not answer the expectations raised by his writings. For Pugin is the Janus of the Gothic Revival; his buildings look back to the picturesque past, his writings look forward to the ethical future.

The mechanical part of Gothic architecture [wrote Pugin about the year 1836] is pretty well understood, but it is the principles which influenced compositions, and the soul which appears in all former works, which is so lamentably deficient; nor, as I have before stated, can anything be regained but by a restoration of the ancient feeling and sentiments; 'tis they alone can restore Gothic architecture.

In these words Pugin first expressed the idea which changed the course of the Gothic Revival and still colours our architectural judgements. It must seem extraordinary to us that such an obvious truth was not applied to Gothic architecture before this date; and perhaps some such argument does lie embedded in the great mass of polemics between Goth and Grecian. But I do not think it likely, for the idea would be quite contrary to the eighteenth century's theory of art. With sufficient skill and knowledge, it was thought, civilized man might do anything. Those who had mastered the teachings of Palladio could easily adopt the architectural style of mere barbarians, and even refine upon it. Standard writers of art criticism – Aristotle, Longinus, and Horace – all described art as something imposed,

so to speak, from without. The idea of style as something organically connected with society, something which springs inevitably from a way of life, does not occur, as far as I know, in the eighteenth century. Of course by Pugin's time the Romantic movement in literature had long ago triumphed and established its own standards of criticism. But in architecture it was still assumed that Gothic was style which might be adopted like any other. 'It is considered suitable for some purposes,' wrote Pugin – 'MELANCHOLY, and *therefore fit for religious buildings!!!* a style that an architect of the day should be acquainted with in order to please those who admire old things.'[1]

It was in opposition to this view that Pugin wrote: 'The history of architecture is the history of the world,'[2] and, turning to the work of his own day, he saw what every serious writer on architecture has seen since.

Will the architecture of our times, even supposing it solid enough to last, hand down to posterity any certain clue or guide to the system under which it was erected? Surely not; it is not the expression of existing opinions and circumstances, but a confused jumble of styles and symbols borrowed from all nations and periods.[3]

Furthermore, he believed that an architect who could adopt any style to suit his client was as unworthy of admiration as a priest who could adopt any creed. Good building depended on the condition of society and the conviction of the architect.

From this general truth Pugin deduced a number of corollaries, some admirable, some disastrous, all extraordinarily influential. The most important are to be found in a lecture delivered to St Marie's College, Oscott, in the year 1841,[4] and

1. *Apology*, 2. 2. ibid., 4. 3. ibid., 5.
4. Actually the *True Principles* was published in 1841 and represents lectures which were given at Oscott at some time after 1837 when Pugin was appointed Professor of Architecture. The exact date is of some interest because Pugin's theories of the Gothic construction are contained in a book by Alfred Bartholomew called *Specifications of Practical Architecture* which appeared in 1840 and was widely read. Cf. George G. Pace, *Alfred Bartholomew – a Pioneer of Functional Gothic* in *Architectural Review*, vol. XCII, 1942, 99.

later published as *The True Principles of Pointed or Christian Architecture.*

The two great rules for design are these [he began]. First, that there should be no features about a building which are not necessary for convenience, construction or propriety; second, that all ornament should consist of enrichment of the essential construction of the building.

It is easy to see how these two principles could be made to destroy the whole Gothic Revival before Pugin's time. With the second, which is, of course, the less important and often contained in the first, he attacked the nightmare world of Victorian Gothic furniture: 'The fender is a sort of embattled parapet, with a lodge-gate at each end; at the end of the poker is a sharp-pointed finial, at the summit of the tongs is a saint.'[1] He also reproduces a Gothic wallpaper of the type Gray found for Walpole, with innumerable niches and pinnacles, and a doorway seen in perspective; and he mentions Gothic carpets with apparently reversed groining. In place of these strange things he suggested medieval flock papers and solid practical furniture, saying, 'In matters of ordinary use, a man must go out of his way to make something bad.'[2] In this he anticipated William Morris, and the ideas contained in his *Floriated Ornament* (1849) anticipate Ruskin. It had long been felt that in nature, God's handiwork, might be found all the highest forms of beauty, and even Gilpin had deplored that 'the old idea that art must do something more than nature is not yet obliterated'. At first sight it was difficult to maintain that Gothic ornament was derived from natural forms. But with the aid of an ancient botanical work Pugin had been able to identify the original plants on which some old designs were based, and he had set himself to make a book in which each design was based on a real flower. In the manuscript copy of the *Floriated Ornament* many of the exquisite little figures have names or numbers

1. *True Principles*, 21.
2. *Apology*, 15.

referring to the botanical work in which they were studied, and one may see with what Ruskinian conscientiousness Pugin has followed nature.[1]

The first of Pugin's true principles is even more far-reaching. Its influence on our feelings towards architecture has been so great that we are unaware of it. When Pugin insists on the importance of local materials and local traditions, he seems, like Montesquieu, to be reminding the world of forgotten platitudes. Most of us prefer buildings to seem 'as if they formed a portion of nature itself, grappling and growing from the sites in which they are placed'.[2] But Pugin's contemporaries found something attractive in the most promiscuous exoticism.

We cannot, fortunately, import the climate of a country with its architecture, or else we should have the strangest possible combination of temperature and weather; and within the narrow compass of Regent's Park the burning heat of Hindoostan, the freezing temperature of a Swiss mountain, the intolerable warmth of an Italian summer; with occasional spots of our native climate.

Such were the deplorable effects of too-easy communications.

But a too-easy reading of history was equally fatal, and the Gothic Revival before Pugin's time was responsible for the worst offenders of all. Neither convenience, construction, nor propriety was observed at Fonthill; nor in the castles with 'how many portcullises which will not lower down, and drawbridges which will not draw up'. The Gothic mansions of the time were either Palladian blocks stuck over with plaster pinnacles, or designed with a view to the picturesque, and 'so unnaturally natural as to appear ridiculous'. Only be natural, said Pugin, only make an honest attempt to overcome local

1. The botanical work was the *Tabanae Montanus cicones Planatarum*, Frankfort, 1590. Pugin's copy and the MS. of the *Floriated Ornament* belong to his grandson, E. Pugin Powell Esq., through whose kindness I was allowed to compare them. The beautiful colour and sensitive drawing of Pugin's designs were completely lost in the primitive colour-reproductions of the day.

2. *True Principles*, 46 et seq., contains this and the following passages quoted or paraphrased.

and constructive difficulties, and picturesqueness would appear like a capricious, unbidden guest. And when this was grasped, the Gothic Revival need no longer confine itself to mansions and churches; Gothic would no longer be one architectural style, but the best and simplest way of building.

There is no reason why noble cities, containing all possible convenience of drainage, water-courses and conveyance of gas, may not be erected in the most consistent, yet Christian character. Every building that is treated naturally, without disguise or concealment, cannot fail to look well.[1]

For such ideas Pugin deserves our gratitude. That they contain the whole secret of fine buildings no one would maintain. All that can be said against them, and a little more, has been said by Mr Geoffrey Scott, and I need not repeat it here. Pugin himself knew well enough that there was a beauty which can be accounted for by no principles, and his work abounds in appeals to a purely visual standard, to what Mr Scott would call 'humanist values'. We may doubt if the treatment of modern industrial areas 'naturally, without disguise or concealment' inevitably produces a noble city; and there are many other instances, especially in town architecture, when his principles do not apply. But to say that they are mere fallacies is deliberate perversity. The two principles of architecture have been compared[2] to two systems of gardening – 'bedding out' and the herbaceous border. Both may be pursued with success; and for formal effects the first is infinitely preferable. But as a principle it is dangerous; it is too dependent on the taste of the gardener and too soon sinks to smugness, pretentiousness, and monotony. While the herbaceous border, even at its most unkempt, keeps something of the freshness and variety of nature herself. Pugin was the first apologist of the herbaceous-border principle; and his importance to the Gothic Revival is clear when we remember that it was on this principle that Gothic

1. E.g. *True Principles*, 16, 17.
2. *The Times Literary Supplement*, 17 February 1927.

had grown up and it was on this principle alone that it could be revived.

To his influence the next three chapters will testify; but since it is always hard to believe that a man so little known was really so very important, it is worth quoting one concrete instance of contemporary opinion. I have chosen this from the writings of Gilbert Scott, who is perhaps the most representative figure in the whole Revival.

I was awakened from my slumbers [he says] by the thunder of Pugin's writings. I well remember the enthusiasm to which one of them excited me, one night when travelling by railway, in the first years of their existence. I was from that moment a new man. What for fifteen years had been a labour of love only, now became the one business, the one aim, the one overmastering object of my life. I cared for nothing as regarded my art but the revival of Gothic architecture. I did not know Pugin, but his image in my imagination was like my guardian angel, and I often dreamed that I knew him.

Nor did Pugin's influence die with his contemporaries. From Ruskin to Mr Geoffrey Scott his ideas formed the foundations of architectural criticism.

Alarmed by such eulogy, the suspicious reader may ask why Pugin's name has been forgotten. Not because he wrote badly. Too often the prophetic mantle muffles speech, and we search darkly for truth in a broth of words. But Pugin wrote a clear, readable style; my quotations give no just idea of his vigour and richness of imagery. It is easy to find other circumstances which assured his oblivion. First, he was an English Roman Catholic; in the works of such men a tiny cloud of religious controversy overshadows great tracts of fertile country. Secondly, his ideas were taken up by a mind far more universal and better equipped for the work of prophecy. If Ruskin had never lived, Pugin would never have been forgotten. And thirdly, there is the distressing fact that Pugin's work contains a great deal of nonsense; for great and inventive as Pugin was in the discovery of new truths, he was even more fertile in their misapplication. His statement of the organic connexion be-

tween architecture and society is admirable. But its action on
the nineteenth-century mind was disastrous. For one thing it
had to be reconciled with a revival of Gothic architecture. An
ordinary man might say why, if architecture must spring from
a state of society, medieval architecture should suddenly
blossom in the world of the Great Exhibition. Pugin could only
answer: 'While we profess the creed of Christians, whilst we
glory in the being Englishmen, let us have an architecture the
arrangement and details of which alike remind us of our faith
and our country.'[1] And he claimed that 'We are governed by
nearly the same laws and the same system of political econo-
my'[2] as those of the Middle Ages, an argument which even the
disputants over the Houses of Parliament were reluctant to use.

Another inference drawn from the same statement was even
more unfortunate. If architecture depends on a state of society,
then the better the society, the better the architecture. From the
verbal logic of this proposition Pugin and his contemporaries
could see no escape; and its application was obvious. Christian
architecture must be as much better than Greek as Christianity
is better than even the best Paganism.[3]

Still greater was the contrast between the men of the Middle
Ages and Pugin's own faithless contemporaries; and in his first
extraordinary book he seeks to show a corresponding differ-
ence between the architecture of the two epochs. *Contrasts: or,
a Parallel between the Noble Edifices of the Middle Ages and the
corresponding Buildings of the Present Day; showing the Present
Decay of Taste. By A. Welby Pugin, Architect*, was published in
1836, three years after its author's conversion. Yet it would be
a mistake to over-emphasize the Roman Catholic element of
the book; Pugin afterwards tempered its violently Catholic
tone;[4] and the work has an importance beyond that of a
Roman Catholic pamphlet. For here we have the clear expres-

1. *Apology*, 6. 2. ibid., 37. 3. ibid., 4–7.
4. In the second edition. Pugin's own copy of this edition is in the British
Museum. It contains an unpublished drawing, 'Catholic Church in 1839'. The
exterior is bastard Egyptian; the interior very tawdry and full of inattentive and
even rowdy people.

sion of two new ideas. One of these – the idea that a work of art is essentially connected with the state of society – we have already stressed. The other is almost as important, for it is really a new conception of the Middle Ages.

Of course there were many sympathetic students of the Middle Ages before Pugin, and many who loved to dwell on the courage and piety of its great men. But their attitude was, in the simplest sense, romantic; they loved the middle age as something remote and unconnected with their ordinary lives. To Pugin, however, the life of the Middle Ages was not strange or impossible, but the only good life. He looked on its social structure as a model by which contemporary society must be reformed; and only when the piety and public spirit of that time were re-established could a true Christian architecture arise. The tiny plates of Pugin's *Contrasts* contain the germs of Christian Socialism and St George's Guild.

At first sight they are innocent enough. They purport to give the opportunity for an unbiased comparison of architectural styles. 'I hope it will be acknowledged', said Pugin, 'that I have conducted the comparison with the greatest candour.' Only the last of them shows a balance in which the fourteenth century, represented by a cathedral, weighs down a mass of nineteenth-century architecture – classical façades and towers piled uncomfortably on a too-small tray.[1] Gradually as we study his fascinating etchings we see how cunningly Pugin has weighed the scales with ethics.

In two, at least, the ethical intention is made quite clear: in the Contrasted Towns and the Contrasted Residences for the Poor. It is not merely visual beauty which makes the 'Catholic Town in 1440' so admirable. The various buildings are numbered, and if we consult the key to the 'Catholic Town', we find that each number refers to an ecclesiastical building; in the key to the same town in 1840 some numbers still refer to ecclesiastical buildings; but what a change from Catholic

1. Among them we can recognize Nash's church at Langham Place and the Duke of York's Column.

unity! Baptist Chapel, Unitarian Chapel, even Mr Evans's Chapel, have taken the place of St Alkmund's, St Marie's and St Peter's; where St Botolph's stood is the Socialist Hall of Science. Worse still, St Thomas has become the new Jail, and All Saints the Lunatic Asylum; and in the grounds of St Marie's Abbey stand the Gas Works. In the drawings the contrast is brought home with extraordinary ingenuity, not only by the immediately forbidding air of the modern town – its jail well in the foreground, its forest of chimneys where once there rose a forest of spires – but by the most subtle details. Only after some minutes do we notice that the pleasure-ground is made over the hallowed dead, that there are railings round the new monument and a tollgate on the iron bridge. In the Residences for the Poor the ethical note is perhaps a trifle shrill. Bentham's Panopticon makes an amusing counterpart to St Cross; but the modern Master, with his top boots, irons, and 'cat', is melodramatic, and the contrast between him and the gentle, generous medieval master is too sharp. We suspect sentimentality, and are put on our guard. Ethical suggestion is more cunningly introduced into the Contrasted Public Conduits. Freely, from the rich Gothic fountain, a robust young man is drawing a cup of sweet water. But from the foul modern pump a policeman has driven away a wan urchin who has come with his battered can (only a drop of water!); while another policeman lounges sardonically in the door of the police-court – and indeed his colleague's action is unnecessary, for the handle of the pump is fastened with an immense padlock.

Not all the nineteen plates weigh the scales so openly; but none provides the material for an unbiased architectural judgement. Perhaps this is just as well. The dignified panelling of the modern Contrasted Altar might seem to us preferable to its fussy Gothic counterpart, were it not made repulsive by an ingenious trick of shading and the disproportionate hugeness of its church furniture. And much of the street architecture which Pugin pilloried has come back into fashion. We have lamented

the destruction of Nash's Regent Street, and have not sought
consolation in any of Pugin's still extant buildings. But how-
ever great the revolution of taste, the skill with which Pugin
has made Gothic appear rich and solid – the lavish shading and
well-contrived detail, and the nineteenth-century architecture,
skimped and preposterous, is irresistible. We are won over by
every unfair artifice at his command; but, then, we do not open
the *Contrasts* to be convinced by close logic or impartial ex-
position. We open it to be amused; and amused we are. Mr
Goodhart Rendel has called it the most entertaining book on
architecture ever written. Superlatives are uncomfortable
things, but the *Contrasts* needs one; and I must make this my
excuse for its having seduced me from the straight path of my
arguments. For, after all, the central doctrine of the *Contrasts*,
and the one that concerns us most closely, is the direct con-
nexion between art and morality. Good men build good build-
ings. We may envy the simplicity of an age which could use
the word 'good' twice in the same sentence without attempt-
ing its definition.

From the *Contrasts* we may date the whole attempt to judge
the value of a work of art by the moral worth of its creator.
Pugin must be made responsible for another and more insidi-
ous way in which morality entered into criticism. He had said
that every feature of a building should be essential to its con-
struction, and that every element of construction should be
frankly shown. Mere decoration, such as a false front, he de-
plored; he also deplored the concealment of important
decorative features, such as the flying buttresses of St Paul's. In
such cases, it seemed to him, the laws of beauty and morality
coincided; an attempt to deceive produced a building archi-
tecturally deplorable. This theory is quite clear, and Pugin him-
self never applied it very strictly. But even his obituary notice
in *The Times* contains passages like the following:

That very little of the architecture of the last century [the eighteenth]
and the present is beautiful is not the heaviest charge we have to bring

against it; the heaviest charge is that it is utterly false, [and] it was he [Pugin] who first showed us that our architecture offended not only against the law of beauty, but also against the laws of morality.

Architecture was to be judged by two independent standards, an aesthetic and a moral of which the second was the more important. It seems unkind to make Pugin responsible for such confusion. Yet I am afraid he began it. An ethical tone pervaded all his writings, and in condemning façades or blind windows he used such expressions as 'unworthy deception' or 'abominable sham'. 'Perhaps the greatest service has been done', wrote Ferrey, 'by Pugin's unsparing exposure of the system of SHAMS in architectural design.'

Thus Pugin laid the two foundation stones of that strange system which dominates nineteenth-century art criticism and is immortalized in *The Seven Lamps of Architecture*: the value of a building depends on the moral worth of its creator; and a building has a moral value independent of, and more important than, its aesthetic value. We must not consider this emphasis on morality peculiarly Victorian. Whenever aesthetic standards are lost, ethical standards rush in to fill the vacuum; for the interest in aesthetics dwindles and vanishes, but the interest in ethics is eternal.

One other of Pugin's doctrines was to influence architecture. He deducted it from the innocent proposition that a building must express the purpose for which it was designed. Now a church is designed for the worship of God; and this purpose is expressible in two ways: by providing all the arrangements necessary to His worship, and by symbolizing the faith of Christianity. Once more it is in the *Contrasts* that we find this treatment of church architecture first insisted upon. Before that date the arrangement of the Commissioners' churches had been criticized, and there are occasional references to the symbolical purpose of Gothic. But Pugin demands an observance of traditional forms far stricter and a symbolism far more fully developed than any which had preceded him.

He gives ecclesiology, so closely connected with his love of ritual, a prominent place in his work. Yet in this matter he has less than his usual claims to be considered as an originator. The need for symbolism was widely felt when he began to preach it, and it was not through his exertions that ecclesiology gained its astonishing dominion over architecture.

Chapter 8

Ecclesiology

'The most important requisite in erecting a church is that it be built in such a way that the Rubricks and Canons of the Church of England may be consistently observed, and the Sacraments rubrickally and decently administered.' These words were written in 1840, not by a ritual-loving papist, but by a Protestant archaeologist and student of architecture. Twenty years earlier they would have been impossible. In all the criticisms of new churches contained in the *Gentleman's Magazine*, the *Quarterly*, and other periodicals, I have found no references to ecclesiology; the word was not known. Then suddenly it appears everywhere. All over the country men arise with feelings of no ordinary kind and address meetings on the subject; little groups are formed to study it; it provides matter for a monthly magazine; it inspires hatred and lifelong persecutions. Because these passions affected Gothic architecture, it is our business to find out how they arose. To do this we must turn back to that religious movement with which the Gothic Revival became inconveniently associated.

Professor Halévy, studying early nineteenth-century England with a comprehensive and unprejudiced mind, found it dominated by two doctrines, the Utilitarian and the Evangelical. Both of these were naturally opposed to the Established Church. On the one side Brougham's steam Intellect Society was producing cocksure scepticism which found religious forms and traditions an easy butt; on the other, the dissenters, equally contemptuous of forms, were employing the last resources of emotionalism, unsupported by solid doctrine or authority. In face of these assaults the Established Church pur-

sued a very unwise policy. We have said that the clergy of that date were naturally opposed to emotion and display. Instead of allowing the Church's traditional authority to impose on men's imaginations, they made feeble appeals to reason; instead of a stately liturgy performed with ceremony, they gave cautious sermons in bleak churches. The establishment rested on a negative force – lethargy and indifference – and by 1832 this force was exhausted. 'The Church as it now stands,' wrote Arnold in that year, 'no human power can save.' And for a time it seemed that he was right. The new Leviathan, having tasted the blood of peers, roared for the blood of bishops. But in July 1833, when things were at their worst, Mr Keble preached his famous assize sermon on National Apostasy; and the same month a few scholars and divines met at Hadleigh to discuss this lamentable state of affairs. They decided to see what could be done by tracts. Newman wrote the first of these; and the Oxford Movement had begun.

The means which the Tractarians used to bring back colour and emotion into religion were similar to those by which the poets had brought back these same qualities into literature. To all who dreaded or despised the present, the past, and especially the medieval past, was wonderfully exciting. Poets had revived the old forms of writing: the Tractarians were to revive the old forms of worship. There was, of course, nothing unusual in this; almost all Christian sects begin by claiming the early Church as their authority. But whereas Luther, Wesley, and the rest sought in remote ages for the purest form of Christian worship, the Tractarians sought for those parts of Christian dogma which were richest and most satisfying to the imagination.

Such a search inevitably led them backwards, and sometimes – there was the difficulty – it led too far backwards. Ask 'What is the English Church?' and 'On what sanction does it rest?' and, if you wish to avoid Erastianism, you must trace it back step by step, back past the Revolution and the Great Rebellion and the various stages of the Reformation, back to

the Holy Catholic Church of the Middle Ages; which means popery. Hurrell Froude's keen mind saw this difficulty, and he spent the last years of his life trying to overcome it. But the majority of Tractarians, more interested in doctrine than authority, had found a comfortable resting-place in the epoch just preceding the Rebellion.

I had a supreme confidence in our cause [wrote Newman, concerning the early tracts]; we were upholding that primitive Christianity which was delivered for all time by the early teachers of the Church, and which was registered and attested in the Anglican formularies and by Anglican divines. That ancient religion had well-nigh faded out of the land through the political changes of the last hundred and fifty years, and it must be restored.

So to the Tractarians themselves their movements made no approaches to Romanism: indeed, they afterwards maintained that it was definitely anti-Roman as much as it was anti-Erastian. Yet, as Dean Church has said, 'It taught people to think less of preaching than of what, in an age of excitement, were invidiously called forms – of the sacraments and services of the Church.' To the old two-bottle school forms meant Rome. The suspicion of popery could not be shaken off; and in 1838 it was determined to test the University's blood by a proposed memorial to the Protestant martyrs. Many of the Tractarians failed at this test; and a year later the greatest of them began to change –

It was necessary for me to have a positive Church theory [wrote Newman], erected on a definite basis. This took me to the great Anglican divines; and then, of course, I found at once that it was impossible to form any such theory without cutting across the teaching of the Church of Rome.[1]

In 1843 Newman retracted all he had said against Romanism and resigned his post at St Mary's; two years later he was received into the Roman Church. He left many of the Tractarians convinced Anglicans, snugly embedded in early seven-

1. *Apologia.*

teenth-century theology; but the movement as a whole was irrecoverably identified with popery.

I hope that no reader of these hasty paragraphs will imagine that the motives of the Oxford Movement were merely romantic. This, indeed, was the great mistake of the movement's enemies in Oxford: they supposed that the Tractarians stood for no more than a sentimental medievalism which had long been fashionable, and they quite overlooked the theological learning and moral earnestness which made the movement solid. Yet it had its strong, if unconscious, romantic side, and it is this which links it with the Gothic Revival. There was, it is true, very little connexion through the chief personalities involved. Mozley, who was himself a keen Gothic revivalist, tells us[1] that Keble was 'a latitudinarian, if not a utilitarian in architecture', and that Newman 'never went in for it';[2] even Froude, though he wrote an article on the rise of church architecture and spent three days with Mozley measuring and sketching St Giles's at Oxford, was clearly 'more penetrate and inspired by St Peter's than even by Cologne Cathedral'. Yet the two movements were very similar in aim and temper; and there was the definite connexion through ritual.

Only special students of the period knew how greatly the English Church of 1830 differed from the English Church today. Chancels and altars, clergymen in surplices, anthems, festivals, frequent standings and kneelings – these form part of everybody's mental picture of an Anglican church. But to understand the development of the Gothic Revival we must imagine a time when all these forms were unthinkable. To a good Protestant of 1830 the least suggestion of symbolism – a cross on a gable or on a prayer-book – was rank popery. All forms of ritual were equally suspect. The clergyman wore a black gown and read the communion service from his pulpit;

1. Mozley, *Reminiscences*, I, 216–18.
2. It has recently been shown, however, that he himself probably superintended the design of his church at Littlemore in a plain Gothic style, cf. John Rothenstein in the *Architectural Review*, vol. XCVIII, December 1945, 176.

no one knelt during the longer prayer, or stood when the choir entered; indeed, the choir, if it existed at all, was hidden in a gallery, where it performed to the accompaniment of violins and a cello. The old Gothic churches had been gradually adapted to suit this type of service. Superstitious features such as piscinae and sediliae were abolished; since altars were seldom used, even as tables, the chancel was either abandoned or employed as a vestry;[1] and whatever symbolical sculpture existed in the nave was concealed by massive, comfortable pews for the rich and precarious galleries for the poor. The new churches, built directly to the required plan, had not the waste space of chancels and side chapels. But even so we have seen that the Gothic style had disadvantages: a small chapel could be a rectangular box, but the larger the box, the more inconvenient it became; piers were needed to support the roof, and the preacher became inconveniently removed from his audience. The only sensible type of large protestant church is the Frauenkirche at Dresden, built like a circular concert hall, and however much the Gothic style was mauled about, it could hardly be adapted to a circular plan. Even the Albert Hall could not echo the style of the Albert Memorial.[2] Fashion and economy had led to Gothic being applied to ecclesiastical architecture, but the connexion was too superficial to have survived practical difficulties.[3] Had Anglican requirements remained unaltered, Gothic would have been abandoned as a style for churches, and the Gothic Revival would have died with the death of Beckfordian romanticism. But the Tractarians wished to revive old ritual, and to do so they required churches in which it could be accurately performed – churches with altars and deep chancels; moreover, they wished to move the imagination through symbols, and for this they required the sculp-

1. A correspondent to the *Gentleman's Magazine*, October 1782, 480, speaks of the 'old preposterous mode of *chancelling* a church', and has to explain what the word chancel means.

2. Though Gilbert Scott actually made a Gothic design for the Albert Hall.

3. Courageous efforts to build a truly Protestant church in the Gothic style were made as late as 1837; cf. *Architectural Magazine* for that year, 505.

1. RUINS AND ROCOCO
(from Bentley's *Gray*)

2. THE GARDEN GATE
(from Walpole's *Description of Strawberry Hill*)

3. AN OCTANGULAR UMBRELLO TO TERMINATE A VIEW
(from Batty Langley's *Gothic Architecture Improved*)

4. THE CHIMNEY IN THE GREAT PARLOUR
(from Walpole's *Description of Strawberry Hill*)

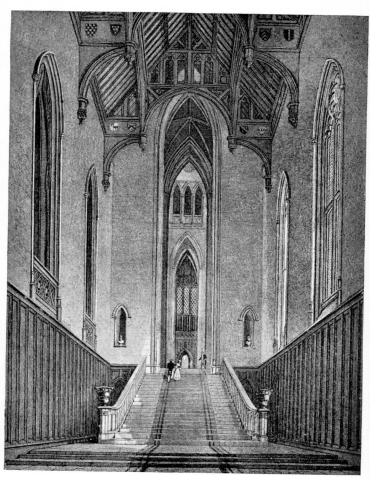

5. THE GREAT WESTERN HALL
(from Rutter's *Deliniations of Fonthill*)

6. FONTHILL ABBEY FROM THE NORTH-WEST (from Rutter's *Deliniations of Fonthill*)

7. ALTERNATIVE CHURCHES FOR THE COMMISSIONERS (from a drawing by Sir John Soane)

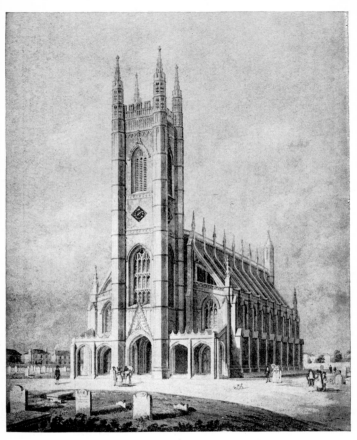

8. ST LUKE'S, CHELSEA
(from an old print)

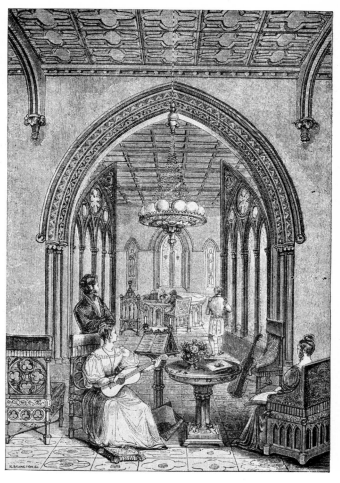

9. A VILLA IN THE THIRTEENTH-CENTURY STYLE
(from the *Architectural Magazine*, 1836)

10. ENTRANCE TO THE DEMESNE OF MARYEE (from Goodwin's *Rural Architecture*)

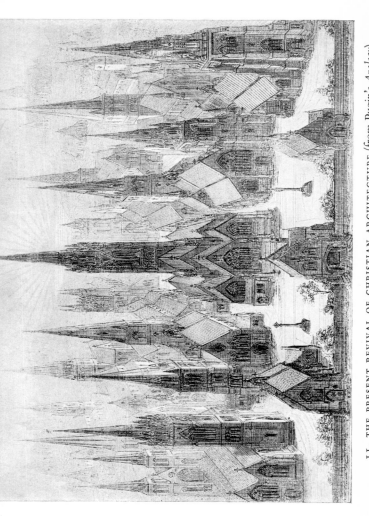

11. THE PRESENT REVIVAL OF CHRISTIAN ARCHITECTURE (from Pugin's *Apology*)

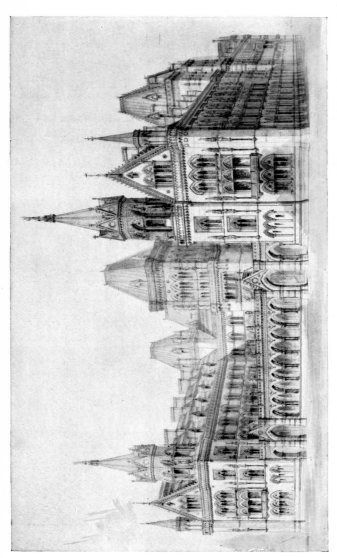

12. COMPETITION DESIGN FOR A NEW FOREIGN OFFICE BUILDING SUBMITTED BY
GEORGE GILBERT SCOTT IN 1856

13. THE OXFORD MUSEUM

14. CONTRASTED TOWNS: A CATHOLIC TOWN IN 1440 (from Pugin's *Contrasts*)

15. THE SAME TOWN IN 1840

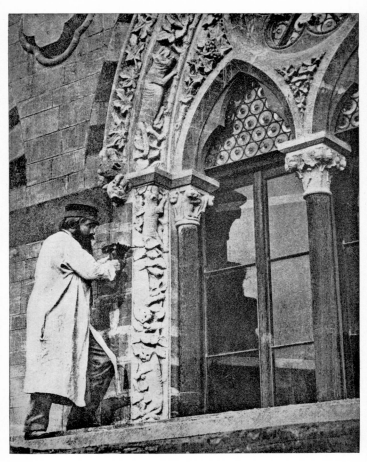

16. O'SHEA AT WORK

ture and architecture of the church to be rich in symbolical device. In short, they wanted a true Gothic church.

The Tractarians had arrived at Gothic architecture by reversing Pugin's position. He had said: to revive Gothic architecture you must also revive old forms of worship. They said: to revive old forms of worship you must revive Gothic architecture. His impulse had been primarily architectural, theirs was primarily religious; and since religion is a wider and more exciting topic than architecture, their theories of Gothic became more influential than his. We have already seen architecture becoming dangerously involved with ethics; in this chapter we shall see a still more curious confusion of values.

The body which was chiefly responsible for this confusion appeared in 1839 with the title the Cambridge Camden Society. Two undergraduates of Trinity College, J. M. Neale and Benjamin Webb, were moved to reform church architecture and revive ritual arrangements. They communicated their enthusiasm to their tutor, the Rev. T. Thorp, and several of the younger members of the University, and formed a club with Thorp as president, and began to publish manifestoes. 'The object of this society', they wrote, 'shall be to promote the study of Ecclesiastical Architecture and Antiquities, and the restoration of mutilated Architectural remains.' To judge by this, their first rule, we might suppose them to have been a body of innocent antiquarians, similar to those described in a previous chapter. But when the members' pamphlets began to appear, and still more when, in 1841, they published a monthly magazine, the *Ecclesiologist*, it became obvious that their aims were not those of Dr Syntax or Mr Oldbuck.

It would be unfair to examine the Society's early writings from an architectural standpoint, for these do not pretend to criticize a building on architectural grounds. The first edition of *A Few Words to Church-builders* does not say, in effect, 'Follow these instructions and you will get a beautiful building,' but 'Follow these instructions and you will get a building in which

service can be decently and rubrickally celebrated and of which every part proclaims the House of God.' If one believes that God desires certain fixed ceremonies, it is natural to insist that His house has all the arrangements necessary for their performance; such considerations are more important than architectural beauty, just as it is more important to have a kitchen and drains in a house than decorative swags over the windows. Drains and ecclesiology are equally remote from architectural beauty, and in the *Few Words to Church-builders* they are not confused with it. The author announces that 'it is rather his intention to dwell on the Catholick,[1] than on architectural principles, which ought to influence the building of a church'. After such an avowal we should not be surprised to find canons of criticism different from our own, to find that aisles are essential because they stand for the most Holy and Undivided (but not, one would have said, Equal) Trinity, and that transepts can safely be omitted because the shape of the church is similar to that of a ship. True, even these ecclesiastical criticisms are tiresomely inconsistent; a church, for instance, is rather less unlike a ship if the chancel be omitted; and that, of course, was unthinkable. On the whole these Catholic principles are distant enough from architecture to be harmless. But between 1840 and 1850 canons of criticism originally ecclesiastical began to be accepted as architectural; an error of ecclesiology was, of necessity, bad architecture. We can trace the progress of this confusion in the Camden Society's publications.

The trouble began in the first number of the *Ecclesiologist*, where, from the innocent ecclesiastical flock, some aesthetic goats lift up their horns.

There are [says the author], many arrangements and details in the church which, on any other ground, are quite indefensible. . . . Such are the . . . enormous Windows in the Aisles; the mullions made to stand on the same plane as the wall; the startling contrast of red brick and the white quoins of dressed ashlar.

1. Changed in later editions to 'ecclesiastical'.

Here are purely visual standards slipped in among the ecclesiastical; and the review contained canons of criticism still more confusing.

Now herein lies the fault of modern church-builders. They *will* have the ornamental part of the church at whatever cost to the church itself. But that day is nearly gone by; and we may hope ... that a generation more pious, if not more rich, than ourselves may rival our ancestors in their glorious minsters by their carved rood-screens glittering with gold and eloquent with figures, their capital flowers, wanting only life to be equal to Nature's. ... But if ornamental appendages are bad when anything real is given up for their sake, much more are they so when they are imitations of that which they really are not. Stucco, and paint, and composition, and graining are not out of place in the theatre or the ballroom; but in GOD's House everything should be *real*.

Piety more necessary than riches, nature's flowers the highest form of beauty, all shams iniquitous – we recognize them at once; they are the chief weapons in that great critical arsenal which we associate with the name of Ruskin; and their use as a matter of course nine years before *The Seven Lamps of Architecture* proves how little Ruskin was an originator, proves that even Pugin was expressing prevalent ideas. But for our immediate purpose these criticisms are important because they form a link between visual standards and ecclesiology. From Pugin's time onwards ethics were accepted as having architectural importance. If ethics, why not symbolism? Both are equally remote from architecture.[1]

In 1843 the Camden Society struck a great blow for ecclesiology. Two of its founders, Mr Neale and Mr Webb, published a translation of Durandus, the chief expounder of medieval symbolism, to which they added an introduction on the place of ecclesiology in architecture. They set out to prove that cor-

1. This is what geologists call an intrusion from an earlier layer of my mind which had been influenced by Scott's *Architecture of Humanism*. Long before my book was finished I had enough sense to see that neither ethics nor symbolism are remote from architecture at all (1948).

rect symbolism – they preferred the obscure but solemn word sacramentality – was essential to Christian architecture, was the quality which distinguished old from new churches – was, in fact, what made old churches more beautiful than new ones. But though they definitely associated ecclesiological correctness and beauty, the word beauty does not often occur in the introduction. 'We cannot', they say, 'hope to convince by aestheticks those who are deaf to more direct arguments'; and these direct arguments are marshalled in a fine philosophical array – arguments *a priori*, arguments from analogy, inductive arguments, and so forth. Yet much of their reasoning is hard to follow.

Now, that the teaching of Nature is symbolical, none, we think, can deny. Shall we then wonder that the Catholick Church is in all Her art and splendour sacramental of the Blessed TRINITY, when Nature herself is so? Shall GOD have denied this symbolism to the latter, while HE has bestowed it on the former? Shall there be a trinity of effect in every picture, a trinity of tone in every note, a trinity of power in every mind, a trinity of essence in every substance – and shall not there be a trinity in the arrangements and details of Church art? It would be strange if the servant could teach, what the mistress must be silent upon: that Natural Religion should be endued with capabilities not granted to Revealed Truth.

Since no examples of symbolism in nature are given, I suppose that it was familiar to the readers of 1843;[1] nor is there any explanation of the trinities quoted; they too were evidently common knowledge. But to most of us they are mysteries. Perhaps this is just as well. The Arguments from philosophy show that our author's reasoning is none the better for being clear. Starting from the undeniable proposition, 'That there is an intimate correspondence and relation between cause and effect,'[2] they soon prove that symbolism is much commoner than we think. Any object, they maintain, which shows the purpose for which it was created, symbolizes that purpose;

1. Who were more familiar than we are with Butler's *Analogy*.
2. *Durandus*, 1.

thus, a chair symbolizes sitting. As I state it, this conclusion seems disappointing, but arrived at through several pages of elaborate exposition, it has the air of an important discovery – a discovery comparable to Monsieur Jourdain's that he spoke prose.

Throughout the introduction the direct arguments are supported by a body of ethical values whose emergence we noticed in the *Ecclesiologist*. Then they were timid and undeveloped; but now they are grown enormously in confidence and articulation. To take the most important of them: in the early numbers of the *Ecclesiologist* the doctrine, 'Good men build good buildings,' hovers nervously in the background. In our introduction it is developed in a way which must have scared many prospective Christian architects, even in that God-fearing age.

To think [they say], that any Churchman should allow himself to build a conventicle, and even sometimes to prostitute the speaking architecture of the Church to the service of her bitterest enemies! What idea can such a person have formed of the reality of church architecture? Conceive a Churchman designing a triple window, admitted emblem of the MOST HOLY TRINITY, for a congregation of Socinians. If architecture is anything more than a mere trade; if it is, indeed, a liberal, intellectual art, a true branch of poesy; let us prize its reality and meaning and truthfulness, and at least not expose ourselves by giving to two contraries one and the same material expression.[1]

This passage shows most clearly the connexion between an architect's religion and his work; and his whole conduct of life was no less important, not only 'the deeply religious habits of the builders of old', but also 'the Hours, the cloister, the discipline, the obedience, resulted in their matchless works; while the worldliness, vanity, dissipation and patronage of our own architects issue in unvarying and hopeless failure'.[2] Here is the Ethical Fallacy in full sail; on a sea so accommodating a Symbolical Fallacy could be launched without risk.

There was another reason, beside those given by Mr Neale,

1. xxii. 2. ibid., xxv.

why ecclesiological values should be popular. The Romantic upheaval of the early nineteenth century had left men with no fixed standards by which to judge a work of art. The sensible old Johnsonian criticism was long ago discredited, and as Grecians retired before Goths in the battle of the styles, the magic light of authority faded from Vitruvius. Vitruvius had provided the world with the simplest of critical weapons – a set of rules; and when these lost their power the critic was forced to rely on his individual judgement, an exhausting and risky state of affairs. By 1840 the world was looking for a new set of rules, for some new authority to spare it the discomforts of thought. For a time the search seemed hopeless; the battle between Goth and Grecian still raged; Professor Cockerell, the official guardian of architectural values, gave milky lectures, with a neat printed syllabus which traced the history of architecture back from the Parthenon to Noah. But from this babel of uncertain sound one voice rose, clear and firm – the voice of the Camden Society. The fact that they usually spoke of questions only accidentally concerned with architecture did not matter. They spoke confidently and they provided a set of definite rules: accept their values and it was once more possible to use the precious word *correct*. 'If, then, one could ensure the greatest technical accuracy in details,' writes a contributor to the *British Critic*, 'still if the Genevan principle of a house of God instead of the Catholic be adopted, the result must be an *architectural* monster.' Ecclesiastical correctness has become an essential part of architectural excellence.

It is hard to believe that the pietistic archaeological society of a University should have a very great influence on architecture. Yet such was undoubtedly the case. With the spread of Tractarian doctrines men began to discover within themselves a half-repressed desire for ritual; and symbolism achieved the sudden popularity of a new sport. The Camden Society was first in the field, and remained the most influential of many similar bodies. The Oxford Architectural Society, as large and almost as active, can be considered under the same head as its

Cambridge counterpart, though there were differences between them; for in Oxford it was unwise to take too great a part in controversial theology, and the Architectural Society could not stiffen its pamphlets with the doctrinal fervour of the Camdenians. Small societies seem to have flourished in most cathedral towns; I have read pamphlets from those of Exeter, Norwich, and Durham timidly echoing the Camden Society's prophetic cry.

There is plenty of evidence that these societies were influential. The correspondence of the Oxford Architectural Society consists almost entirely of letters from country clergymen who wish to rearrange their churches, or from committees who are entrusted with the building of new ones. Can the Society advise them as to *correct style* and arrangement? Is a spire essential? Can a stove be placed in the vestry? Is it better for the west window to have two lights, symbolizing Christ's dual nature, or three, symbolizing the Trinity? Finally, how is it possible to raise funds? Perhaps the Society can help, with a small subscription, to re-establish religious architecture in this Christian land? And later we read how, with the Society's help and advice, chancels have been cleared and pews removed,[1] and even altars erected.

The Camden Society's correspondence seems to be lost. It must have been similar to that of the Oxford Society, but even more extensive. It is clear from the letters and articles in the *Ecclesiologist* alone how widespread was the desire for correctness, how numerous were the appeals for help. And its influence did not stop at country parsons and committees. Prosperous architects sought and followed its advice.

1. Sometimes prematurely. A Mr Hancock of Yeovil removed the pews from his church and gave bills to the recipient of pew rents which he was unable to realize. Month after month he wrote the Society appeals for money: 'I tell you, in confidence, that unless I get substantial help by Friday I am utterly ruined here. . . . I can no longer hold the pen in my hand.' There is no record of help being sent to Mr Hancock. Every cause has its martyrs, though the Gothic Revival has fewer than most (*Unpublished Correspondence of Oxford Architectural Society*, letters 420–33).

My first church [wrote Sir Gilbert Scott] dates from the same year with the foundation of the Cambridge Camden Society, to whom the honour of our recovery from the odious bathos is mainly due. I only wish I had known its founders at the time.[1]

Throughout his life he appealed to the University societies whenever he wished to influence public opinion in his favour;[2] and in all matters connected with publicity Gilbert Scott's instincts were infallible.

The Camdenians were not in a position to use their power mercifully. In a world full of doubt their intolerance was their strength, and they knew it. They were ruthless and infallible tyrants.

I remember [wrote Gilbert Scott] one amusing little key to their line of conduct. They had criticized one of the very best churches I had ever built [and one in which all their principles were carried out to the letter] in a way which led to a remonstrance from the incumbent, who pointed out glaring errors in matters of fact. The line of defence they took was this, that as they had nothing on which to ground their critique but a small lithographic view, the onus of any errors they might have fallen into did not lie with themselves but with the architect, who had abstained from submitting his working plans for their examination.[3]

No wonder architects turned pale at their name, like heretics before the great inquisition;[4] for rebellion was as the sin of witchcraft and refusal was as the iniquity of idolatry. With Pugin, who had exposed the inconsistency of their religious position, they committed a sort of patricide, uttering grave warnings against the insidious charm of his designs; and if their own offspring turned away from the light they were pitiless. Like Calvin and Robespierre, they allowed no human accidents

1. *Recollections*, 86. The tribute should be unbiased, for Scott had broken with the Camden Society when he wrote his recollections.

2. *Correspondence of Oxford Architectural Society*, letters 105, 106, 477, 478, 479, 485.

3. *Recollections*, 105–6.

4. Only two, Carpenter and Butterfield, survived; and Carpenter died young.

to weaken their zeal for truth. The few Gothic architects who did not submit were used as awful examples to the elect. Petit, for instance, had mentioned taste and proportion, 'principles which . . . we will persist in condemning as most pernicious in themselves, and most derogatory to God's glory'.[1] Architects who continued to build in the Grecian style were ignored; only Professor Cockerell's academy lectures were noticed, and they, of course, were lamentable. 'The scriptural notion of art, as shown in the case of Bezaleel, is never recognized.' Furthermore, the professor had said that 'the Middle Age Church was wholly founded on superstitious associations, which, if said deliberately, means something too ignorant and too profane to need refuting'. But worst of all was his belief 'that such a thing as Anglo-Protestantism ought to exist or does exist in any authoritative form'; for the professor had struck at the foundations of Camdenism.

The architectural doctrines of the Camden Society depended on the revival of full Catholic ritual. Now the clauses of Elizabeth's ecclesiastical settlement were known to be ambiguous; they contained such vague phrases as 'in times past', and referred to an Act of Edward VI without saying which Act was meant. If full advantage were taken of these ambiguities it might have been possible to justify lavish ritual. But this justification would have been Erastian, and as such very distasteful to the Camdenians. Like the Tractarians, they tried to base their position on the early seventeenth century, though with even less success, for it had been possible to get doctrinal satisfaction from the writings of the Caroline divines; but it was not possible to justify ritual from their practice. Fortunately, human beings need no evidence for an agreeable belief, and a great number of honourable men sincerely believed that under Laud church services were conducted with all the traditional ceremonies. The tradition of ritual, they said, was only interrupted by the Puritans, who abolished the old ecclesiological arrangements, and the Camden Society spread these doctrines

1. *Ecclesiologist*, I, 78.

147

so convincingly that to this day a country sexton will tell you that his church was sacked by Cromwell, though it lie in a Royalist centre where Puritan arms never penetrated.

The revival of ritual had been no gradual dawn; and for a moment the more conservative churchmen were blinded by a strong and sudden light. The founders of the Camden Society had, by moral earnestness and the unconscious cunning of the convinced, won over a number of bishops and other influential men to their cause. Yet from the first their innovations had aroused opposition. The use of the word 'altar' instead of 'communion-table' hinted at a grave doctrinal change, a change in the very nature of the Sacraments. And the Camdenians not only used the word but they had erected what was probably an altar in their church at Cambridge. 'Probably' because the definition of 'altar' was a delicate matter: a solid block of stone undoubtedly was an altar; a stone slab on wooden supports was an altar-table, a graceful compromise. The Camden Society had placed its stone slab on stone supports; but the orthodox were dissatisfied.[1] Other features of church arrangement were equally involved with doctrine; for instance, if the pulpit were in the middle of the aisle, the building was a mere preaching house; if at the side, it was a catholic church. In some churches the pulpit was placed on rails that it might be pushed backwards and forwards according to the taste of the community.[2]

The Camden Society was bound to be in trouble as soon as the dumb and dazzled orthodox could perceive its true motives. From the first it had been difficult to refute the profane and reassure the perplexed; and in 1843 the more timid of local architectural societies began to try to dissociate themselves

1. I doubt if altars were used under Laud; if a communion-table found its way into the chancel it was because there happened to be chancels in old churches and it was as well to use them. Nevertheless, a few solid stone altars were erected all through the eighteenth century; they were not associated with any doctrinal controversy and nobody noticed them.

2. Mr H. M. Colvin tells me that such a pulpit still exists in a church in Carlisle, and seems to be in working order (1961).

from Cambridge 'for the purpose, under the Divine blessing, of re-establishing peace and harmony among the members of the Church'. The same year the Bishop of Down and Connor retired; he wrote a most polite letter, saying that he was forced to do so by his committee, but the next month published a violent pamphlet against Camdenism. In 1844 the storm broke. Of the many attacks levelled at the Society I will quote from two, one by a critic of architecture, the other by a theologian.[1]

We feel it a duty [said a writer in *Weale's Quarterly*], at least on the score of professional chivalry, to break a lance with that grand high church champion, who, bearing on his shield the words 'DIOCESAN ARCHITECTURAL SOCIETY', assumes to himself the absolute right of critical dictation. . . .

The matter, *architecturally* not less than *spiritually*, seems to have originated with certain '*clerkes* of OXENFORDE'. As the tracts theological, so have the treatises churchgothical, swarmed upon us; till a public, hitherto ignorant of architecture *in any variety whatever*, is now crammed to suffocation with a spurious knowledge of it *in one variety alone*. An eleventh commandment seems to have issued from heaven itself, declaring, 'Thou shalt not worship the grandeur of Egypt, nor the beauty of Greece, nor the grandeur of Rome, nor the romantic delicacy of Mohammedanism, nor the plastic varieties of Italy – but thou shalt worship only GOTHICISM! Through its mysterious vistas and lengthened arcades alone shalt thou hope to reach the high altar of Christ!'

Impotent incipiency of a bastard superstition! Hopeless tyranny of English church parsondom, seeking, under the banners of architecture, to revive not the power of the Pope – but the power of Popery in its own body! Sad acknowledgment of a want of vitality in Church of Englandism, – of utter despair in its originative influence on the noble art of architecture![2]

As far as I know, this criticism was never answered; for, despite its rhetoric, there is more good sense in it than the Camdenians could easily refute. 'When will our buildings of

1. In these and all following quotations the italics and capitals are transcribed as accurately as the limits of typography will permit.
2. *Weale's Quarterly Papers on Architecture*, II, i (July 1844).

every description – instead of being mere classic or Gothic *recitations* – become original exhibitions of *spontaneous eloquence* ornate with old quotations, but emphatic with new experiences?'[1] The triumph of ethics was not yet complete, and architecture could still be criticized from a standpoint little different from our own.

But mere good sense is a weak weapon, even when supported by typography. Nobody listened to *Weale's Quarterly*; but Mr Close's sermon brought about the Camden Society's fall. It was preached on 5 November 1844, and afterwards published with the title, *The 'Restoration of Churches' is the Restoration of Popery: proved and illustrated from the Authentic Publications of the 'Cambridge Camden Society'.* My copy is 'Fourth edition, four thousand, 1845'. I wish I could quote the whole sermon, which is wonderfully representative of nineteenth-century art criticism. Dr Close's sustained emotion – he employs, I venture to think, more italics than any other author of the century – and the even richness of his language make quotation difficult. The disconnected fragments which follow give little idea of the style of the whole.

It will be my object to show that as Romanism is taught *Analytically* at Oxford, it is taught *Artistically* at Cambridge, – that it is inculcated theoretically at one University, and it is *sculptured, painted and graven* at the other. . . .

In a word – the *Ecclesiologist* of Cambridge is identical in doctrine with the Oxford *Tracts for the Times*. . . .

It is not a question of brick and stone – of taste or of science – the points at issue are purely doctrinal – it is whether Romanism or Protestantism shall prevail. . . .

But enough of such sickening details; enough to establish beyond controversy that *such Restoration* of churches *not only tends to,* but *actually Is* POPERY.

It was a pleasure for the Camden Society to refute this sort of attack; and their reply is in the right tradition of theological controversy.

1. *Weale's Quarterly Papers on Architecture*, II, i (July 1844).

But were the charges ever so intelligible we should scruple to attempt an answer, for a reason which we will put down clearly, yet we are sure in no spirit of vindictiveness or personal hostility. The accuser of the Cambridge Camden Society is a priest: he professes to take up religious ground against the society. Some of his objections are concerned, we understand, with the doctrine of the Incarnation. Now we respectfully, but positively, decline to argue any religious questions, and above all these questions, with him, until he shall have cleared himself from a report which appeared in the public journals during the summer of 1844 and remains, so far as we can learn, uncontradicted namely, that he did at a public meeting, speak in laudatory terms of certain avowed Nestorian heretics. If the report be true we cannot but decline all controversy, and especially on that great article of the faith, the Incarnation, with one who may be thought to share in the anathema of St Cyril and the condemnation of the third general council.

Such was the fervour which our ancestors brought to 'The Study of Ecclesiastical Architecture and Antiquities'.

The Camden Society's dialectical triumph was complete; but theirs was no more than a moral victory. Useless to accuse Dr Close of heresy, useless the anathema of St Cyril, useless even the fact that he himself had erected an altar with a *stone-panelled front*, the most dangerous kind of all. Dr Close had diagnosed the plague, and those in authority could not risk infection. They fled: first the Bishop of Exeter, then the Bishop of Lincoln, then the Chancellor and Vice-Chancellor of the University. In February 1845 it was moved that the Camden Society be dissolved.

Other diocesan architectural societies were shaken. That of Oxford immediately issued a report as strongly anti-Camdenian as was consistent with admiration for Gothic;[1] and even so, those with a grudge hastened to accuse it of Camdenism. A Mr Shepperley, for instance, whose books on Tombs and Monuments had been overlooked, wrote a letter which would be worth reading for its prose style alone.

1. Cf. also *Correspondence*, 267.

In addition to these objections, I am able to assert, from my acquaintance with all the most valuable Works on Gothic Art published in this Country, that the undue interference of parties stranger

to } the every } real spirit of this style ['save to the mere taste of arranging

the type', crossed out] is liable to Entail Consequences directly at variance with the Interests of the Church and to cause the Literary Credit of the Universities of Oxford and Cambridge into a reputedly degraded effusion of Ephemeral ill-digested and discordant productions.

The spacious and outvying Structures of the Church of Rome rising in all parts of the kingdom, with all their dazzling and imposing attractions . . .[1]

And so forth, for many pages, with every now and then the author's personal grievance flashing through the clouds of Protestant eloquence. But the Oxford Society had always been circumspect, and ten years after the great storm had blown over an old member could write and congratulate the Society on its steadiness at that crisis. Nothing, he says, gives him greater pleasure than 'looking at the lists of members and reflecting on the *very*, VERY few among our ranks who have deserted our Church for Rome'.[2]

Even the Camden Society surmounted the crises by the simple expedient of changing its name. As the Ecclesiological Society it continued to publish the *Ecclesiologist* and to control the movement which it had begun. The new title was appropriate, for the Society's chief concerns were ethics and Sacramentality. Since good building depended on good morals, the Society aimed at improving the morality of all who were connected with the erection of a church. I have mentioned the high standards demanded from architects; they were equally concerned with the morals of the workmen employed; and from carpenters, in particular, they demanded 'that holiness of life and thought which, while it is necessary for all their fellow-

1. *Correspondence of Oxford Architectural Society*, 280.
2. ibid., 437.

workers in their several degrees, is to none more becoming than to those in whose occupation He, Whose House they are adorning, did not disdain while on earth, to employ His Sacred Hands'.[1]

Several pamphlets were published exhorting the masons to live holy and serious lives; and especially to repress swearing among the bricklayers.

Even the value of church bells was affected by the morality of the ringers:

> But of the Ringers – the Bells are dumb without them. It is they who enable the Bells to put forth their solemn sound, and tune them to their various purposes. How holy, therefore, is the ringer's office! How deeply religious is the service of such men! How careful should they be about their manner of ringing! How sinful must any careless-ness of ringing be! How very sinful any levity in the performance of their duties! ... How very watchful should the ringers be of their own lives and conversation![2]

We cannot know how far the Society was successful in these endeavours; but correct arrangement was more within the compass of human power, and in 1854 the editor of the *Ecclesiologist* could write, with quiet triumph, 'Church architecture is no longer tentative. It approaches to something of an exact science. It is admitted to be the subject not so much of taste as of facts.'

Had the Camden Society aimed solely at correct symbolism and satisfactory morals, I do not think it would have done much harm. Ecclesiology need not affect the architectural merit of a building either way; indeed, the limitations it im-poses – limitations of form – may lead to the restraint, the intensity, the subtle variations of classicism. But no good can come from limitations of style. By imposing these the Camden Society did its worst service to Gothic architecture.

1. *Ecclesiologist*, I, 151.
2. *The Use and Abuse of the Church Bell* by W. Blunt, A.M. A Priest of the English Church, 1846. His views on the subject may be contrasted with those of an earlier English churchman who wrote, 'Down with these old Chyming chimneys to the drunken whore of Babylon.'

Its final utterance on the question of style occurs in the third edition of its famous *Few Words to Church-builders* (1844). On this point earlier editions of the pamphlet had been lax; they had suggested Early English for small churches and 'either of the other two styles' for larger. It was enough, I suppose, if the church were in a moderately correct Gothic. But by 1844 the Camden Society's doctrines had gained ground. 'We are not now called upon to prove that *Gothick is the only true Christian Architecture*,' says the author; the question now is what period of Gothic is the truest and most Christian. And for many reasons it was clear that one style, and one only, could be tolerated: the Decorated or Edwardian. A few of these reasons are given in the rather obscure language which the Camden Society was forced to employ.

Now if we really indulge the hope that there is yet a higher pitch of glory to be attained [says the author], and which future architects may hope to reach, we may well go back to that point where decay and debasement began, if so be that we may thence strike out a more real and more faithful course; more real because Perpendicular employed meretricious enrichments, and *made* ornament for its own sake; more faithful because the Tudor architects forgot their high vocation of *setting forth truth by beauty*, and symbolized worldly pomp instead of the Catholick Faith; instead of the teaching of the Church, the promptings of Erastianism.

I cannot say precisely what this passage means; the phrase 'setting forth truth by beauty', for instance, seems to me beyond analysis. The critical background is ethical; the Tudor architects were faithless men, and, what was worse, Erastians; no style which continued after the Reformation could be called Catholic. And the passage hints at another motive which Mr Geoffrey Scott has called the Biological Fallacy. Every movement, it was thought, must have a rise, a zenith, and a decline, and the Victorians, with a mistaken sense of symmetry, always placed the zenith in the middle of a movement's course. The 'best period' was the central period. To a later generation it seems that the arts follow no simple, parabolic

line of development. But whether or not 'Decorated' is really the best style of Gothic architecture, it was certainly the worst style for the Gothic Revival. Either of the other two styles was preferable. Early English needed very little detail which an ordinary craftsman could not manage; perpendicular was infinitely the most adaptable of medieval styles and the only one which had been widely applied to civil architecture. But the very simplicity of Early English meant a lack of those ecclesiological details which were the essential part of Camdenian doctrine. A style which flourished before Durandus had written his *Rationale* could not, they argued, be truly Sacramental, and so could not be *real*. And perpendicular was out of the question. It had always been considered beginner's Gothic; those in the know, from Gray onwards, despised it, and the Camden Society had, as we have seen, religious grounds for its opposition.

The strict limitation to the Decorated style has always seemed to me the greatest disaster which befell the Gothic Revival. With limited funds and uninspired craftsmen, it was hard enough to build churches 'Decorated'; and when the revival spread to civil architecture the difficulty was insurmountable. There was practically no English civil architecture of the 'best period'. The wretched architect who set out to build a Gothic railway station was forced either to employ the style of the Angel Choir at Lincoln, or to borrow from abroad. It is hard to decide which course was the more unfortunate. The extraordinary thing is the docility of the architects. Close at hand lay a simple solution to their problem – the forbidden styles. Yet few of them fell; between Pugin and Norman Shaw few reputable architects dared to employ perpendicular.

The full consequences of this restriction may be reserved for a later chapter. But one of them must be mentioned here, for it is a good example of the courage with which the Camden Society stuck to its principles. It needed courage for a society which professed a reverence for medieval antiquities to spend

much time destroying them; but this activity is understandable if we consider the second object for which the Society was founded: 'the restoration of mutilated architectural remains'. The difficulty of restoration lay in this, that most English churches are a patchwork of styles. There are two ways, said the Camden Society, of restoring a church built at different periods: either restore each of the various alterations and additions in its own style, or restore the whole church to the best and purest style of which traces remain. Of these alternatives the Society unhesitatingly recommended the second. Now there were few restorable churches in which some fragment of 'decorated' could not be found. Perhaps there was a porch or a chancel, perhaps only a window, and forthwith the whole church was transformed to suit it. But sometimes the architect was faced with a church built too late to include any detail of decoration. Should he restore 'perpendicular'? Surely not. Surely his manliest course was to pull down the whole church and rebuild it in a real and natural style.[1] It would be interesting to know if the Camden Society destroyed as much medieval architecture as Cromwell. If not it was lack of funds, *sancta paupertas*, only true custodian of ancient buildings.

Little of the matter collected in this chapter is to the Camden Society's credit; and much more that is discreditable can be discovered in its publications. Yet the Camdenians had admirable and sympathetic qualities. They loved old buildings, or at least buildings of the right age; and they loved, though accidentally, some beautiful buildings. On the whole they saved such things from destruction more often than they destroyed them. No one can read the account of a Camdenian field day[2] without being touched by their simplicity and enthusiasm, shining out through the smug, parish-magazine language. Indeed, much of their absurdity is linguistic; phrases that were natural then seem pompous now. Some comic Victorian utterances are quite sensible if translated into the more circumspect

1. Cf. *Ecclesiologist*, May 1847.
2. ibid., I, 58.

language of today. I must own that the Camdenians were unreasonable, overbearing, and sometimes deceitful; but even at their worst they were on the right side, the anti-philistine side.

And no one can deny their success. Through them more than any other agency the Tractarians gained their ultimate victory. For fifty years almost every new Anglican church was built and furnished according to their instructions; that is to say, in a manner opposed to utility, economy, or good sense – a very wonderful achievement in the mid nineteenth century. It is doubtful if there is a Gothic church in the country, new or old, which does not show their influence. I have never seen one which lacks an altar, or in which the chancel is still disused. I have seen few which still contain all their box pews and galleries. In most there are far more positive traces of the Society's influence – encaustic tiles, newly carved sedilia, or elaborate restorations. The Camden Society created the standard Anglican form; so that if, in some glaring Italian street, we see a small Gothic building in the 'decorated' style, we say 'English Church' without hesitation. Even in the east, I am told, one may come upon Camdenian churches, looking as homesick and uncomfortable as the mosque at Woking.

That a long chapter in the history of a widespread taste is devoted to a college architectural society must seem, at first sight, to show a deficient sense of scale. But I doubt if anyone who has studied the subject will deny the Camden Society's importance. For a long time this small group furnished the Englishman's imagination in all that concerned religious architecture. The Camdenians, for complicated reasons, insisted on certain forms; and the average man, who asks nothing more than to have his forms supplied ready-made, accepted them. As these shapes moulded his vision, he became uncomfortable if he did not see them everywhere, not merely in churches, but in shops and railway stations and in his own home; so that instead of building his Gothic villa with simple and practical

Tudor windows, he darkened his rooms and complicated his life by trying to set a sash window between decorated mullions. When we consider the inconvenience of applying correct ecclesiological detail to domestic architecture, we cannot but admire this triumph of idealism in a utilitarian age.

Chapter 9

Gilbert Scott

Everyone who has tried to simplify a period of history knows that he cannot do so without a certain amount of distortion, and that his best hope is to find some representative personality or event which provides a rough-and-ready symbol of the whole complicated affair. In studying the Gothic Revival after 1850 there is, fortunately, one man who can be so used without great injury to truth. In his own day Gilbert Scott was universally believed to be the greatest architect of the revival,[1] and he may still be taken as the most representative. A bare table of Scott's works goes a long way to support the second claim. We have no record of his early works, though we know that between 1835 and 1845 he built at least fifty workhouses, besides churches, mansions, and lunatic asylums. But a list published in 1878[2] gives the names of over 730 buildings with which he was concerned after 1847. It includes 39 cathedrals and minsters, 476 churches, 25 schools, 23 parsonages, 43 mansions, 26 public buildings, 58 monumental works, and 25 colleges or college chapels; but the list is said to be incomplete.[3]

But, in contrast to the architects of the middle age and the Renaissance, who spent their whole lives on two or three buildings, all Gothic Revival architects were hugely produc-

1. This is untrue; or at least it is like saying that de László was believed to be the greatest portrait painter of the twentieth century. He conquered the official and, so to say, the public-speaking world, including a good many people who ought to have known better. But he never convinced the minority who really care (1949).

2. *Builder*, XXXVI, 343.

3. Cf. *Architectural Review*, 185 *n.*

tive, and industry alone does not make Scott an epitome of the movement. For twenty years after Pugin's death three questions agitated the revivers of Gothic. The first of these was how Gothic could be applied to domestic architecture; and, largely dependent on this, was the second, what style of Gothic should be employed; the third was the problem of restoration. Each of these questions is important to us, and in each Gilbert Scott played the chief part. Moreover, he was a popularizer. 'Carpenter and Butterfield', he wrote, 'were the apostles of the high-church school – I, of the multitude . . . they were chiefly employed by men of advanced views who placed no difficulties in their way, but the reverse; while I, doomed to deal with the promiscuous herd, had to battle over and over again the first prejudices.'[1] Nor did he alarm the uncultivated masses by a dry breath of pedantry: 'I am no medievalist,' he said; 'I do not advocate the styles of the Middle Ages as such.'[2] Gilbert Scott stood for the ordinary man who felt an inexplicable need for pointed arches, and it is fitting that he represented Gothic in that great culminating engagement in the battle of styles, the dispute with Lord Palmerston over the Government offices.

'It is common knowledge', wrote Mr Briggs, in the only recent article on Gilbert Scott, 'that his practice was not only the largest, but also the most fraught with historical and national importance that has fallen to the lot of any architect since the Great Fire.'[3] Alas! this is no under-statement, and we naturally ask how Scott came to achieve such a position. After his death contemporaries dwelt chiefly on his modesty, his boyishness, and his genuine piety, but of these enviable qualities only the last can have been of service to him as an architect. Certainly it was not his modesty which brought him to the head of his profession. Scott himself is fond of insisting on his diffidence, but his writings show one of his chief assets to have

1. *Recollections*, 112. All the quotations in this chapter are from this book, unless otherwise indicated.

2. *Domestic Architecture*, 188.

3. *Architectural Review*, August 1908.

been the firmness and audacity with which he recommended his own designs. He was, indeed, a man of great talents, but these were not specifically architectural, were, rather, Gladstonian, and would have won him a high place in public life. Of these talents the chief, and the first to bring him fame, was industry.

In 1834 Scott's father died suddenly. Scott, who was a young architect with no prospect of commissions, acted with typical good sense. He wrote a circular to all his father's influential friends, asking for patronage; and he 'used his interest to obtain the appointment of architect to the union workhouses in the district where his father had been known'. Both steps were successful, especially the second. The new Poor Law Act of 1834 had just been passed, and workhouse guardians, who knew nothing of architecture, fell before Scott's business-like methods.

For weeks [he writes] I almost lived on horseback, canvassing newly-formed unions. Then alternated periods of close, hard work in my little office at Carlton Chambers, with coach journeys, chiefly by night, followed by meetings of Guardians, searching out of materials, and hurrying from union to union, often riding across unknown bits of country after dark.

Finding his old friend Moffat an equally urgent canvasser of unions, Scott adroitly entered into partnership with him; ten years later the partnership was, as adroitly, dissolved. In the midst of his exertions he became engaged to marry his cousin, Catherine Oldrid. 'This', he says, 'afforded a softening and beneficial relief to the too hard, unsentimental pursuits which at this time almost overwhelmed me, and to which I must now return.'

In 1838 Scott built his first church.[1] 'I cannot say anything in its favour,' he tells us, 'excepting that it was better than many then erected.' But 'unfortunately everything I did at the time fell into the wholesale form; and before I had time to discover

1. At Lincoln.

the defects of my first design, its general form and its radical errors were repeated in no less than six other churches'. And he describes their meagre construction, plaster mouldings, even for the pillars, and lack of any regular and proper chancel. 'I had not then', he says, 'awaked to the viciousness of shams, I was unconscious of the abyss into which I had fallen.'

Up to 1840, then, Gilbert Scott was an ordinary utilitarian architect, unusual only in his pertinacity. He had loved Gothic as a child and sketched medieval remains as an apprentice, but in the turmoil of his workhouse practice he lost these dreamy habits; and Scott might never have built in the Gothic style had it not been for Pugin and the Camden Society. The two causes of his conversion acted, he tells us, almost simultaneously; but they influenced his life in different degrees. From the Camden Society, from Mr Webb himself, Scott learnt the importance of ecclesiology, and thenceforward his churches were faultless in arrangement. But, as the son of a low-church parson, he could never completely satisfy the Camdenians, and he horrified them by building a cathedral for a Lutheran congregation at Hamburg. Though Scott was able to show, with great theological skill, that on the cardinal points of doctrine Lutherans and Anglicans agreed, the Society continued to dog him with unweariable malice.

But all through life he worshipped Pugin, and the passage I have quoted in my chapter on Pugin (see p. 127) was written a few months before Scott's death. In an earlier entry he describes how Pugin's articles excited him almost to fury, how he trumped up an excuse for writing to him, and how, to his tremulous delight, he was invited to call, and found Pugin tremendously jolly. The brand of Pugin's burning idealism was stamped into Scott's tough mind, and almost every word he wrote is a reflection of Pugin's principles. Like all disciples, he was forced to fill out his master's terse, abstract propositions, and he often pushed Pugin's ideas rather further than they would go. Pugin, for example, had designed his floriated ornament from an ancient botanical work; Scott became a

serious student of botany, and gave in the Architectural Museum a lecture 'of a very impassioned character', to the effect that all medieval detail might be found in nature. But a difficulty arose: for the foliage of the Early English style no natural origin could be found.

> One night [says Scott] I dreamed that I had found the veritable plant. I can see it now. It was a sear and yellow leaf, but with all the beauty of form which graces the capitals at Lincoln and at Lichfield. I was maddened with excitement and pleasure.

Such was the violence of Gilbert Scott's conversion, such the intoxicating effect of ideals on an otherwise practical mind.

Most inconveniently this revelation found Scott engaged on a church for which he had already designed plaster mouldings; and these had to be converted into stone, 'the builder promising to accept some other change as a compensation'. But the builder 'died before the completion of the work, and his executors ignoring this promise, a good deal of dissatisfaction ensued, though, I must say, they had a very cheap building, and the best church by far which had then been erected'.

The early evidences of Scott's conversion were not all of a kind to satisfy his teachers. We have already seen how the martyrs' memorial was used as a sieve in whose meshes the Camdenians stuck; and we have seen how vigorously Pugin received it. The winning design was by Gilbert Scott. This he owed 'to the kind influence of his friends', for, as he says, it was strange that anyone so little known should have been selected. 'I fancy', he adds, 'that the cross was better than anyone but Pugin could have produced.'

The next four years was a period of church-building, and Scott must have gained some reputation in that field, for in 1844 he was selected as the English representative in the competition for St Nicholas's Church, Hamburg. He began immediately to study German Gothic, whisked through Germany drawing a cathedral a day, and began his plans on the first

morning of his voyage home from Hamburg.[1] Perhaps his admiration for Pugin led him to believe that a stormy sea inspired fine draughtsmanship. It took him several days to recover from the effects of this crossing, but even in his bed of sickness he completed the drawings which were to affect his career so profoundly. The success of Scott's design was, he tells us, 'perfectly electrical'. Germany was not yet awake to the Gothic Revival,[2] and 'as they were labouring under the old error that Gothic was German (Alt Deutsch) style, their feelings of patriotism were stirred up in a wonderful manner'. The effect on Gilbert Scott was equally remarkable. He no longer thought of himself as a modest builder, but as a very great architect, and the world was prepared to share a conviction so strongly held.

The first result of Scott's success was a series of commissions to restore the cathedrals of England. The melancholy details of his work in this field cannot be squeezed into this essay. Most of them can be found in his *Recollections*, which is a necessary supplement to any handbook on English cathedrals. The question of how much avoidable damage was done in these restorations can never be settled. Today we assume that Scott was ruthless and insensitive; and those who have not read his works imagine that he rejoiced in the substitution of new stones for old. Against this view Scott never ceased to protest; his first book was a defence of his methods against those who said he restored too little, and his last pamphlet against those who said he restored too much. In both he insisted that he was a strict conservative, who, if he erred at all, erred in retaining ugly and inappropriate features solely on account of their age; and after

1. It was on this journey that Scott met 'Dr Schopenhauer, an old German philosopher, who usually took his meals at the hotel at which we stayed. I think I never met a man with such grand powers of conversation; but alas! he was a determined infidel. . . . I meant to have sent him some books on the evidences, etc., of Christianity, but I forgot it.'

2. Though in appreciation of Gothic Goethe was among the first, and, since Overbeck and his following, the 'primitives' were popular in Germany. Cf. also Madame de Staël, *Lettres sur l'Allemagne*.

Scott's death numerous deans wrote to confirm this view, telling how Scott had refused to destroy a font or a porch in their cathedral, generously waiving ecclesiological propriety on account of the object's age and beauty. Scott moreover, had the good excuse that the buildings he restored were falling down, and some of them must have been on the eve of collapse, though I fancy he always overrated their danger. If he saved a few cathedrals from ruins, we must, I suppose, look more kindly on their smalmy surfaces.

To reconcile Scott's repeated protestations of conservatism with his present ill fame is not so hard as it seems. In the first place, conservative restoration is a relative term. In Scott's day there were two types of restorer: there was the ordinary hack builder, who might be a rascal ready to sell whatever he thought of value in the church, and, at best, felt it his duty to replace anything which showed signs of age; and there was the Camden Society. The Camdenians, as we have seen, confined their admiration of Gothic architecture to buildings in the 'decorated' style. At their annual meeting in 1847 they discussed the relative merits of two systems of restoration, the Eclectic and the Destructive. By Eclectic they meant rebuilding the whole church in whichever of the old styles was prevalent there; by Destructive, rebuilding entirely in 'decorated'. The members were almost unanimously in favour of this last course, and it was decided that, should funds permit, it would be a worthy object of the Society to pull down Peterborough Cathedral and rebuild it in the style of the best period. Compared to such sweeping methods, Gilbert Scott's restorations were tame indeed, and we can understand the surprise and admiration he must have aroused by refusing to pull down the porch of St Mary's in Oxford. Scott himself claims that he even went so far as to save Renaissance panelling from destruction, though the loss of such stuff could not be taken seriously. 'I fear', he writes of Worcester, 'that I am responsible for the removal of the Jacobean and Elizabethan canopies, and of the choir screen, but I forget now how this is.' Old things –

except, perhaps, old furniture – were commoner then than now.

We must remember, too, that Scott was concerned with *restoration*, not *preservation*. By conservatism we mean leave things as they are, but Scott meant make things as they were. He is careful to point out that he seldom rebuilt from pure conjecture. He would find half the arch of an 'Early English' window embedded in a wall, and so would feel justified in pulling down the 'perpendicular' windows on that wall and rebuilding all of them in the 'Early English' style. 'That,' he would say triumphantly, 'is what the original church looked like'; but to us it looks like nothing except Gilbert Scott. And often he was able to draw evidence as to the original disposition of a building from very slight clues. A few mortises and carpenters' marks provided the evidence on which he rebuilt the lantern at Ely, and at Oxford he pulled down the whole east end of the cathedral, with its decorated window, and rebuilt it in the Norman style, solely because he knew it must once have been Norman. Scott's conservative system of restoration would, if logically pursued, have led him to a position which we can hardly distinguish from the Camden Society's. He might have pulled down Westminster Abbey to rebuild it Norman, as the Society might have pulled down Peterborough to rebuild it 'decorated'.

This seems to us appalling, for we forget one great difference between Gilbert Scott and ourselves: he believed that he built very good Gothic, we that he built very bad. As long as the Gothic revivalists had faith in their movement they thought of restoration merely as the substitution of one good thing for another. On the other hand, additions made to churches during the sixteenth and seventeenth centuries seemed bad in themselves and obviously inharmonious. We, having now romanticized the eighteenth century, feel that a hundred years can harmonize all the styles a church can contain, and to our sentimental eyes Scott seems to have done no good. Perhaps we shall forget his restorations when they have weathered,

though they are often in cursedly hard stone; but sometimes he is indefensible.

I have lately [he wrote to Freeman] been doctoring up, rather than restoring, a little church at Clifton Hampden, near Abingdon, which you will, I fear, not altogether like, as it is not a strict restoration – indeed, we had hardly anything left to restore – it is rather a refoundation, keeping (*in the main*) to the old plan, and viewing it as such we have put the monument of the gentleman from whose bequest the funds proceed in the place of the Founder's tomb, rightly or wrongly I do not know.[1]

Wyatt moved tombs, but he did not throw them away.

By 1850 the triumph of Gothic in church building was practically complete, but such Gothic civil architecture as was built was in the old pre-Camdenian style, and was violently repudiated by advanced Gothicists. And though the site and associations of the Houses of Parliament had made Gothic acceptable there, the ordinary man was not prepared for its application to other public buildings. Two men were chiefly responsible for converting England to secular Gothic: one of them, Ruskin, will be the subject of the next chapter. The other is Gilbert Scott.

Remarks on Secular and Domestic Architecture, Present and Future by George Gilbert Scott, 1857, is one of the most convincing apologies for the Gothic Revival ever published. Substantially the book is no more than a working out of Pugin's principles, but Scott, being neither a Catholic nor a medievalist, can subdue some of the glaring prejudices which made Pugin's work so alarming. His argument is this: we have lost the living style of good architecture, we pick and choose among the dead; ideally we should create something completely new, but this is impossible because, with our historical sense, we can never completely forget the styles of the past. Our best course, therefore, is to choose that one of the old ways of building which is, first, nearest to facts of construction and so most adaptable; secondly, closest to nature in decorative detail; and thirdly, most in

1. *Unpublished Correspondence of Oxford Architectural Society*, 205.

keeping with native traditions. There can be little doubt that these qualities belong to Gothic rather than to any of the derivatives of Classical, so we must adopt Gothic; but we must use it so freely that it will eventually become a new style – the modern style. Mullioned windows, pointed arches, and high-pitched roofs can be dropped, if inconvenient, without sacrificing the true character of Gothic.

These doctrines are, perhaps, the soundest and most enduring legacy of the Gothic Revival. The chief of them, the doctrine of following constructive needs, is still used, and will always be used subject to various interpretations in practice; for if pressed to its logical extreme it leads to fierce ferro-concrete boxes, and fortunately ferro-concrete boxes do not satisfy man's imagination. He needs some special shape to echo the harmony which, at that period, inhabits his spirit; but if his need be pointed arches, or round arches, or pediments, he will find some way of justifying it by reference to construction. So it is not surprising that the Gothic Revivalists propounded this theory, and then used lancet windows as if they were completely suitable to modern conditions; but it is surprising to find that the theory received its fullest and most liberal exposition from Gilbert Scott. For there were two definite groups in the later Gothic Revival: the builders, like Butterfield and Philip Webb,[1] and the men who won competitions with showy designs; and Gilbert Scott was one of the second.

The year in which Scott's *Domestic Architecture* was written a grand opportunity occurred for the realization of his principles. A competition was opened for two new Government offices in Whitehall, and naturally Gilbert Scott entered. His plan was based on French Gothic, but with a certain squareness and horizontality of outline which were considered Italian. 'My opinion is,' was Scott's comment, 'that my details were excellent, and precisely suited to the purpose. I do not think the

1. Strange to find Butterfield and Webb in the same 'group', but I remember that both are recorded to have said that they thought first whether their chimneys would draw (1949).

entire design so good as its elementary parts. It was rather set and formal. With all its faults, however, it would have been a noble structure; and the set of drawings was, perhaps, the best ever sent in to a competition, or nearly so.' The judges, however, 'knew amazingly little about their subject', and Scott's design was not successful. 'I did not fret myself at the disappointment,' says Scott; but when he heard that Lord Palmerston had set aside the results of the competition and was about to appoint a non-competitor, 'I thought myself at liberty to stir'. And stir he did, with such effect that having been third for one building, and not even mentioned for the other, he got himself appointed architect for both. This triumph of dignified self-confidence was to destroy Scott's peace of mind for many years; for no sooner were the designs made and approved than a Mr Tite, a classical architect, who was M.P. for Bath, objected to them in the House; and 'Sir,' said Palmerston, 'the battle of the books, the battle of the Big and Little Endeans, and the battle of the Green Ribbands and the Blue Ribbands at Constantinople were all as nothing compared with this battle of the Gothic and Palladian styles.'[1]

This time the classical party were well led. Palmerston, humorous, unscrupulous, sensible, was more representative of the average man than the cultured Mr Hamilton. Scott speaks of 'a quantity of poor buffoonery, which only Lord Palmerston's age permitted', but the speech he refers to, when found in Hansard,[2] contains nothing but good sense. Mr Scott, says Palmerston, won neither competition; nor is his style national, being confessedly French and Italian with a dash of Flemish; nor is it possible to maintain that a window with a mullion and a cusped and pointed arch can let in as much light as a plain rectangle. Lastly, he asked members to look at Sir Charles Barry's classical buildings in Parliament Street, and then at the new Gothic building recently erected by Mr Scott in the Broad Sanctuary. This last experiment is still possible, and I

1. *Hansard* (164), 535.
2. ibid. (152), 270 *et seq.*

can imagine no more powerful argument against the Gothic Revival.

'I showed all this up pretty vigorously,' says Scott. But actually there was very little the Gothic party could say, and that little was useless. Possibly it was true that 'men above sixty still love Palladian, men below sixty hate it',[1] but Lord Palmerston, who was approaching eighty, was beyond conversion; and when the battle was at its height, a General Election brought him in as head of the Government. After a short delay he sent for Scott.

He told me, in a jaunty way [writes Scott], that he could have nothing to do with this Gothic style, and that though he did not want to disturb my appointment, he must insist on my making a design in the Italian style, which he felt sure I could do quite as well as the other. That he heard I was so tremendously successful in the Gothic style that if he let me alone I should Gothicize the whole country, etc., etc., etc.

But the admirers of Gothic were not so easily put off. They pointed to the number of Gothic public buildings then in course of construction; Palmerston replied that buildings in the classical style still formed a considerable majority. They quoted from Scott's *Domestic Architecture*; Palmerston replied that he would welcome a new order of architecture specially designed to meet modern needs; but Gothic was not new. They spoke of Mr Scott as a first-rate genius who need not fear comparison with architects of all time, and of his designs as radiant with grace and beauty, and glowing with thought and imagination; Palmerston was not impressed.

For some months the dispute dragged on. Both parties sent deputations, both parties intrigued, both were indignant, and Palmerston grew bored with the whole thing. He sent for Scott, and said in a most easy, fatherly way, 'I want to talk to you quietly, Mr Scott, about this business. I have been thinking a great deal about it, and I really think there was much force in what your friends said.' 'I was delighted', says Scott, 'at his

1. *Hansard* (164), 535.

conversion.' After a pause, Palmerston continued, 'I really do think that there is a degree of inconsistency in compelling a Gothic architect to erect a classic building, and so I have been thinking of appointing a coadjutor, who would in fact make the design.' The force of this blow may be judged from Scott's admission that he was unable to do justice to his case *viva voce*; but on his return he immediately wrote a strongly and firmly worded letter.

I dwelt [he tells us] upon my position as an architect, my having won two European competitions, my being an A.R.A., a gold medallist of the Institute, a lecturer on architecture at the Royal Academy, etc. I forget whether he replied. I also wrote, if I remember rightly, to Mr Gladstone.

For the first time in a twenty-four years' practice Gilbert Scott found it necessary to take a 'quasi-holiday, with sea air and courses of quinine', and during this holiday he prepared for the next campaign. Clearly Gothic must be abandoned, but he conceived the idea of trying a medieval style, which should yet have some of the characteristics of classical, and he decided on Byzantine, in hopes that its round arches might put Lord Palmerston off the scent. The new designs were, Scott tells us, both original and pleasing in effect, but when they were submitted to Palmerston, Scott's glimmering hope was snuffed. They were neither one thing nor t'other – a regular mongrel affair, and Palmerston would have nothing to do with them either. 'I came away thunderstruck and in sore perplexity,' says Scott. And indeed the position was very painful to a man of Scott's character. Never, perhaps, has the opportunity of martyrdom to a great cause offered itself more conveniently; yet, as Scott said, 'to resign would be to give up a sort of property which Providence had placed in the hands of my family'. He set his teeth and studied the Italian style.

But those first splendid drawings could not be entirely wasted. Travellers to the north must often have been surprised by the enormous structure which confronts them at St Pancras

and which seems to combine the west end of a German cathedral with several Flemish town halls; and they must have wondered how so much masonry came to be lavished on a station hotel. The building is by Gilbert Scott and is the gorgeous fruit of his great disappointment.

It is often spoken of to me as the finest building in London [he wrote]; my own belief is that it is possibly *too good* for its purpose, but having been disappointed, through Lord Palmerston, of my ardent hope of carrying out my style in the Government Offices, I was glad to be able to erect one building in that style in London.[1]

Never again in his life is Gilbert Scott so representative of Gothic Revival ideals. That culminating success of his career, the Albert Memorial, though obviously Gothic in inspiration, being, in fact, 'the realization in an actual edifice of the architectural designs furnished by the metal-work shrines of the Middle Ages', was not conceived in a Gothic Revival spirit, nor, in execution, is it typical of the movement. It was intended to have, and certainly achieved, a popular success, whereas the true Revival appealed to men with ideals, either aesthetic or religious. Of course the philistine is always compelled to borrow a pinch of ideals in order to make his lump rise, and in the Albert Memorial we can just taste the leaven of single-minded men. The craftsmanship owes something to Pugin, the use of colours to Ruskin; and from the workmen, 'who alluded to the temperance which prevailed amongst them, whilst others observed how little swearing was ever heard', we catch an echo of the Camden Society. But for the most part the Albert Memorial is the expression of pure philistinism, and as such is not a document of much value to the student of taste.[2] For the test of such a document is that it ex-

1. An account of the Foreign Office controversy forms the fourth chapter of Scott's *Recollections*. All my quotations are drawn from this except those from Hansard, and the last, which is from *Recollections*, 272.

2. Untrue; and the arguments which follow unconvincing. But arguable that the Albert Memorial is a document for the study of mid-Victorian taste rather than of the Gothic Revival (1949).

presses the changing demands of man's imagination, and forms which satisfy one generation seem quite meaningless to the next. But the conscious demands of the philistine are unvarying, and the Albert Memorial has always appealed in the same degree to the same class of people – the people who like a monument to be large and expensive-looking, and to show much easily understood sculpture, preferably of animals. So great were the concessions made to philistinism that the sculptures on the memorial made no pretence of a medieval style suitable to the architecture, as it was feared that such quaintness would be popularly considered unworthy of the occasion. In revenge the obvious 'Victorianism' of the figures now looks much more 'quaint' than the thorough medievalism of Pugin. The historical importance of the Albert Memorial is great; as Sir Austen Layard told Scott, 'Such a monument could not have been erected out of England,' and the pages which Mr Strachey has given to it in his *Queen Victoria* show his instinct for significant as well as entertaining incidents. But the memorial has no independent architectural life, and where it shows some reminiscence of the Gothic Revival's stylistic discoveries, they are put to vulgar uses, like tags of poetry in a politician's speech.

It was by his extraordinary diffusion of Gothic forms, rather than by any one great building, that Scott influenced the taste of his time. From his well-equipped office he peppered England with churches, and all over the country cathedrals in bright new shells showed his healing touch. The size of his practice seems to have given him satisfaction, though to more conscientious builders it might seem a matter of shame. Even in his own day it was a source of legend. Once, when Scott had left town by the six o'clock train, his office, on slackly assembling, found a telegram from a Midland station asking, 'Why am I here?' On another journey he is said to have noticed a church that was being built and to have inquired who was the architect. 'Sir Gilbert Scott', was the reply – a classical story about busy painters, but I have never heard it told of another arc-

hitect.[1] These stories are believable when we remember that Scott concentrated not on the erection of buildings, but on the winning of competitions; and his mastery of this exacting art was superb. An air of well-being pervades his photograph-like drawings; the streets before his buildings are thronged with prosperous men, sunshine streams in through his windows; and if (for human blindness is infinite) his designs were not accepted, Scott knew the precise moment to call an indignation meeting, the precise moment to write to *The Times*. The wonder is that he ever failed. For on one occasion Scott did fail, and his failure was made immeasurably bitter by the greatness of the prize – the new Law Courts. Though the details of Scott's plan exceeded in merit anything that he knew in modern designs, and though he used all his arts to bounce the committee into electing him, he was passed over. There was jealousy, said Scott: enemies, whom he had innocently supposed not to exist, crept from their lurking places; and the affair of the Government Offices had alienated even his supporters. But we need not reject the simplest explanation of Scott's failure. The selectors were not a meek and impressionable town council; they judged the designs on their merits, and Scott's were not the best.

George Edmund Street, the successful competitor for the Law Courts, was a far better architect than Scott, more serious, more learned, more personal. So was Butterfield, with his grasp of good building and sadistic hatred of beauty.[2] So was the brilliant play-acting Burges; and even Waterhouse had a

1. Both stories are from 'Philip Webb and his Work' by W. R. Lethaby, *Builder*, 1 May 1925.

2. 'Sadistic' can stand, for there is a Dickensian need of cruelty in Butterfield. But the reason why he administers so many shocks to the sensitive eye is more like that which has induced some modern musicians to shock the sensitive ear – a kind of ruthlessness, a determination not to let mere taste and amiability interfere with conviction. He is the first master of discordant polyphony. And he is worth comparing with Gerard Manley Hopkins in his clash of interrupted rhythms, no less than in the indigestibility of his detail. Cf. John Summerson in *Architectural Review*, vol. XCVIII (December 1945), 166, for the best critical essay yet written about a Gothic Revival architect.

sense of construction which makes his buildings more real (as the Camdenians would have said) than Scott's. If this book were a critical valuation of Gothic Revival architecture, Gilbert Scott would not have taken up many pages. But in answering the questions, 'How did Gothic become so popular?' 'Who gave men their mental patterns and their standards of criticism?' he is more important than better men. By the extent of his practice and his power of self-advertisement, Scott became a popularizer of Gothic and a great purveyor of standard Gothic forms. Only one man surpassed him. For his industry and ambition could never achieve quite the force of disinterested conviction, and while Scott's churches were rising from a hundred health resorts, Ruskin had already dazzled men's eyes with bright Southern styles and bewitched their ears with his melodious principles.

Chapter 10

Ruskin

In an earlier chapter we saw how, before 1840, few architects shared the ideals and principles which were to direct the Gothic Revival; and as an example we found the conductor of the *Architectural Magazine* recommending cast-iron tracery and artificial stone crockets. In this magazine and in the *Builder* of the same date there were few sentiments which would not have enraged Pugin and appalled the Camdenians; but in 1837 the *Architectural Magazine* began to publish a series of articles entitled 'The Poetry of Architecture', and in these Pugin would have found, echoed in turgid, Byronic language, his own vehement ideals. Nothing was known of the author, who signed himself, significantly, Kata Phusin, but the articles were much admired.[1] They were not, I imagine, at all influential, and in 1838 the *Architectural Magazine*'s short life was at an end, the conductor finding himself £10,000 to the bad. It was ten years before Kata Phusin wrote on architecture again. When he did so it was under his own name, John Ruskin, and in a book which was, in the history of taste, perhaps the most influential ever published, *The Seven Lamps of Architecture*.

A great many people have written about the *Seven Lamps*, but no one, so far as I am aware, has ever said what will be apparent to the reader of this book: that Ruskin's way of looking at architecture was not a new way, but one which had been common for at least ten years before the *Seven Lamps* appeared. The book was written, Ruskin said, in later life, 'to show that certain right states of temper and moral feeling were

1. Cf. *The Times*, 2 February 1839.

the magic powers by which all good architecture has been produced'.[1] Like Pugin and the Camdenians, Ruskin tried to gauge the merit of a building by the virtue of its builders. Naturally there are many places in which Ruskin, in longer sentences but with no more force, makes points which Pugin had already made. The whole 'Lamp of Truth', for example, is an attack on shams; and even 'The Lamp of Beauty', though at first sight the least ethical of the Lamps, is actually no more than the Gothic Revival doctrine of nature. Ruskin felt, and we can share his feeling, that created beauty is analogous to a natural form; but he gave this great truth a very crude application, for he argued that a close imitation of natural forms was the way to ensure beauty:[2] and we have seen that this was one of the first foundations of Gothic Revival teaching. Again, 'The Lamp of Memory' begins with an echo of Pugin's sentence that the history of architecture is the history of the world; and 'The Lamp of Obedience' contains the familiar Gothic Revival plea for a universal style, chosen from among the ancient styles, as suitable for our climate and conditions, and suggests that this style should be early Decorated English. In smaller things, too, Ruskin's tone is one with which we are familiar, and the average educated person would not hesitate to attribute the following passage to him:

Mere naked form, however graceful in itself, is cold and unaffecting; may we not add unnatural? For whether we look at the inanimate works of creation, at the sky or the earth, at the setting sun, the glowing cloud; at the fields, mountains, trees, flowers, or at living objects, animals, reptiles, the glittering fish, the painted bird, the gaudy fly; or again at the descriptions of the Tabernacle, the Temple, or the New Jerusalem; we see that every work of God – and from what other source has man any perception of beauty? – is adorned with colour.

1. *The Crown of Wild Olive,* § 65.
2. He also argued against this view. In writing of Ruskin it is almost impossible to quote one of his views without being able to quote a flat contradiction of it – often from the same work. This delighted him, and he said that he only felt truth was in sight when he had contradicted himself at least three times.

Actually it is from a number of the *Ecclesiologist* (III, 142), and appeared five years before the *Seven Lamps*.

So in many ways Ruskin was voicing ideas for which the world was prepared. But he was quite unaware that he was doing so. No man was less likely to accept without question the authority of his contemporaries, and when Ruskin wrote the *Seven Lamps* he was untouched by the Gothic Revival and had probably read very little of the literature which that movement had produced. What little he knew about it he disliked:

> The stirring which has taken place in our architectural aims and interests within these few years [he wrote] is thought by many to be full of promise: I trust it is, but it has a sickly look to me. I cannot tell whether it be indeed a springing of seed, or a shaking among bones.[1]

This independence from the body of Gothic Revivalists which makes Ruskin so important to us was due, in part, to his upbringing.

Ruskin himself has described this upbringing in *Praeterita*, and his description is so beautiful that most writers are lured into dwelling on that period of his life, more perhaps than its importance warrants. Out of Ruskin's own transparent pictures of his childhood, two impressions remain, one of extraordinary isolation, the other of unbending Protestantism. Young Ruskin was in a position rare in the history of letters – he was the child of rich parents who appreciated him. The elder Ruskin, a well-to-do sherry merchant, was also a lover of books and pictures; as soon as his son showed any signs of a literary gift – and he showed them early, writing fluent letters at the age of four, and 'Eudoxia, a Poem on the Universe', at the age of nine – the parents decided that God had entrusted them with a genius. He was too delicate, they felt, to send to school, and too brilliant to undergo a course of systematic studies. He must be shielded from crude companions, shielded from contemporary literature, shielded from anything that

1. *Seven Lamps*, 'The Lamp of Life', § 3.

might stain the pure spring of genius. Even when they allowed him to become a gentleman commoner of Christ Church, his mother took rooms in High Street during term time, and John Ruskin had tea with her every afternoon. But through the soft atmosphere of his youth there blew one bracing mind; his mother's relentless Protestantism. Every day fixed hours were set apart for religious instruction, every day two chapters of the Bible were read aloud and other parts of the Bible were studied. And Sunday was the Sabbath of Puritan legislation. It was many years before Ruskin read any book but the Bible on that day, nor on it, till middle age, did he draw; and every Sunday, for the fifty-two years that he lived with his parents, screens were put in front of all his pictures, lest their bright colours might distract the mind in its contemplation of man's sinful estate.

These two influences on Ruskin's youth were fortunate, I think. The isolation saved him from an English public school and gave him that wonderfully innocent vision which later he turned so devastatingly on economics; and the Puritanism counteracted any spoilt self-satisfaction which parental pampering might have produced. But from such an environment Ruskin could not plunge immediately into the unctuous flood of the Gothic Revival, with its flavour of cliquishness and catholicism. Indeed, one of the incidental purposes of the *Seven Lamps* was to dissociate Gothic architecture and high ritualism by fierce, irrelevant attacks on popery; and to the first volume of *The Stones of Venice*, published three years later, he added an appendix on Romanist Modern Art specially aimed at the Gothic Revivalists, and in particular at Pugin.

But of all these fatuities [he says, speaking of inducements to Romanism], the basest is the being lured into the Romanist Church by the glitter of it, like larks into a trap by broken glass; to be blown into a change of religion by the whine of an organ-pipe; stitched into a new creed by the gold threads on priests' petticoats; jangled into a change of conscience by the chimes of a belfry. I know nothing in the

shape of error so dark as this, no imbecility so absolute, no treachery so contemptible.

So much for the Camden Society. Pugin he describes as 'one of the smallest of conceivable architects'; and only once again, in the thirty-nine large volumes of his works, is his great precursor mentioned. 'I never read a word of any of his other works,' he says, referring to one of Pugin's reviews, 'not feeling, from the style of his architecture, the smallest interest in his opinions.' The sentence shows how an eminently truthful man can say what is precisely the reverse of true.

Ruskin's Protestant eloquence achieved its end. Had he not salted his description of Italian Gothic with attacks on Rome, he would certainly have been considered a Roman Catholic apologist; and, even as things were, Charles Kingsley, with his keen nose for popery, sniffed something queer in Ruskin's love of Italian landscape.

> Leave to Robert Browning
> Beggars' fleas and vines,
> Leave to mournful Ruskin
> Popish Apennines,[1]

he wrote; and he goes on to contrast this heretical range with the, implicitly, Protestant stones of Snowdon. But for the majority of readers Ruskin succeeded in disinfecting Gothic architecture; and it is because he was the first person consciously to attempt this, because his work could be read without fear of pollution, that he is remembered as the originator of Gothic Revival doctrines. The dissociation of Gothic architecture and Rome was, perhaps, Ruskin's most complete success, and, alas, it was the one which he least desired!

Anyone who loved order and tradition and visual beauty as Ruskin loved them was sure to feel the magic of the Roman Catholic Church. Even in his youth, when most under his mother's influence, his spirit was torn between instinctive love

1. This rhyme is called 'The Invitation: to Tom Hughes'.

and inculcated dread. 'Curious essay of Newman's,' he wrote in his diary in 1843, 'full of intellect, but doubtful in tendency. I fear insidious; yet I liked it.'[1] And in 1848 he recorded the conviction 'that all these proud pillars and painted casements, all these burning lamps and smoking censers, all these united voices and solemn organ peals, had their right and holy use in this [the Roman Catholic] service'.[2] In the same year Ruskin wrote a note to the *Seven Lamps* referring to the Catholic Emancipation Act as a national crime on which the Deity would inflict special punishment; and it is easy to see that one passage explains the other. His violent attacks on Rome were what psychologists call a piece of defence mechanism. But with a man as brave as Ruskin this could not be a very permanent influence on his work. It is true that he never achieved a facile synthesis of truth and beauty, never quite reconciled his principles and his sensibility, could not escape from his own brave surprising conclusion that he had never met a Christian whose heart was, as far as human judgement could pronounce, perfect and right before God, who cared about art at all.[3] But after middle age Ruskin was well content to let inconsistent elements live at peace within himself, and from the 1880 edition of the *Seven Lamps*, that 'wretched rant of a book', as he called it, the vehement Protestant passages are omitted. However severely he tried to bind it with dogma, Ruskin's sensibility usually escaped in the end, and, curiously enough, it was precisely this sensibility, and not Protestantism, which was most fatal to his championship of the Gothic Revival.

Read in the light of modern art criticism, Ruskin's constant appeal to ethics seems strange, and it is with this that his doctrines are now associated. But his contemporaries felt the exact opposite. They always spoke of Ruskin as putting architecture on an *aesthetic* basis; and in doing so they were perfectly right.

1. *The Works of Ruskin*, ed. Cook and Wedderburne (hereafter referred to as C. & W.). This must be one of the best editions of a prolific and various author ever produced, and makes work on Ruskin very easy and agreeable.

2. C. & W., VIII, 268.

3. ibid., X, 124.

The theories in the *Seven Lamps* are those of Ruskin's time, the sensibility displayed is his own.

> I don't think myself a great genius [he once wrote to his father], but I believe I have genius; something different from mere cleverness, for I am *not* clever in the sense that millions of people are – lawyers, physicians and others. But there is the strong instinct in me which I cannot analyse, to draw and describe the things I love – not for reputation, nor for the good of others, nor for my own advantage, but a sort of instinct like that for eating and drinking. I should like to draw all St Mark's and all this Verona stone by stone, to eat it all up into my mind, touch by touch.[1]

It is this passionate sensibility which makes Ruskin so great an art-critic, and even in his most theorizing work one may feel it pass like a breath over the *Seven Lamps* till their hard, dogmatic flames dance and flicker with life.

But this quality, so sympathetic to us, was as alien to the Gothic Revivalists as to the eighteenth century. Ruskin, they thought, first felt an object to be beautiful, and then tried to fit it into some theory; he confessed that he might have increased his Lamps indefinitely. No revival could be based on such unprincipled empiricism. Ruskin, for his part, found that very few Gothic Revival buildings satisfied his hunger for beauty, and the greater number were positively distasteful to him. Of course the forms they used appealed to him strongly; the tune they played was his tune, but they played it very badly.

So we can understand why, in 1848, Ruskin was antagonistic to the Gothic Revival. But in 1855 he brought out a second edition of the *Seven Lamps*; and in the preface to this edition he says that he wishes to correct 'the expression of doubts as to the style which ought, at present, to be consistently adopted by our architects. I have now no doubt that the only style proper for modern Northern work, is the Northern Gothic of the thirteenth century, as exemplified in England, pre-eminently by the cathedrals of Lincoln and Wells, and in France by those

1. To his father, 2 June 1852. C. & W., x, xxv.

of Paris, Amiens, Chartres, etc.'[1] In these years Ruskin had be-
come a Gothic revivalist. Precisely how and when he changed
his views I cannot discover, but his conversion was inevitable.
His work on the stones of Venice had led him to study Gothic
architecture very closely, and he became more and more
devoted to it. His devotion to the old Gothic outweighed his
prejudices against the new, and at the end of this great work, he
says clearly that we must adopt Gothic in England. 'In this
style let us build the church, the palace and the cottage; but
chiefly let us use it for civil and domestic buildings'; for his
Puritan conscience was not yet numb, and 'the most beautiful
forms of Gothic chapels are not those which are best fitted for
Protestant worship'. However, he gives great praise to a
Gothic Revival church in Margaret Street.[2] 'Having done this,'
he says, 'we may do anything.' Perhaps his championship of
Revival was connected with his support of the Pre-Raphaelites,
which began in 1851; and certainly his first active participa-
tion in the movement, the Oxford Museum, was, as we shall
see, very much a Pre-Raphaelite affair. But whatever the
cause, by 1855 Ruskin had contributed both theory and prac-
tice to the Gothic Revival.

Many of the theories which Ruskin preached were, as we
have seen, those by which the Revival was already supported;
but there were points on which he differed completely from
Pugin and his school, and it is these points which are important
to our study. Perhaps these differences sprang from the fact
that Pugin was a trained architect and Ruskin an art critic; and
they took this form, that Ruskin stressed the importance of
ornament and Pugin of construction. Pugin believed that if the
construction of a factory or a railway station was strong,
simple, and bold, the buildings would, *ipso facto*, be beautiful;

1. C. & W., VIII, 12.
2. By Butterfield, begun in 1849, and decorated during the next ten years, it
was intended by the Camden Society to be a model church. It has many
features which we consider Ruskinian – e.g. horizontal bands of coloured brick;
but these antedate *The Stones of Venice* by three years. Butterfield probably
derived them from the study of Siena Cathedral.

but Ruskin's conception of beauty, so complicated, so subtle, clouded with associations and resonant with overtones, could not allow so crude a theory. To him a factory must always remain hideous. There is no doubt that Pugin's theory inspired a far sounder school of architects, the school of which Philip Webb is a typical member. 'This is a universal law,' wrote Ruskin. 'No person who is not a great sculptor and painter *can* be an architect. If he is not a sculptor and painter he can only be a builder.'[1] To which Webb would have replied, 'A builder is precisely what I want to be. It is your high-falutin architects who have landed us in our present fix, and the only way out is to make our houses strong, practical, and economical, with windows which don't let in draughts, and chimneys which don't smoke. From this we may evolve a new style.' This doctrine has shown an extraordinary power of survival, and still shelters men with such different ideals as Professor Lethaby and M. Le Corbusier, and nearly all the young architects on the Continent have made it their gospel. They tell us that the only things produced today which have an authentic, living style of their own are those in which line and mass are subordinated to one unifying constructive end – powerful cars, for example, or American grain distributors; and in a recent Salon des Indépendants a petrol-filling station stood in the entrance hall in the position which, fifty years ago, would have been occupied by some gigantic group of Abundance crowning the Third Republic.

Of course Ruskin did not deny the value of construction, but he did deny that it was the same thing as good architecture; and his reasons for doing so embodied his chief theory of Gothic. To the school of builders he would have said, 'A house built on your principles would be no more than a rectangular box, with a certain number of rectangular holes on it. A box has no style and is not architecture. But make the windows a little bigger or a little smaller than is absolutely necessary, or add the least suggestion of a moulding, and you have given

1. Appendix to Edinburgh Lectures; C. & W., xii, 85.

your box some style. These unnecessary things are ornament. Now the box was built for man's material welfare; but the ornament, however slight, even if it consist only in the grouping of chimneys, exists to satisfy some non-material, some spiritual or imaginative need.' That is what Ruskin meant when he began the first chapter of his *Seven Lamps* with the aphorism 'All architecture proposes an effect on the human mind, not merely a service to the human frame'; and it was his belief that buildings should contribute to man's 'mental health, power and pleasure' that led him to value ornament. Even the severest of the building school would, I think, have conceded this, and certainly their own work has a very pronounced style – that is to say, contains many unnecessary features. But they would have said that though a certain amount of ornament was inevitable, this ornament was less important than construction, and should consist more in disposition than in detail. The question raised cannot be solved by discussion; but in defence of Ruskin I must suggest to the reader the following experiment. Let him imagine his favourite cathedral completely refaced in absolutely new stone, with the ornament disposed as in the old building, but with all the detail cast in artificial stone from one or two convenient moulds, and all the mouldings machine-cut in one or two stereotyped forms. In this way he may gain some idea of what part ornament plays in Gothic architecture.

Ruskin was convinced that ornament was very important, and looking at medieval ornament, he found that, however crude, it had a fancy and life which made it immeasurably superior to anything done in his own day. The reason for its superiority lay, he thought, in this, that every mason had been free to do his best and enjoyed doing it. Freedom, humility, joy – these were the conditions in which Gothic ornament was produced; and the neat, respectable rooms in which sat Ruskin's astonished readers were the inevitable product of slavery, pride and unhappiness. The idea is foreshadowed in the best of Ruskin's *Seven Lamps*, 'The Lamp of Life', but its full develop-

ment is, of course, in the famous chapter of *The Stones of Venice*, called the Nature of Gothic. The first half of that chapter seems to me one of the noblest things written in the nineteenth century;[1] even now, when the ideas it expresses are accepted and the cause it advocates is dead, we cannot read it without a thrill, without a sudden resolution to reform the world. No wonder the chapter exercised a profound and immediate influence on Ruskin's contemporaries, was reprinted separately within a year of publication and sold for sixpence to working men,[2] became the inspiration of William Morris and was one of the earliest productions of the Kelmscott Press.[3] But this influence was not chiefly an influence on architecture. Ruskin, like the Camden Society, had been forced back from the merits of a building to the merits of the men who built it. Just as the simple Camdenian doctrine that virtuous men build good buildings resulted in efforts to put down swearing among bricklayers, so Ruskin's infinitely more profound theory of Gothic ornament changed him from a critic of architecture into a critic of society. And down this new road we must not follow him.

In one way, however, his writings did have a definite and only too visible influence on architecture, for they popularized Italian and especially Venetian Gothic. He did not advise this style for Northern countries; indeed, he closes his *Stones of Venice* with the recommendation of English 'decorated'. But eloquent praise of Venetian architecture had the irresistible charm of novelty.

It is hard to believe that Ruskin's admiration of Venice was anything very original; nowadays few people fail to find the place attractive, and a hundred years ago a Venice without tourists or restorations or postcard sellers or motor-boats must have been enchanting beyond our dreams. But those to whom

1. Down to the end of § 50. After that come paragraphs of nonsense, and then the sky clears, and there is the most lucid description of what architectural features really constitute Gothic.

2. C. & W., xi, lx.

3. Mackail, i, 36.

time permitted this enchantment, some other mysterious agency made blind.

Of all the towns in Italy [wrote Gibbon], I am the least satisfied with Venice. Old, and in general ill-built houses, ruined pictures and stinking ditches, dignified with the pompous denomination of canals ... and a large square decorated with the worst architecture I ever saw.[1]

And though by Ruskin's time Venice was generally admitted to be picturesque, critics of architecture still considered Venetian Gothic monstrously ugly, and praise of St Mark's was taken as evidence of insanity.[2]

When one considers the part played by reaction and love of novelty in the formation of taste, it is easy to see why men listened to Ruskin's praise of Venetian Gothic and disregarded his sensible recommendation of English. There is no better witness to Ruskin's influence than Eastlake, who saw the whole process happening under his eyes, and who wrote while that influence was still alive.

Students [he writes], who but a year or so previously had been content to regard Pugin as their leader, or who had modelled their notions of art on the precepts of the *Ecclesiologist*, found a new field open to them, and hastened to occupy it. They prepared designs in which the elements of Italian Gothic were largely introduced: churches in which the 'lily capital' of St Mark's was found side by side with Byzantine bas-relief and mural inlay from Murano; town halls wherein the arcuation and baseless columns of the Ducal Palace were reproduced; mansions which borrowed their parapets from the Calle del Bagatin and their windows from the Ca'd'Oro. . . . They made drawings in the Zoological Gardens, and conventionalized the forms of birds and beasts and reptiles into examples of 'noble grotesque' for decorative sculpture.

Nor was this all. Not a few architects who had already established a practice began to think that there might be something worthy of

1. Letter to his stepmother, 22 April 1765.
2. Cf. C. & W., ix, xliv. Ruskin quotes a contemporary architect's views on St Mark's and the Doges' Palace – 'even more ugly than anything I have previously mentioned' – in *Seven Lamps*, Chapter v, § 14.

attention in the new doctrine. Little by little they fell under its influence. Discs of marble, billet-mouldings, and other details of Italian Gothic, crept into many a London street-front. Then bands of coloured brick (chiefly red and yellow) were introduced, and the voussoirs of arches were treated in the same fashion.[1]

These remarkable results of vision, enthusiasm, and eloquence distressed Ruskin profoundly, and he afterwards disclaimed responsibility for them.[2] But he cannot be allowed to do so, for the only building in the erection of which he was directly concerned, 'that practical and standing commentary on "The Nature of Gothic"',[3] is in a Venetic style. This is the Oxford Museum, and the story of that building contains so much that is typical of the Gothic Revival that it is worth retelling at some length.

In 1854, after seven years of agitation by Dr Henry Acland,[4] the University of Oxford decided to build a museum for the study of National Science, and opened a competition for the design. Out of a large number of drawings two were chosen, one Palladian, the other, which bore the motto 'Nisi Dominus aedificaverit domum', Gothic – 'Veronese Gothic,' said Professor Hort, 'of the best and manliest type in a new and striking combination.' It was by Messrs Deane and Woodward, who had already designed the Museum of Trinity College, Dublin, on Ruskinian principles. Ruskin, who was an old friend of Acland's, had been interested in the building from the start, and was naturally a keen supporter of the Gothic design, though more on general grounds of its style than from admiration of the design itself. 'I think N.D., though by no means a first-rate design,' he wrote, 'yet quite as good as is likely to be got in these days.' 'But by degrees', says Cook,[5] 'he waxed warmer, and acquaintance with Woodward himself made him a complete convert.' The juxtaposition of Gothic and Classical styles

1. Eastlake, 278. I have cut out several other instances of Ruskin's influence.
2. See below, p. 194. 3. C. & W., xvi, iii.
4. Cf. *The Oxford Museum* by Dr Acland, and *Sir Henry Wentworth Acland, Bart. A Memoir* by J. B. Atlay, for the whole story.
5. C. & W., xvi, xliii.

resulted in the usual storm of pamphlets. Finally convocation voted for the Gothic design by sixty-eight votes to sixty-four. 'I have just received your telegraphic message from Woodward,' wrote Ruskin to Acland, 'and am going to thank God for it and lie down to sleep. It means much, I think, both to you and to me. . . . The museum . . . will be the root of as much good to others as I suppose it is rational for any single living soul to hope to do in its earth-time.' Ruskin, indeed, hoped that the museum would realize his principles, and was strengthened in his hope by the fact that Woodward was a great admirer of *The Stones of Venice*, and a friend of the Pre-Raphaelites. Millais and Miss Siddal had designed capitals for Woodward's Dublin library, and Ruskin was determined to get the whole Brotherhood at work on the Museum. 'I hope', he wrote to Acland, 'to be able to get Millais and Rossetti to design flower and beast borders – crocodiles and various vermin – such as you are particularly fond of – Mrs Buckland's "dabby things" – and we will carve them and inlay them with Cornish serpentine all about your windows. I will pay for a good deal myself, and I doubt not to find funds. *Such* capitals as we will have!' Rossetti did not design anything for the museum, but he persuaded some of his friends to do so, and it was during a visit to Oxford to suggest improvements on the work that he saw another of Woodward's buildings, the Union Library, and fell in love with it – with what result is well known. Ruskin, however, interested himself in every detail, took charge of the work when Woodward fell ill, and made many designs for the Museum, though only one, the window on the first floor to the left of the central bay, was carried out. This, and six brackets, are the only designs of Ruskin's ever realized, though the average Oxford undergraduate attributes to him most of the modern Gothic buildings in Oxford. Ruskin also reared, with his own hands, one of the brick columns in the interior; but it was later found necessary to demolish this column and reconstruct it by a professional bricklayer.

But the spirit of Gothic could not be revived by the occasional contributions of artists; it could only spring from the enthusiasm of the workmen employed; and in this Ruskin's hopes seemed for a time to have been fulfilled. Woodward had brought his workmen over from Ireland, and in Oxford they formed a small independent colony, leading a vigorous communal life. To Ruskin's delight, it was discovered that the stone-cutters' interest in the fine designs given them made them work with unusual vigour, and elaborate carvings were positively an economy. Above all, Ruskin was delighted with the brothers O'Shea, one of whom was a sculptor of great originality and talent. Every morning, we are told, the brothers would appear bearing plants from the Botanic Gardens to be copied on to the capitals; and animals as well as plants sprang to life under their chisels. But such vigour and originality could not go long unpunished. One afternoon O'Shea rushed into Acland's house in a state of wild excitement. 'The Master of the University,' he cried, 'found me on my scaffold just now. "What are you at?" says he. "Monkeys," says I. "Come down directly," says he, "you shall not destroy the property of the University." "I work as Mr Woodward orders me." "Come down directly," says he, "come down." '

The next day [says Acland], I went to see what had happened. O'Shea was hammering furiously at the window. 'What are you at?' I said. 'Cats.' The Master came along, and says, 'You are doing monkeys when I told you not.' 'Today it's cats,' says I. The Master was terrified and went away.

Officialdom triumphed, and O'Shea was dismissed; but he had his revenge. Acland tells how he found him on a single ladder in the porch striking the stone with Michelangeloesque fury.

'What are you doing, Shea? I thought you were gone.
Striking on still, Shea shouted:
'Parrhots and Owwls! Parrhots and Owwls! Members of Convocation.'

There they were, blocked out alternately.

What could I do? 'Well,' I said meditatively, 'Shea, you must knock their heads off.'

'Never,' says he.

'Directly,' said I.

Their heads went. Their bodies, not yet evolved, remain, and may still be seen, though few can recognize in these shapeless trunks a monument to official stupidity.

Long before O'Shea was dismissed the museum's supporters began to have misgivings. In 1858 Acland wrote a doubting letter to Ruskin, and Ruskin replied with the cold comfort that 'We must always be prepared for a due measure of disappointment.' How great his measure of disappointment was to be he did not then realize; but in the following year the University authorities took a very characteristic step. Having allowed the building to proceed for four years, they decided to withhold the funds necessary for its completion. Ruskin, who was not used to dealing with corporate bodies, was surprised. 'This difficulty', he wrote to Acland, 'I did not anticipate, and it is only by strong efforts that I can conceive its existence.' His letters were published, together with various exhortations by Acland, but the authorities were unmoved, and the building remains incomplete. Of the twenty-four windows for which Ruskin had had such glowing hopes, only six are carved, and one is left half finished; of the four hundred capitals and bases in the interior, three hundred remain uncut. Worst of all, Woolner's richly carved porch, which was to give depth and unity to the whole façade, was never even begun. The designs are still in the University Galleries, awaiting a change of taste and a convenient millionaire.

With the museum as it stands no one has ever been very satisfied, and the highest praise of it that I have ever found is that 'The chromatic effect of the whole is very charming on a bright sunny day'[1] – as are most things when surrounded by lawns and trees. Even the building's warmest supporters felt its

1. Eastlake, 284.

meagreness, and naturally attributed this to the fact that it was incomplete. But Ruskin was too sensitive and too sincere a man to allow himself so easy a retreat. Out of loyalty to Woodward's memory he never criticized the design; but he did not hide his opinion of the execution. All the decorative part in colour was vile,[1] the materials were common brickbats,[2] and the sculpture, at best mere formless imitation of nature, was the work of men without tradition or mastery.[3] Years later, when lecturing in the museum, he confessed that it had failed signally of being what he had hoped; and this, I fancy, would have been his opinion even if the University had not 'carved on her façade the image of her Parsimony'.[4]

For Ruskin's enthusiasm for the Gothic Revival did not last long. By the time that the public had come to look on him as the leader of the whole movement, he had reached a condition of resigned disillusion, which gradually developed into active loathing of all modern architecture. During the fight between Gilbert Scott and Palmerston, for example, he was believed to be the leader on the Gothic side. 'Above and beyond all,' wrote the *Daily Telegraph*,[5] 'it [the controversy] is a Godsend, a windfall, an apocalypse to Mr Ruskin'; his works were quoted in Parliament, and Gilbert Scott justified his final submission to the classical party with the words, 'Even Mr Ruskin told me that I had done quite right.' Fortunately for him, Scott had not seen a letter which contains Ruskin's feelings on this controversy and on the Revival generally.

Nice sensible discussion you're having in England there about Gothic and Italian, aren't you? And the best of the jest is that, besides nobody knowing which is which, there is not a man living who can build either. What a goose poor Scott (who will get his liver fit for a *pâté de Strasbourg* with vexation) must be not to say at once he'll build

1. Letter to his father, 6 January 1859. C. & W., LII.
2. *Readings in Modern Painters*.
3. Second Letter in Acland's *Oxford Museum*.
4. ibid. But this and the quotation on page 188 were not printed by Acland, and are to be found in C. & W., XVI, 218 and 227.
5. 31 August 1859.

anything! If I were he, I'd build Lord P. an office with all the capitals upside down, and tell him it was in the Greek style, inverted to express typically Government by Party. Up today, down tomorrow.[1]

After 1860 I can only find one favourable reference to a completed Gothic Revival building in all Ruskin's works – Waterhouse's Manchester Assize Courts, which he called 'much beyond everything yet done in England on my principles'. Perhaps he was influenced by the irresistible fact that 'The clerk of the works, when he was a youth, copied out the whole three volumes of *The Stones of Venice*, and traced every illustration.' For naturally Ruskin's pleasure at seeing his principles put into practice sometimes tempted him to praise a design. His pleasure never survived the design's execution. 'I do not doubt', he writes in 1872, 'that the public will have more satisfaction from his [Street's] Law Courts than they have had from anything built within fifty years.' But the Law Courts were not begun till 1874, and, says Cook, 'The hope expressed in this letter is therefore, unfortunately, no expression of opinion on the work itself.'[2]

More often the realization of his principles caused him nothing but pain, for, by a piece of grotesque irony, they inspired the kind of building which Ruskin loathed.

I would rather, for my own part [he says] that no architects had ever condescended to adopt one of the views suggested in this book, than that any should have made the partial use of it which has mottled our manufactory chimneys with black and red brick, dignified our banks and drapers' shops with Venetian tracery, and pinched our parish churches into dark and slippery arrangements for the advertisement of cheap coloured glass and pantiles.

And elsewhere he wrote,

I have had indirect influence on nearly every cheap villa builder between this and Bromley; and there is scarcely a public-house near the Crystal Palace but sells its gin and bitters under pseudo-Venetian

1. To E. S. Dallas, August 1859. C. & W., XXXVI, 315.
2. C. & W., X, 459.

capitals copied from the church of the Madonna of Health or of Miracles. And one of my principal notions for leaving my present house is that it is surrounded everywhere by the accursed Frankenstein monsters of, indirectly, my own making.[1]

But despite Ruskin's protests, the 'streaky bacon' style persisted. Under the heat of conviction the public mind will receive any stamp pressed upon it, and that stamp cannot be removed save by equal heat or the slow attrition of time. Ruskin had stamped certain shapes into men's imaginations, and these were used, without any question of their fitness, over and over again, until they were worn out. No one listened to Ruskin when he disowned the ugly children of his enthusiasm.

Ruskin's ultimate disillusion with the Gothic Revival, like his original distrust of it, was the result of his sensibility to beauty. There is plenty of evidence in his later works that he hated the movement because it destroyed beautiful buildings and built ugly ones; and though he became resigned to the ugliness of new buildings, the systematic destruction of all the architecture he valued was hardly to be borne. In 1874 Ruskin was offered the medal of the Royal Institute of British Architects. For answer he wrote the names of four of the most beautiful buildings in Europe which, at that moment, were being destroyed. Had the Institute made a single effort to save those buildings, or the hundreds of others which yearly suffered the same fate? The Institute, of course, had not; indeed, as Ruskin knew, but did not say, members of the Institute led the work of destruction in England, and the President was Sir Gilbert Scott himself.

The notes which Ruskin added to the later editions of his early architectural works are a lamentation over destroyed beauty. In *The Stones of Venice* his splendid description of an English cathedral[2] had become a mockery, and for the words 'the great mouldering wall of rugged sculpture', he advises us

1. Letter to *Pall Mall Gazette*, 16 March 1872, in answer to the charge that his direct influence was bad, his indirect good. C. & W., x, 459.

2. *Stones*, IV, § 10.

to read 'the beautiful new parapet by Mr Scott, with a gross of kings sent down from Kensington. . . .'. And to the *Seven Lamps* he added a preface summing up all the bitterness he felt towards the movement he was supposed to lead. 'I never intended to have republished this book, which has become the most useless I ever wrote; the buildings it describes with so much delight being now either knocked down or scraped and patched up into smugness and smoothness more tragic than uttermost ruin.'

Nothing shows the gulf between Ruskin and the true Gothic revivalists more clearly than their different attitudes to restoration. To the Camdenian restoration was the substitution of one good thing for another, or even, if the style of the new work be purer and more real than that of the old, of something better. They built in a style not because it was beautiful, but because it was right. But to Ruskin, hampered by an exquisite sensibility, restoration always means 'the most total destruction which a building can suffer'.[1] Seen at our present distance Ruskin is not the man who made the Gothic Revival; he is the man who destroyed it. He found the Revivalists armed with the powerful weapons of a religious sect – consciousness of a divine mission,[2] a rigid creed, based on faith, not works, absolute logic within self-created limits, absolute self-confidence. Convinced minorities, we all know, may do anything. But just as that small section of the public which notices architecture was being won round by Camdenian audacity and logic, Ruskin published his *Seven Lamps*. We can see how dangerous he was. The promoters of the Gothic movement, Gilbert Scott tells us,

1. *Seven Lamps*, 'Lamps of Memory'.
2. 'The ardent promoters and sharers in the Gothic movement had fondly flattered themselves that theirs was a preternatural, heaven-born impulse; that they had been born, and by force of circumstances trained, and led on by a concurrence of events wholly apart from their own choice and will, to be instruments under Providence in effecting a great revival' – Gilbert Scott, *Recollections*, 372. He is writing in 1878 of the new 'Queen Anne' style, which he calls 'a vexatious disturber of the Gothic movement'. Hence the words 'fondly flattered themselves', which would not have appeared before 1870.

viewed the revival 'as in part religious, in part patriotic'.[1] Ruskin was opposed to the religious side and damaged the patriotic by his introduction of Italian Gothic. With his fatal gifts of enthusiasm and eloquence, he had only to praise a style, and his countrymen adopted it. Now he praised a style simply because he found it beautiful; and that might lead anywhere. But the Camdenians did not realize their danger. Deceived by Ruskin's superficial resemblance to themselves, they generously disregarded his anti-Catholic tone and praised his principles. They allowed him to sow his seed in their tidy garden, and immediately it became a tangle of exotic weeds.

Meanwhile the sower would gladly have made a bonfire of the lot. Rereading in 1880 that book of his which had made and unmade the Gothic Revival, and coming on the sentence in which he questions the movement's early value, Ruskin added a note, 'I am glad to see I had so much sense thus early.'

1. Gilbert Scott, *Recollections*, 372.

Epilogue

We can never forget the Gothic Revival. It changed the face of England, building and restoring churches all over the country-side, and filling our towns with Gothic banks and grocers, Gothic lodging-houses and insurance companies, Gothic everything, from a town-hall down to a slum public-house. . . . There cannot be a main street in England quite untouched by the Revival. And in the suburbs it is as strong as ever: the impulse which revolted against classical forms, and which created from the Middle Ages a new ideal world, still finds dismal, half-hearted expression in thousands of gabled villas.

What a wilderness of deplorable architecture! What a pathetic memorial to Pugin, Butterfield, and Street!

But of course we do not judge an artistic movement by its extent; we judge it by the beauty of its best productions; and for the forming of such a judgement on the Revival we are, at present,[1] quite unfit. As early as 1880 the so-called Queen Anne style of Norman Shaw was a menace to the Gothic party, and by 1900 the Revival had ceased to be a creed, and Gothic was only used when architectural considerations de-manded it. Once more taste has swung back from the vertical to the horizontal, from the shrill, assertive music of the pointed arch to the comfortable melodies of the shallow curve, from the prickly, irregular thistle to the swag of smooth and luscious fruits. But though the classical reaction which rules our vision makes any such judgement dangerous, no one, I think, will ever deny that the architecture of the Gothic Revival is disappointing. We should, indeed, find it hard to believe that

1. 1927; perhaps untrue in 1949.

a movement so widespread, and the focus of so much passionate effort, could fail, did we not reflect that any attempt to revive medieval styles was attended by inevitable, and perhaps insurmountable, difficulties.

Many of these difficulties are quite obvious, and were quoted by opponents of the revival in every battle of styles. Enough has been said of the fact that Gothic windows admit less light than plain rectangles, or that Gothic detail collects dirt. Trouble lay at the very root of the Revival not in any practical detail, though to the use of Gothic in civil architecture there was one practical objection of very great importance. Between medieval and modern architecture lies the appearance of the street. Medieval architecture was in the round; modern architecture, street architecture, is flat. One could walk all round the medieval cathedral, watching an endless interplay of spires and buttresses, but the street front has to depend entirely on a façade. In Italy, indeed, street architecture appeared when the Gothic style was still popular, and it is for this reason, rather than from any love of deception, that the Italians built façades for their Gothic cathedrals. But to a good Gothic revivalist the façade was impossible, was the negation of all that he valued in medieval building. Reality, naturalness, variety, truth, all were sacrificed to a flat imposture. The only façade architecture which the leaders of the Revival ever allowed was that of Venice, which Ruskin found so beautiful that he was forced to give it moral justification. But the more intelligent architects, realizing that Venetian Gothic could not be transplanted, were faithful to their ideal of truth and irregularity. The result is a series of erosions and excrescences, breaking the line of our streets, wasting valuable ground space, and totally disregarding the chief problem of modern civil architecture.[1]

1. This is the stupidest and most pretentious sentence in the book. I knew little enough about 'modern civil architecture', but if I had stopped to think for a second would have realized that the beauty of all towns depends on 'the waste of valuable ground space'; and I had not to go further than Oxford High Street to see what beauty a street can derive from its line being broken by erosions and excrescences (1949).

In church building the Revival suffered less from changed conditions, and certainly achieved a greater measure of success. But though the forms of service had altered very little in three hundred years, the function of the village church had dwindled. The church was no longer a combination of a club and a theatre; it was not even the sole centre of intellectual and spiritual life. Comprehensiveness and virility had gone out of it, and this loss is reflected in the buildings of the time. Smug, shiny, impotent, niggling – in a Gothic Revival church these adjectives fly into one's brain, and range themselves opposite the familiar description of an old Gothic church – rather rough, but broad, peaceful, and alive.

The narrowness of spirit which was so often fatal to small churches was doubly dangerous when the revivalists attempted a large church or cathedral, for the medieval cathedral, even more than the parish church, was a centre of human activity in all its manifestations. In such buildings were concentrated, over a very long period, the best endeavours and aspirations of a whole district; whereas the large churches of the Revival were built with strict limitations as to price and time, and without the smallest interest being taken in them by the community as a whole. No one saw this difficulty more clearly than Pugin, who used to alarm diocesan councils by saying that his design would take from fifty to sixty years to carry out, and on one occasion wrote to a bishop, 'My dear Lord, – Say thirty shillings more, and have a tower and spire at once. A.W.P.' But the consideration that medieval architects frequently gave their whole lives to one or two buildings did not, as we have seen, deter Gilbert Scott from working on more than seven hundred and thirty. As a result his buildings have a ready-made look, which, of all things, is fatal to Gothic architecture. For, as Ruskin never tired of pointing out, true Gothic is not made in the architect's office, but in the mason's yard.

Gothic depends on detail, and the individual architect, however gifted, is powerless without a body of good craftsmen. Here lay the great difference between the Revival and the

romantic movement in literature, for, as Mr Geoffrey Scott has said, the sleepiest printer could set up the poems of Byron and Wordsworth; but the traditional skill of the medieval mason could scarcely be learnt in a century: and by 1800 this skill had been completely lost. The importance of craftsmanship was so obvious that even as early as Wyatt architects made an effort to train good carvers, and the rebuilding of the Houses of Parliament produced, as we have seen, a whole school of craftsmen. Yet of all branches of the Revival detail remained the least successful. Late in the century the movement produced some beautiful buildings, but, as Norman Shaw said, the backs were always better than the fronts. Some light is thrown on this failure by a passage in Scott's *Recollections*, in which he speaks of his gift for detail. 'I might have done great things,' he says, 'I had it in me, but I had no leisure to stop to cultivate it'; as it was 'I did as much as most men to forward the art of carving' solely 'by influence'. These are the sentiments that made Ruskin despair of the Revival, for as long as the architect was too much of a snob to do manual work, as long as he produced his detail by influence, there was no hope, Ruskin thought, of recapturing the medieval spirit. Alas! the medieval spirit was more elusive than Ruskin imagined, and would still have evaded him even had Sir Gilbert Scott taken the mallet and chisel in his hands. It was not skill and intelligence which produced Gothic detail: the Revival produced some carvers technically as skilful as any of the thirteenth century, but their detail never ceased to be tame and self-conscious. Their madonnas were always genteel, their saints always venerable, butter would not melt in their angels' mouths; and the awful events of the Apocalypse were conducted with the decorum of a garden party.

For, of course, the quality of Gothic architecture depended entirely on the character and sentiments of the middle age, and for this reason, above all, Gothic was quite beyond revival. No doubt it is true that all styles reflect irrecoverable moods, but while some can be formulated into a body of rules, others

spring spontaneously from sentiment. Clearly styles of the second kind cannot be revived in any pedantic spirit. At most our circumstances and feelings may be so like those which created a previous style, that we instinctively borrow its forms. If we share a seventeenth-century architect's feeling for curves, and contrasted movement, and diagonal recession, we may use some of the inventions of Borromini. But if we try to build sham seventeenth-century baroque we are lost, for we can never feel exactly as Borromini felt, and there are no rules of baroque to guide us.

This was the great mistake of nineteenth-century Gothicizers. They tried to revive a style which depended on sentiment as if it depended on rules, and they looked for these rules in the buildings themselves. The absurd attempt of Batty Langley was made all through the Revival. There was, indeed, a short period – the period of Fonthill – when it seemed as if Gothic forms could be adapted to the spirit of Romanticism. But even then a certain amount of archaeology was considered respectable; and under the Camden Society the craving for an exact reproduction of medieval forms became involved with the belief that these forms had symbolical and moral value, or at least were the expression of a noble state of society. The true Gothic Revivalist could not modify these moral forms to suit a corrupt society; so instead of saying, 'You must adapt Gothic to modern life,' he said, 'You must change modern life to produce true Gothic.' The best spirits of the Revival – Pugin, Ruskin, William Morris – turned from the reform of art to the reform of society, from the advocacy of dead decorative forms to that of undying principles of social order.

Despite difficulties which made the Gothic Revival an almost hopeless undertaking, and despite the mistakes of its promoters, the movement produced some buildings to which, with the worst will in the world, we must allow great merit. Nearly all the best work of the Revival was done after the death of Gilbert Scott; that is to say, it does not come within the scope of this book, and to write a book on the Gothic

Revival which does not mention its best buildings may sound absurd. But the subject of this book is the ideals and motives of the Revival, and by the time of Ruskin all its motives were plain and its ideals had been given permanent and splendid expression. These motives were never very strictly architectural, were rather literary, patriotic, archaeological, and moral, and though this does not account for the movement's failure (morals have at least as much to do with architecture as perspective and the spectrum have to do with painting, and Uccello and Seurat were great painters), it suggests that the chief legacy of the Gothic Revival is to be found not in buidlings, but in a body of principles and ideals.

There is, however, one way in which the Revival has had a permanent influence on our sense of beauty. It accompanied and, in large measure, promoted a profound change in human perception, a change which can be loosely described as the growth of a taste for the Primitives. In so far as the word primitive retains any meaning of crude or inept, it cannot, of course, be used of such a painting as Botticelli's *Primavera*; but the term has always been applied to those pictures of the fifteenth century painted in what Vasari called '*la maniera secca e cruda*', and has come to have this special meaning in the vocabulary of art. Now if we compare one of these primitive pictures with a work of the sixteenth century in order to find out what each tells us of the age which produced it, we shall, I think, come to the old-fashioned conclusion: that primitive art is essentially religious art, and that painting since Raphael is essentially worldly. The earliest writers on primitive art felt this distinction very strongly, and, though their efforts to account for it were quite unsuccessful, Montalembert, Rio, Lord Lindsay, Mrs Jameson all spoke not of 'primitive', but of 'Christian' art, and Ruskin, whose emphasis on the religious appeal of the early painters sticks in the modern reader's throat, was actually one of the first critics to praise their work for non-religious qualities. It was to be expected that the Christian element in primitive painting would make an especially strong

appeal to the Gothic Revivalists, and, in fact, they welcomed it rapturously. Fra Angelico became for them the greatest figure in art, their patron saint, as Raphael was the patron saint of the classical party. That innocent sensualist must have been a relief after the severities of Gothic architecture, though the revivalists themselves confessed to very different motives. 'Foremost among those', writes the younger Street in his biography of his father, 'whose works breathe a spirit of purity and devotion stands Fra Angelico, and so strongly did my father feel the exalted nature of his work, that he made a proper appreciation of it a test of his own moral state.'[1]

This simple, uncritical way of looking at the primitive seems a long way from our own, but every change of taste has been achieved by some such roundabout means. The language of a new style must be learnt gradually, and only when a great many objects in that syle have been collected and examined from an entirely non-aesthetic standpoint, can we begin to look at them as works of art. The ethnologists made possible an appreciation of negro sculpture; the pietists did the same for fifteenth-century painting. Of course Pugin and his followers were not insensitive to the beautiful shapes and colours in primitive pictures; but these were not their chief concern, and were never the reasons they gave for their preference. Instead they would say that in fifteenth-century paintings saints displayed greater ecstasy than in those of a later epoch – which is definitely untrue. Indeed, as long as they based their arguments on subject matter they were bound to be in trouble, for though the saints in a modern Catholic image shop are extremely virtuous, they are obviously the products of an utterly worldly civilization, whereas the gargoyles of a medieval cathedral, though monsters of vice, are alive with the spirit of a truly religious age. But, whatever their motives, there can be no doubt that the Gothic Revival made many thousands of people look at primitive pictures who would not otherwise have done so. Mozley tells us how eagerly he and other keen Gothicizers

1. I suppose I thought this absurd, but I now think it true (1949).

sent to Germany for lithographs of fifteenth-century paint-
ings; and the Arundel Society's colour prints, which, more
than anything else, spread the taste for the primitives, are
musty with the faded smell of the Gothic Revival.

If many thousands of people look intensely at works of art
for many years, a few will come to find them beautiful. And
the Gothic party were fortunate in having a guide who, in his
writings, led them through all the phases of appreciation. In
this, as in other fields, Ruskin watered and weeded what the
Gothic Revival had sown. He found a number of pious persons
gazing with rather inane admiration at Fra Angelico's pretty
angels, and he led them back, with a literary touch which they
could understand – back past even the sturdy, unseductive
angels of Giotto to the no longer human angels at Ravenna and
Torcello. Thus a new world of beauty was prepared for our
changed spirits, and a little chink of transcendental light,
shining into the self-contained world of the eighteenth century,
fell on these long-forgotten symbols of belief and fear.

Though the influence of the Gothic Revival on our percep-
tions is traceable only in our taste for a symbolic art, its influ-
ence on our ideas and our artistic principles is varied and alive;
and the full body of its doctrine must have been acceptable
long after Gothic Revival buildings were in disgrace. Probably
it is still accepted by the mass of people who have no special or
sophisticated interest in the arts. Such people are beyond the
reach of ordinary fashionable standards, and practically im-
pervious to aesthetic appeal. Once fixed in their minds, there-
fore, ideas on art are likely to remain there for at least a cen-
tury, and it seems unlikely that Gothic Revival ideals will be
expelled until some critic appears combining sensibility with
eloquence and moral enthusiasm. For naturally it is moral, not
aesthetic, ideas which move the people, and the Gothic Revival
owes its rare force to the way in which it reduced all architec-
tural matters to a religious or a moral issue.

But among those whose taste for the arts is at all self-
conscious, very few Gothic Revival principles have survived a

new way of judging works of art which was, indeed, formed in conscious reaction against them. Beauty, it was said, lay simply in some mysterious combination of shapes and colours. It had nothing to do with rules, nor with associations, nor with the subjects represented; least of all did it depend on morals. Those ideas were expressed as early as Whistler's ten-o'clock lecture, but they did not become popular till at least twenty-five years later, and do not seem to have been applied to architecture till Mr Geoffrey Scott published his *Architecture of Humanism* in 1914. Since that time a belief in the amorality of art, the isolation of aesthetic experience, has taken root in the fashionable mind; and it is a proof of Pugin's genius that a few of his principles have survived this reaction, and are perhaps more influential today than when he framed them.

The first of these is the doctrine that sound construction frankly displayed is of itself beautiful. Under the title 'The Mechanical Fallacy', Mr Geoffrey Scott has made this theory look very foolish, and it is indeed a distorted glass in which to view the architecture of the Renaissance. But it is not entirely fallacious today. Mr Scott admits that the appearance of structural power is important to a building's beauty and shows that Renaissance architects often achieved, and even heightened, this appearance by constructive methods which were very unsound. But few modern architects have a vigorous pictorial sense, and none works in a living style; and perhaps their best chance of an appearance of structural power is to take full advantage of modern skill in engineering. At worst their buildings will not offend our sense of fitness, at best they will achieve a kind of crude dignity and the unity of many parts subordinated to a single end which is one of the chief qualities of a work of art. The mechanical fallacy still flourishes in a mechanical age. And it is not only in the doctrines of Le Corbusier and the grain elevators of St Lawrence that what we may call the theory of true construction has survived: today no reputable architect would build the stucco boxes which covered the country in Pugin's time, or the stucco-fronted

streets of Nash. All our houses are solider for the Gothic Revival.[1]

It is easy to see how the theory of truthful construction led directly to another great achievement of Gothicizm, the revival of vernacular architecture. The serious Gothic architect, who wanted to catch his style alive, saw that his best chance of doing so was to build in those local styles which had never really died, to use local materials in the traditional way. This idea appeared as early as the picturesque period, was vigorously stated by Pugin, and was the text of Gilbert Scott's *Domestic Architecture*. But it was not an idea which the Gothic Revivalists could follow very strictly, for there are many vernacular styles, and though we, with easy eclecticism, are prepared to build in any of them, they could only adopt those which dated from the sixteenth century. Their love of Gothic forms was stronger than their belief in any theory, and where the local styles were of the eighteenth century, the Gothic Revivalists unhesitatingly invented a medieval vernacular of their own.

Because they believed uncompromisingly in the value of Gothic forms, the revivalists could never produce agreeable architecture. Yet it is this very conviction which makes the Gothic Revival so interesting. The great heaps of clinkers which it left all over the country once burned with fiery belief, and we may still feel the warmth of a few embers. In an age when the gross were utilitarians and the men of fine spirit were disillusioned, the Gothic Revivalists, like Arnold's Scholar Gipsy, had one dominating ideal; and they converted the materialists to this ideal, as only great enthusiasts can. We may envy their solidly furnished spiritual world. 'Blessed are those who have taste,' said Nietzsche, 'even although it be bad taste.'

1. Curiously enough, they are brighter and better furnished. For the Gothic Revival coloured the mind of William Morris, who took from the tapestries and painted glass of the Middle Ages gay patterns to transform the drab Victorian drawing-room. I wish it had been possible to include in this essay some discussion of his influence and of the whole arts and crafts movement, perhaps the most promising and most disappointing child of the Gothic Revival.

Index

Abbotsford, 93

Acland, Dr Henry, and the Oxford Museum, 188–92
and O'Shea, 190–1
and Ruskin's letters, 191, 192

Adam, R. and J., their revolt against Palladianism, 67

Adam, R., quarrels with Walpole, 50 n.
his Gothic buildings, 68

Addison, Joseph, 23, 36
on Milton, 18
his essay on *Chevy Chase*, 18 n., 56
on Milan and Siena, 28

d'Agincourt, 76, 94

Aikin, Edmund, 95

Akenside, *Pleasures of the Imagination*, 28

Albert Memorial and Hall, 138, 172–3

Allen's grounds, near Bath, 37

Allhallows Church, Derby, 5 n.

All Souls College, Oxford, 7, 11

Alton, hospital at, 119

Amiens Cathedral, 23

Angel Choir, Lincoln, 155

Angelico, Fra, 203, 204

Antiquaries, Society of, refounded, 13, 15
publish *Archaeologia*, 61
support the term 'English', 62

Arbury, 49

Archaeology, the craze for, 58–66

Architectural Magazine, quoted on Caracci, 94 n.
on papier-mâché Gothic, 97
on Gothic and Nature, 102
on cast-iron tracery, 176
publishes *The Poetry of Architecture*, 176
comes to a lamentable end, 176

references to, 97 n., 138 n.

Architectural Review:
articles on Pugin, 97 n.
Briggs' article on Gilbert Scott, 160
Summerson's article on Butterfield, xvii, 174 n.

Architectural societies, 145, 151; *see also* Camden Society

Aristotle, 22, 122
use of 'Nature', 100

Arundel Castle, 69

Arundel Society, 204

Ashridge, 73, 74

Ashton, friend of Gray, 23

Atkinson, William, 93 n.

Aubrey, John, 13 n., 29 n.

Austin, manufacturer of Artificial Stone, 97

Balliol College and Pugin, 111

Bankhead, Edith, *The Tale of Terror*, 33 n.

Baroque, 6, 7, 8, 38

Barrett, Thomas, of Lee Priory, 50, 70, 77

Barry, Alfred, 113, 114, 115

Barry, Sir Charles:
his Gothic churches, 83, 91, 92
his Gothic mansions, 95 n., Chapter 6 *passim*
his designs for Houses of Parliament, chosen, 99
not a convinced Goth, 101
use of medieval detail in Houses of Parliament, 103, 104
praise of Houses of Parliament, 104, 105
authorship of Houses of Parliament disputed, 113–16
Pugin's letters to, 115, 116

INDEX